50 Art Ideas
You Really
Need to Know

Susie Hodge

greenfinch

Contents

Introduction

Throughout its history, art has had numerous functions and it has always mirrored the times in which it was made. At its simplest, it is a form of communication or decoration, but it has also been created for countless other purposes, such as religious representation, propaganda, commemoration, social commentary, interpretation of reality, depiction of beauty, storytelling or portrayal of emotion. It is often enigmatic, perplexing or even disconcerting, leaving us hard-pressed either to understand or define it.

This book is about many of the ideas that have been behind art, from prehistory to today. It considers art that was produced in certain places at particular times and how an amalgamation of elements, such as traditions, techniques, materials, technology, the environment, social or political events or circumstances and individual personalities, have resulted in some unexpected, inspirational or puzzling innovations. It also focuses on the links between art and a society's activities and aspirations and how the results can sometimes be, for instance, awe-inspiring, shocking, beautiful or downright ugly.

Roughly chronological, the book begins with the earliest art and includes many groundbreaking ideas, including the astonishing creations of the Renaissance, the provocative paintings and sculpture of the 16th century and Japanese 'pictures of the floating world', for example. It shows how artists from various times, cultures and countries have produced a multiplicity of processes, styles and images and how the role of artists changed over time and across continents. Later sections of the book discuss the explosion of ideas that emerged during the 19th and 20th centuries, from the revolutionary work of the Impressionists and the development of abstract art, to the extensive reactions and reinterpretations that occurred around the two world wars. The final section of the book explores some of the latest notions that indicate some exciting, surprising and unanticipated possibilities for the future of art.

Susie Hodge

01 Prehistoric art (c.30,000–2000 BC)

The idea that art was magic in some way, that it had special powers or could conjure up the spirits, was a common belief in many early societies. Few examples of prehistoric art have survived, but those that have been found reveal various social systems and religious ideas that were probably generally understood thousands of years ago and can only be speculated about now.

The beginnings of art precede written records. So it is not known whether the oldest artwork that has been found is typical of its time and period – or even if it was art at all. The earliest work that can clearly be classified as art comes from the late Stone Age and particularly the period between 15,000 BC and 10,000 BC, when humans painted, printed and scratched images of animals, hunting, hands and patterns on cave walls and rock shelters.

The Stone Age is usually divided into four main periods: Lower and Middle Palaeolithic c.750,000–40,000 BC; Upper Palaeolithic c.40,000–10,000 BC; Mesolithic c.10,000–8000 BC and Neolithic c.8000–1500 BC. Palaeolithic people were hunter-gatherers. Mesolithic and Neolithic people became farmers and so had greater control over their own destinies. Although the styles and subjects of art changed across these periods, the basic idea that artistic creation could be infused with a spell or prediction of what was to come continued.

Cave paintings created about 10,000 to 30,000 years ago in France, Spain, Italy, Portugal, Russia and Mongolia, are some of the best-known prehistoric works of art. The most astonishing are in Lascaux in south-west France, where about 300 paintings and 1,500 engravings decorate two large caves. Remarkably vivid, the paintings show accomplished skills in rendering perspective, form and motion. It is believed that most of this prehistoric art was produced for rituals and was intended to bring good fortune, or certainly to affect the future for the benefit of society or individuals.

Fertility and food

Supernatural powers were also believed to be imbued into sculpture. The first carvings were made of ivory, stone or clay. Small, rounded

limestone female figures, about 11cm high, dating from around 25,000 BC were found in Austria and are known as Venus figurines. These and similar statuettes from other parts of Europe are believed to have been carved to function as fertility icons.

'Hall of Bulls'

The huge, lifelike paintings of animals, including bison, horses and deer seem to stampede across cave walls and ceilings. All were painted using powdered pigments such as red and yellow ochre, umber, charcoal and chalk, which were crushed on stone palettes and mixed with animal fat before being applied to the cave walls and ceilings with fingers, pieces of bone, twigs, moss or brushes made of fur. Many may have been copied from dead models. The naturalistic rendering, the frequent representation of animals pierced by arrows or spears, the casual overlapping of images and locations in the most inaccessible parts of caves all suggest that the making of these pictures was a magical ritual to ensure success in the hunt.

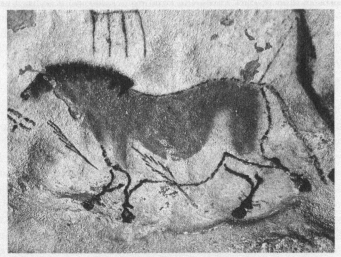

Cave painting, Lascaux, c.15,000 BC

Power, superstition and religion

Interpretations of prehistoric art still vary. Almost certainly viewed as a powerful protection against the forces of nature or evil spirits, multiple footprints have been found in front of many of the cave paintings, indicating religious gatherings. Because Palaeolithic paintings of humans are uncommon and unrealistic, it is likely that the artists believed they were capturing spirits through their art. As they needed an influence over the uncertain food supply on which they depended, they aimed to establish good relations with the unseen

'Drawing is still basically the same as it has been since prehistoric times. It brings together man and the world. It lives through magic.'

Keith Haring

powers they believed existed around them. The images they created were ways they felt they were controlling their destiny. It is not clear whether they believed in gods or one supreme being, but the idea of supernatural powers being evoked through art was a strong one that lasted for thousands of years.

By the Mesolithic period, artists began painting more on open rock surfaces than in dark caves, the painting became more stylized and people featured more frequently. Representations of the human figure were abstracted and men were often shown as warriors. The Mesolithic idea that the people were controllers rather than victims of their environment meant that they depicted themselves in confident action rather than focusing completely on their prey.

Function and form

During the Neolithic period, life became more stable and people cultivated plants and animals, replacing hunting with ploughing. This was the time of great megalith building such as Stonehenge in southern England and Beltany in Ireland, famous for their astronomical alignments. It is not understood how the massive stones were manoeuvred and the ideas behind these megaliths are still unclear, especially as they were reused by subsequent generations for different purposes, but theories include healing centres, burial sites, temples for solar and lunar worship, ancestor worship or even vast calendars. Archaeological evidence indicates that Stonehenge, for instance, served as a burial ground for the first 500 years of its

existence. The links with the sun and moon have long been understood
as humans' way of connecting with supernatural powers.

An enduring belief

The earliest ideas behind the creation of art were passed down through
the centuries. A belief has emerged in many different art movements
throughout our history that once created, art had magical powers
connected with superstitions and beliefs in higher powers in or
beyond this life, and of humans' ability to influence the world around
them through symbolizing or recreating their experiences in static
images. Without written confirmation of this, the great ideas of
prehistoric art can only be speculation, but the evidence of where the
art has been found, what it represents and how it is depicted add to
the probability that it was used for spiritual purposes.

the condensed idea
Art had magical powers

02 Ancient Egyptian art (*c*.3000–30 BC)

ncient Egyptian civilization lasted for about 3,000 years and over the entire time, Egyptian art barely changed. Early Egyptian artists developed a system for depicting everything and these set ideas were passed down to successive artists. They became the rules of representation and no artist could deviate from them or incorporate any individuality into their work.

The Egyptians, like other ancient civilized people, were profoundly influenced by magic and by a belief in the existence of gods who had to be kept happy to ensure their goodwill. As a result, most of the art was created with them in mind. The core of Egyptian religion was the belief in the afterlife.

Art for the dead

Most Egyptian art was created for tombs and was not meant to be seen by the living. So although it might appear attractive to us, that was not its purpose; it was created for something entirely different. A clue lies in one of the Egyptian words for sculptor; 'he-who-keeps-alive'. This was the role of all ancient Egyptian artists – not to adorn or embellish, not to bring luck to the living, but to assist the (wealthy) dead to reach the afterlife, to be accepted by the gods and, once there, to spend their time as they had on earth. So tombs were decorated with everyday objects and scenes depicting the deceased person's earthly activities. Statues or statuettes of the dead showing how they lived were included, along with images of the people who surrounded them in life, such as family members and servants. The ancient Egyptians believed that a painting, relief or sculpture had the potential of actually becoming the subject of the art once the tomb was closed. So a likeness of a servant, for example, would become a servant when needed in the afterlife.

A precise system

It was the artists' mission to show everything as plainly and unambiguously as they could. So the art was essentially diagrammatic. Personal interpretations, observational drawings from life,

imaginative embellishments or any other deviations were strictly forbidden. Instead, during lengthy apprenticeships, artists had to memorize the strict codes of representation and to use them in every painting, relief or sculpture. Although the shapes and forms of Egyptian art look simple, there is a fairly complex balance and harmony in the geometric regularity and placement of every element. The aim was to avoid stylization and ambiguity, but through the

Egyptian tomb paintings

Queen Nefertari's tomb is typical of royal tombs of the period. Decorated with religious texts and painted reliefs of the queen during her life, it was intended to help her transition to the next world. Painted in about 1255 BC this image shows her playing a board game and follows the conventions of portrayal. For instance, the torso and eyes are shown from the front while the head, arms and leg are seen from the side. The game pieces are also seen from the side in their clearest representation. Hieroglyphs within the image offer a spell designed to transform Nefertari into a bird, helping her to leave her earthly body and begin the afterlife as an immortal.

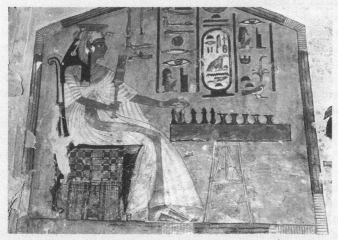

'The queen playing chess', Tomb of Nefertari, Thebes, c. 1255 BC

unchanging forms of representation, they still created a unique and distinctive style of design, which was admired and imitated excessively in the centuries that followed.

The method

The artists' approach to their work was methodical and systematic. For wall paintings, to begin with, grids were marked on using string dipped in red paint. Next, the image was drawn lightly, copied from initial drawings on papyrus and, finally, the work was painted in vivid, flat colours. No attempt was made to represent depth, perspective or texture and everything was shown from its most characteristic angle. Reliefs were tackled in a similar way and sculpture was also carved from grids and followed strict rules of representation. The statue of a departed king provided a sanctuary for his spirit. If the statue was sculpted in hard stone, that refuge would endure for eternity.

> '(Egypt) is a great place for contrasts: splendid things gleam in the dust.'
>
> Gustave Flaubert

Rules of depiction

As well as limbs and features being shown from their most characteristic angles, the most important people were indicated by size. So men were bigger than their wives, for instance, and they would both be bigger than their servants. Women were usually portrayed as passive, while men were shown in more active roles. Men were coloured in darker brownish-red hues, while women were usually coloured in lighter yellows. Objects such as trees, houses or boats for example, were drawn from the side, while rivers and fish were shown from above. There were strict rules about the appearance of every god, of which there were over 2,000, and symbols, believed to be understood by the gods, were often incorporated within paintings, such as the scarab, which was a symbol of creation, and the frog and duck, which depicted fertility. Seated statues always had their hands on their knees and standing statues had one foot in front of the other. As in painting and reliefs, sculpture relied on predetermined rules and not on optical fact, so there are few individual likenesses portrayed in royal statues. Permanence was more important than

naturalism. In this way, the Egyptians believed that they could leave each dead person (usually royal, but also sometimes from the highest nobility) sealed in their tombs. The gods would understand all the images, prayers, spells and offerings and would take the deceased to the afterlife as an immortal.

Three aspects

The art of the Egyptians began as it continued; there was no early period of development and only one change of style throughout the entire period. The art of the earliest periods was as proficient as – and comparable to – the later work. It emerged from the culture's three major concerns: religion, death and the importance of conforming to established practice.

the condensed idea
Art helped the dead

03 Classical Greek art
(c.500–320 BC)

The ancient Greeks were absorbed by people, reason and nature, and these concerns manifested themselves in their art. Their fascination with people and nature in general materialized in close observations of reality, but they were also lovers of beauty, so they idealized their recordings. It was this mixture of naturalism and idealism that shaped Classical Greek art.

For the first thirty years after the Greeks' victory over the Persians in 480 BC, there was a new unity among the scattered city states of the country. The peace, power and confidence they felt emerged in a new flowering of art. They had been a creative race for generations, but this period became even more prolific.

Technical mastery

In contrast with the Egyptians, Greek artists focused on life rather than death. Fascinated by the development of the mind, the Olympic Games (first recorded in 776 BC), reflected a corresponding interest in physical prowess. In general, people aimed to hone themselves mentally and physically and in reflection of these popular aspirations, artists depicted perfect figures and unflawed surroundings. The belief that their gods resembled ideal humans was part of the reverence of beauty and flawlessness.

In Athens, there was a surge of creativity as art was produced to adorn both public and religious places. Buildings were embellished with reliefs, wall paintings and statues. Subjects included mythological stories, heroes, gods and goddesses. Figures were shown as youthful and energetic, with well-proportioned torsos and slim, muscular limbs. The ideas that lay behind the art were revolutionary. Before this, all cultures had stylized or simplified their art in some way. This was the first time artists had studied their subjects at close hand and tried to make them look lifelike. Realistic elements such as foreshortening and texture were explored for the first time and artists included accurate details in their attempts to represent life as they saw it. Even badly damaged, the art of this period shows the technical mastery and close observations of its creators. It was then improved to

make it look perfect. Because of the climate and the fact that many were on wood, most ancient Greek paintings have not survived, although ancient Roman copies of many are in existence. The colourful paint has often rubbed off the statues, but these lifelike images must have seemed incredible to ordinary citizens, who would not have had not seen anything like this before.

Discus Thrower

The blend of lifelike and ideal elements appealed to the Greeks' admiration of physical beauty and of their artists' intellectual accomplishments. Copying from real models was an approach that had not been tackled to such a standard before, and Myron's *Discus Thrower* (*Discobolus*), created in about 450 BC, is a convincing representation of a body in motion.

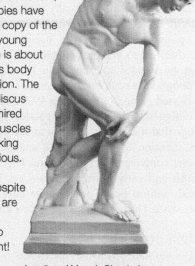

Although the actual work is lost, some ancient Roman copies have been preserved, and this copy of the original statue depicts a young athlete at the moment he is about to hurl a heavy discus, his body twisted in anticipated action. The physical appearance of discus throwers was greatly admired because no one set of muscles was over-developed, making their proportions harmonious. The figure is expressive, realistic and flawless – despite the fact that the muscles are not straining; whether or not this is the best way to throw a discus is irrelevant!

A replica of Myron's *Discobolus*

Innovative sculptors

For the first time in history, some artists' names became singled out from the mass of artisans who created art anonymously. Three sculptors in particular are believed to have started the Classical Greek style and the artistic tradition of running schools, which continued long after their deaths. Myron of Eleutherae worked around 480–440 BC. He created lifelike statues of gods and heroes, but became famous for his representations of athletes in strong, dynamic poses. Phidias (500–432 BC) is usually viewed as one of the greatest of all Classical Greek sculptors who began enhancing Athens after the victory over Persia. As the overseer of public works, he was commissioned to build major statues for the city. Among many other things, he directed and supervised the construction of the Parthenon and designed its sculptural decoration. His Statue of Zeus at Olympia was classed as one of the Seven Wonders of the Ancient World. He also designed two statues of the goddess Athena in the Acropolis, one so huge that it could be seen out at sea. His work is characterized by close attention to realistic detail and skilful rendering of drapery. Another contemporary sculptor was Polykleitos, who worked during the fifth and early fourth centuries BC. He created ideal figures in relaxed, natural poses, which were later followed by artists of the Renaissance. His particular pose is now known as *contrapposto*.

Perfect proportions

The Golden Ratio, named by the Greeks, was a balance of proportions, measured in rectangles that are universally pleasing to the eye. The Golden Ratio was first used by the ancient Egyptians and centuries

later named 'phi' by Leonardo da Vinci, after Phidias, who applied the balanced proportions to all his work. The exterior dimensions of the Parthenon follow the Golden Ratio, and all the sculpture can be divided into these specifically proportioned measurements. For instance, in the statue of Athena, the measurement from the top of the head to the ear, compared with the length from the forehead to the chin and nostril to earlobe, could all be broken down into these specific proportions.

Greek vases

Although pottery had not previously been classed as fine art, the ancient Greeks included it in their quest for perfection. The pottery they produced was smooth, finely worked and elaborately decorated. Painted on small curving surfaces, Classical Greek pottery features detailed groups of figures arranged harmoniously. Pottery painters also give us clues about the compositions of the paintings that were produced at the time as ceramicists kept pace with the developments of the great master artists whose works are lost.

'Our love of what is beautiful does not lead to extravagance; our love of the things of the mind does not make us soft'

Pericles, (c.495–429 BC)

the condensed idea
Realism enhanced by perfection

04 Buddhist art (*c.*600 BC–AD 700)

Buddhism and its arts have existed for more than 2,500 years. In about 600–500 BC, Indian artists began creating iconography and symbolism to spread Buddha's teachings. Within 600 years, Buddhist artists were using ideas they had absorbed from Roman artists, who in turn had been strongly influenced by the Greeks.

Buddhist art was all about illustrating the story of Buddha and explaining events from the experiences of Siddhārtha Gautama, a spiritual teacher who founded Buddhism. The religion spread from northern India across Central, Eastern and South East Asia. In the earliest Buddhist art, Buddha was not represented in human form. Instead, his presence was indicated by a sign, such as the lotus flower, footprints, an empty seat or a space beneath a parasol. Artists originally created stylized, flat-looking paintings and reliefs. By studying the images, it was intended that followers would come closer to a deeper understanding of Buddhism or might even achieve enlightenment.

Depictions of serenity

The first image of Buddha in human form was carved around the end of the first century AD in an area of India known as Gandhara. The art that developed there was clearly inspired by Greek and Roman art as the Buddha was portrayed realistically and usually with curly hair, resembling Roman images of Apollo. He also wore Roman-style jewels and togas. Increasingly, artists adopted the lively and realistic narrative style of Roman art, but by blending this with the symbolism of their earlier art, they created a more individual approach. In other parts of India, artists began creating their own styles and individual interpretations of Buddha. Gandharan art influenced the sculpture of Mathura, a city in northern India and the ideas spread to parts of China, Korea and Japan. Mathuran artists reinterpreted the Buddha. His body was inflated by sacred breath (*prana*) and his robe was always draped across his left shoulder. In southern India, Buddha was usually depicted wearing a robe draped across his right shoulder and looking serious. This style spread to Sri Lanka. Eventually, images of

Buddha became one of the most popular representations in Buddhism, although the original symbols continued to feature and remained an important part of the art, but they were no longer essential.

The Gupta Empire

The Gupta period, from the 4th to the 6th centuries AD in northern India, is sometimes referred to as a Golden Age. It was a period of inventions and discoveries in science, engineering, literature, mathematics, astronomy, philosophy and art. The empire was based on classical civilization, and peace and prosperity reigned. Artists created countless works of art, inventing their own 'ideal image' of the Buddha, which combined elements of Gandharan and Mathuran art. Gupta Buddhas have their hair arranged in tiny individual curls and their eyes are lowered. Gupta Buddhas became the archetype for future generations of Buddhist artists across Asia.

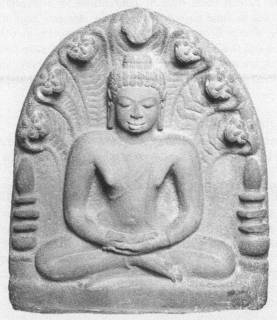

Buddha in meditation, c.4th–6th century AD

However he was represented, the Buddha's expression was always serene and his hands were posed in symbolic gestures. His hair was knotted on the top of his head and his robe, although still similar to a toga, began to seem more traditionally Indian.

Religious instruction

As with the majority of religious art, Buddhist art was intended as a spiritual teaching tool, a means of attracting and focusing worshippers' attention and teaching the background to their religion. Another aim of Buddhist art was to aid meditation. Worshippers were encouraged to focus on the art and contemplate the complex symbolism. In doing this, they were to strive to experience a spiritual awakening.

Over the following centuries, a new form of Buddhism emerged, which involved more gods and more intricate rituals. An entirely new group of deities began to be depicted as well as Buddha and the symbols. At first there were no conventions for representing these deities, but as time passed, recognizable elements kept appearing, which gradually became essential. It was important that they were repeated and that viewers recognized them as the main idea behind Buddhist art was to convey the stories clearly, enabling viewers to understand what they were looking at and to encourage and reinforce their beliefs.

Enlightened beings

Bodhisattvas are enlightened individuals or 'wisdom-beings' who wish to become Buddhas and to help others. Bodhisattva is a Sanskrit

Perfect proportions

Whatever the style, images of Buddha always express harmony and serenity. This was achieved by a compulsory system of ideal physical proportions, to which all Buddhist artists had to conform. Whether big or small, images of Buddha always adhere to these set dimensions and ratios. It was an essential idea in Buddhist art as these perfect proportions represent one of the ten qualities or powers of Buddha.

term derived from *Bodhi* (enlightenment) and *sattva* (being). A Buddha is capable of unlimited compassion and wisdom, and the Bodhisattva will endure any type of suffering to help another living creature. From early on, even when everything else was set, artists incorporated their individual interpretations of Bodhisattvas into their art. They were generally portrayed as youthful, beautiful god-like creatures, dressed in exotic silks and jewels, usually happy or serene and in tranquil positions.

As Buddhism spread through Asia, as well as different artistic styles and interpretations of Buddha, various symbols were shared across cultures. Some of these became distinctly different, while other aspects were the same as each other. Colours and hand gestures were two particular areas of symbolism that became incorporated into the art of various countries. For instance, eyes symbolize wisdom, the lotus flower signifies the progress of the soul, the swastika implies good fortune and well-

'An idea that is developed and put into action is more important than an idea that exists only as an idea.'

Buddha

being, a parasol means protection and the wheel of law represents the Buddha's teaching of the path to enlightenment. Colours also have universal meanings in Buddhist art: the five colours of white, yellow, red, blue and green were believed to assist spiritual transformations if viewers meditated on the individual colours, so they frequently appeared in the Buddhist art of various countries. Each was believed to have its own special power – for instance, blue signifies calm and reflective wisdom, white indicates knowledge and learning and green implies vigour and action.

the condensed idea
Art assists meditation and spiritual transformations

05 Byzantine art
(c.300–1204)

As Christianity spread across Europe, the realism of Greek and Roman art was abandoned. Statues were considered a form of idolatry and exalted portraits of ordinary people were frowned on as, in Christianity, humans were not supposed to be glorified above God. Christians believed that God gave artists their skills, so art should be used only to convey his message.

Christian art began long before the Roman Emperor Constantine converted and declared Christianity a legal religion in AD 313. The earliest known Christian art was painted on the walls and ceilings of the catacombs under the city where believers gathered secretly to practise their prohibited religion. These paintings were quite crudely rendered, but that did not matter as they were there to illustrate Christian concepts and not to be admired for the creative skills they conveyed. Biblical themes were shown, and Christ often resembled Apollo, while God assumed Zeus's or Jupiter's features, making it clear to onlookers who were used to Greek and Roman art that they were divine figures. These were about the only references to Greek and Roman art, however, as Christians rejected many of the earlier artists' ideas in an effort to focus on the teachings of the Church. So there were no depictions of the nude for instance. Neither was the imagery particularly narrative as the art was not meant to teach detailed stories of the Bible, but was simply intended to remind those looking at it of the glory of God and the holiness of the scriptures.

Inspiring the illiterate

In AD 323, Emperor Constantine moved the capital of the Roman Empire to Byzantium and renamed it Constantinople. Within a short time, Christianity became the main religion of the entire Roman Empire, and throughout Byzantium, Christian basilicas were built and reliefs, murals and particularly mosaics became popular methods of decorating them. The new Christian art spread along with Christian beliefs to other places, such as Ravenna, Venice, Sicily, Greece and Russia. Mosaics, public and private icons, illuminated manuscripts, fresco paintings and reliefs were produced to convey the wonder of

the scriptures to all. The only worldly concern that was depicted was showing people how to behave in order to get into heaven. As the majority of worshippers were illiterate, all the art captured the spirit of the Bible, rather than any detailed, complex issues. The purpose was to give the faithful a focus during prayer and to encourage the conversion of many more. With the glittering mosaics, gilded backgrounds and awe-inspiring scale, the art that was seen helped to popularize Christianity.

The glory of God

Byzantine artists usually belonged to religious organizations; most were monks. As lifelike representations were believed to contradict the second commandment ('you shall not make for yourself an idol') realism was not valued and sculpture was not particularly popular. In paintings and mosaics, figures were created to look two-dimensional, with no shadows and no perspective. They faced forwards, nearly always looked straight ahead and had little variety of expression. Their garments were heavily draped so the shape of the body was not revealed. Whereas classical artists had tried to imitate life accurately, Byzantine artists sought a more symbolic approach as viewers were not meant to marvel at the artists' skills or to confuse art with life. Backgrounds were invariably gold as art was meant to convey the wonder and magnificence of God and the Holy Family. Opulence and other-worldliness, as in the churches springing up all around, were one of the main methods of inspiring awe in worshippers and demonstrating the omnipresence of God. Holy symbols became integral to much of the art and these became recognized as important

Icons

One of the most important elements of Byzantine art was the icon –
an image of a sacred person, such as Christ, the Virgin, or a saint.
As a means to aid contemplation, icons in different scales were
placed in churches and in homes. They did not look realistic, but
they were venerated as they were believed to display the holy aura
of the figure depicted.

The Virgin Orans is a common Christian portrayal of the
Virgin Mary in prayer. Made in the 11th century in the Saint Sophia
Cathedral in Kyiv, the mosaic is influenced by Byzantine art and
characteristically presents the Virgin with her arms outstretched in
prayer. The handkerchief on her belt is to wipe away the tears of
those who bring their problems to her.

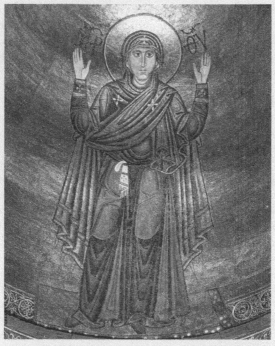

The Virgin Orans, 1037–61, mosaic, Saint Sophia Cathedral, Kyiv

aspects of Christianity. Christian symbols included keys, representing the power of the Church; a chalice, a symbol of Holy Communion and the forgiveness of sin; and the cross, the main sign of Christianity, indicating the cross that Jesus died on.

Iconoclasm

The main purpose of Byzantine art was the glorification of God and the Holy Family. As a result, countless depictions of God, Jesus, the Virgin Mary and the saints and martyrs were produced, and Byzantine artists developed new decorative techniques to make them appear extraordinary. The first great age of Byzantine art occurred during the reign of Justinian I (483–565), who organized Roman laws so they followed Christian beliefs, which in turn affected the art. But by 730, the Islamic opinion that depicting the human form was blasphemous led Emperor Leo III to prohibit the use of images of the Holy Family and the saints. This became known as the Iconoclastic period, which lasted until 843. During that time, all artistic developments were suppressed.

> 'Painting can do for the illiterate what writing does for those who can read.'
>
> Pope Gregory the Great, 6th century

Illuminated manuscripts

As Christianity spread, elaborate manuscripts, mainly of prayers and Bible stories were written by scribes. Although they strictly followed the Christian ideas of other Byzantine artwork, they were intended for different viewers. Perfectly rendered illuminated manuscripts were made for the literate, who were usually members of the clergy or the nobility.

the condensed idea
Symbolic representation of Christianity

06 Gothic art
(c.1140–1500)

Like the Byzantine and Romanesque art that preceded it, Gothic art was infused with spiritual symbolism and aimed to inspire viewers with the grandeur of God. Although all three styles were Christian, the ideas differed. Gothic art grew out of Gothic architecture, at a time when churches were built to reach up to heaven and when church interiors were bathed with light from huge stained-glass windows.

Gothic art originated in France in the 12th century and quickly spread throughout Europe, remaining dominant for over 200 years. It began in 1144 when Abbot Suger (c.1081–1151) supervised the rebuilding of the church of Saint-Denis in Paris. When the towering structure was completed, with light pouring through the huge glass windows, described by Abbot Suger as the 'liquid light of heaven', a new style was born. Saint-Denis inspired many other churches with spires soaring into the sky and other innovative features. Artists resolved to match the accomplishments of the architects.

Barbaric style

The term Gothic to describe the art was intentionally derogatory. The label was first used during the ensuing Renaissance period, referring to the Gothic barbarian tribes that sacked the Roman Empire and destroyed much Classical art. Renaissance artists were scornful of the style, but while Gothic art was being produced, it was considered grand and noble – and the artists who produced it had nothing to do with the sacking of the Roman Empire. Much later, Gothic art became respected for the original ideas that conveyed Christian teachings in a new and vivid manner.

Most Gothic art was integral to the Church and it represented an increasingly prosperous and civilized society. Simultaneously, Gothic artists and architects were encouraged to adorn large cathedrals and churches. Abbot Suger believed that being surrounded by beautiful objects would raise worshippers' souls and bring them closer to God. Artists created massive, stained-glass windows to take up large parts of church walls, where previously there would have been murals. Like

translucent mosaics, Gothic stained-glass windows are often complex and intricate, illustrating biblical stories and saints' lives. Inside churches, they appear like glittering jewels as light shines through, sending pools of rainbow colours onto the congregation. The many poor parishioners who might not have understood all the messages of the images around them would almost certainly have felt that they were experiencing something divine and sacred.

Illustrating ideas

More than trying to create natural or realistic images, Gothic artists focused on illustrating ideas. Art was there to serve religion and express God's omnipotence, not to be admired for its own sake. During the early Gothic period, technical skills were valued more than creative ability, so artists were not considered as important as craftspeople. Artists working in different media tried to gain respect by developing new approaches. Sculptors, for instance, were more concerned about portraying emotion than other medieval artists. By the late 12th century, they were beginning to look at surviving Greek and Roman sculpture and to emulate some of its ideas. But whereas Greek artists designed images of beautiful figures, Gothic artists aimed to tell sacred stories as convincingly as possible. Artists, architects and craftsmen all tried to express the words of God as clearly as possible.

Gradually the role of artists grew, and they became more valued. Many began to sign their works in order to be acknowledged for their skills. As well as stained glass and sculpture, they produced panel

Convincing figures

Gothic sculptors wanted their work to be as noticeable as architecture and stained glass. Statues that had previously been part of the walls were now often made to be free-standing, a style that had not been popular since the fall of the Roman Empire. Following Byzantine and Romanesque art, figures remained elongated, but sculptors now also concentrated on creating realistic-looking drapery, facial expressions and varied gestures. The sculptor of these statues from Chartres Cathedral tried to make his Old Testament figures come to life: Abraham, turning to listen to God, holds his son Isaac ready to be sacrificed; Moses holds the tablets containing the Ten Commandments; Samuel sacrifices a lamb; and David, crowned, carries a lance.

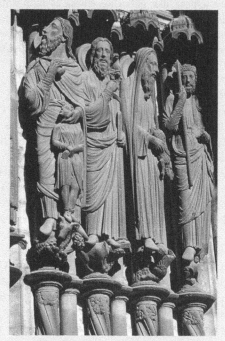

Chartres Cathedral, central portal, France

paintings, frescoes, illuminated manuscripts, tapestries and more. Painters began enlivening their work by portraying figures in natural poses with draping garments, but anatomy was not studied and they were still not aiming for the convincing realism of Classical art, although they did try to make their work more realistic than had been acceptable in earlier Christian art. In general, Gothic artists emphasized salvation rather than damnation and in place of apocalyptic scenes, worshippers in cathedrals and churches were now confronted with images from the lives of Jesus, the Virgin Mary and the saints – and these holy figures were portrayed looking compassionate. Instead of plain gold, artists also began to experiment with architectural and landscape backgrounds.

> 'The noble work is bright, but, being nobly bright, the effort should brighten the minds, allowing them to travel through the lights to the true light, where Christ is the true threshold.'
>
> Abbot Suger

International Gothic

The 13th century was a time of economic prosperity; by the end of the century, economic expansion reached its peak. The textile industry grew in Europe. By the end of the next century, with trade routes established across much of Europe, the increase in commerce led to a growth of cities, establishment of universities, rise of a new bourgeois class and spread of literacy. With easier travel, artists began exchanging techniques and ideas. Soon, more complicated and sophisticated images featuring elegant and graceful figures were being produced in France, Italy, England, Germany, Austria and Bohemia. Although they were more contrived and less natural-looking than Greco-Roman art, a taste was developing for realism and detail. Much later, the style was called International Gothic.

the condensed idea
Spreading God's message

07 Early Renaissance
(c.1300–1500)

The term 'Renaissance' was established in the 19th century to describe a period, roughly from the 14th to the 16th centuries, when there was a rebirth of interest in the philosophies, literature, values, architecture and art of ancient Greece and Rome. Developments began in Florence and Siena in Italy, when artists, scientists and philosophers rediscovered their past and simultaneously found their individuality.

Because the period that has become known as the Renaissance was so long and bursting with so many ideas, it is usually divided into the Early Renaissance and the High Renaissance. Although the ideas of the Renaissance spread across Italy and Flanders (present-day Belgium and the Netherlands) and then throughout Europe, it did not affect everyone in the same way; but it was a complex and exciting combination of ideas that had repercussions on 200 years of European history.

By the late 15th century, due to various factors including an expansion of trade, the development of the printing press in Europe and subsequent new interests in learning, many Europeans were becoming increasingly interested in the world around them and less concerned with the medieval ideas that had established Gothic art and architecture. Parts of Italy were particularly prosperous and attracted scholars and the wealthy. Italy also had its roots in the ancient world and a renewed interest in ancient Greece and Rome materialized. A few groups of scholars set about translating works written by ancient Greek philosophers and architects. Discussions about the ideas and theories were revived and reinterpreted.

Humanism

The ancient Greek philosophy of humanism was one of the ideas that emerged. Humanists asserted that humans have the ability for logical thought, and that learning and improving the world were more important considerations than spending one's whole life preparing for life after death. Because the invention of printing occurred at about this time, humanist ideas were easily spread. They sometimes went

against the traditional teachings of Christianity, but they encouraged artists to give new emphasis to worldly notions. The Church continued to be an important patron of the arts, but it was in the secular world in the cities, where the ideas really developed. There, the aristocracy and the growing merchant class commissioned art for themselves as well as for the Church. Religious themes were still illustrated and the ideals of Christianity were not abandoned, but artists made much of the increasing interest in secular subjects and the new confidence in humans' significance in the universe. Art was no longer created just for religion's sake; it was now valued for itself as well. Under the combined influences of an increased awareness of nature, a revival of Classical learning and this more individualistic view of the human race, efforts were made to create art that reflected the world in as lifelike a manner as possible.

Observation and perspective

Several early Renaissance artists revolutionized art. Giotto di Bondone (1266/7–1337) modernized Florentine painting at the time that Duccio di Buoninsegna (1255/60–1315/18) was doing the same in Siena. Giotto broke away from stylization, which had been customary in Byzantine and Gothic art, and introduced natural-looking human figures with individual expressions and realistic poses, while Duccio created richly coloured works with figures that looked almost three-dimensional and clothed in convincing drapery. Masaccio (1401–c.1428) had an immense impact on the direction of 15th century painting through his application of linear perspective to create

Social status

One of the ideas that made Renaissance art so different from any other art before it was the change in attitude towards artists. Whereas artists were traditionally anonymous artisans who promoted God's word, they now sought individual renown, partly to attract more commissions and partly to improve their patrons' status. Many Renaissance artists became extremely famous in their own lifetimes.

illusions of three dimensions on two-dimensional surfaces. Paolo Uccello (1397–1475) was also enthusiastic about the new mathematical method of linear perspective and Piero della Francesca (c.1415–92) applied all these new ideas, as well as creating illusions of light and tone. Picking up on Giotto's lifelike positions and expressions in figures, he also included linear perspective and painted light and

Painting with depth

In comparison with the formal mosaics of Byzantine art and the glorified, stiff-looking Gothic works, Giotto's, *Adoration of the Magi*, c.1266, has a convincing appearance of mass and solidity, but retains a sense of dignity, which enhanced both its human interest and religious feeling. By arranging his figures in relationships with each other and placing them against architectural backgrounds, he created a feeling of depth. This was completely revolutionary at the time and it created an illusion of reality that served to enhance viewers' understanding and belief in the Bible stories he illustrated, but also reflected the renewed interest in humankind and in building on the achievements of ancient Greek and Roman artists.

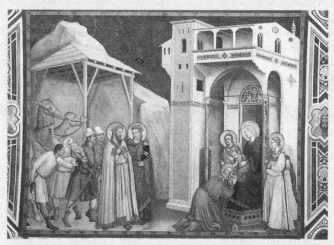

Adoration of the Magi, Giotto di Bondone, c.1266, fresco

dark tones across his images to convey convincing illusions of depth and realism.

Northern Renaissance

Meanwhile Flanders, full of wealthy merchants, was also experiencing a renewed vigour in the arts and from the late 15th century, many of the Italian art ideas were filtering through. The most successful artists in Flanders at the time produced elaborate illuminated manuscripts that featured credible lifelike imagery. Soon these artists were commissioned to produce larger works, and around 1410, they began to paint on wooden panels using pigment mixed with oil that was different from the traditional pigment mixed with egg, or tempera, which was still being used in Italy. Oil made the paint easier to work with, made colours appear brighter and imparted a rich sheen. Jan van Eyck (c.1390–1441) worked out how to layer oil paint in glazes, to create stronger colours and illusions of light. Rogier van der Weyden (1399–1464) and Robert Campin (c.1375–1444), also known as the Master of Flémalle, produced extremely realistic paintings with the appearance of depth and space. There was a growing emphasis on domestic details, which were often incorporated into their paintings for symbolic reasons.

'Certainly many painters who do not use perspective have also been the object of praise; however, they were praised with faulty judgement by men with no knowledge of the value of this art.'

Piero della Francesca

the condensed idea
A new era of greater realism

08 High Renaissance
(*c.*1498–1527)

A s the new ideas of the Renaissance spread across Europe, taking their lead from Italian and Flemish artists, younger artists' work became more dexterous, diverse and confident. Art had never flourished so profusely, profoundly and productively at one time – so many ideas, so much creative brilliance and so much belief in the importance of what they were doing.

By the end of the 15th century, the artistic revolution of the Early Renaissance matured to what is now known as the High Renaissance. Painting and sculpture reached a peak of technical competence, focusing on realistic interpretations, compositional balance, spatial harmony and drama to match or surpass the works of ancient Greece or Rome. Historians suggest that the step from Early Renaissance to High Renaissance occurred with the completion of Leonardo da Vinci's (1452–1519) painting in Milan of *The Last Supper*, 1495–98, coinciding with the move of the centre of culture from Florence to Rome, where Pope Julius II commissioned much important art. By then, many skilful artists were gaining great respect and renown for their achievements, from Venetian painters like Giorgione (*c.*1477–1510) and Titian (1488–1576), who used brilliant colours to create light-filled, colourful and dynamic compositions, to the northern masters, such as Dürer (1471–1528) and Holbein (1497–1543), who produced acutely lifelike and sophisticated works, to the greatest of all, Leonardo, Michelangelo (1475–1564) and Raphael (1483–1520), who were all supremely technically and creatively accomplished and celebrated in their own time. It was Leonardo's achievements that first inspired the idea of artists being classed as geniuses.

The genius

Leonardo was a painter, sculptor, architect, engineer, philosopher, mathematician, inventor and scientist. His paintings and drawings were hugely influential for their innovative compositions and original ways of capturing light (one of his inventions was a technique called sfumato, which was a method of blurring paint to create soft, gradual, almost smoky tones). His many notebooks, crammed full of studies

Vitruvian Man

The *Vitruvian Man* is a drawing created by Leonardo da Vinci in about 1487. Surrounded by notes based on a book by the ancient Roman architect Vitruvius, the drawing of a male figure inside a circle and a square shows ideal human proportions. Vitruvius had explained in his book that the proportions of the classical orders of architecture are based on the human figure and Leonardo's drawing demonstrates his fascination with proportion and anatomy as well as the new idea that art and science were connected. Leonardo also believed that the workings of the human body correlated to the workings of the universe.

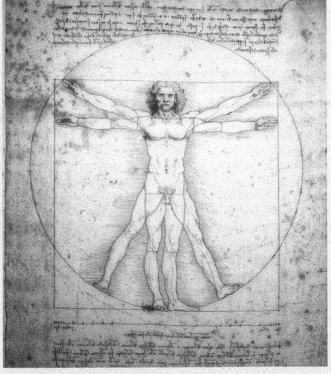

Vitruvian Man, Leonardo da Vinci, *c.*1485-90, pen and ink

and drawings of the natural and scientific world, reveal his enquiring mind and ingenuity, but he left many projects unfinished as his mind was always moving on to the next idea. Michelangelo was also multi-talented, with abilities as a sculptor, painter, architect and poet. From the start of his long career, he was heralded as the leading artist of the century, with his capacity for portraying figures full of energy and expression and his revolutionary ideas in paint, marble and concrete. Raphael was the third Italian artist to be labelled a genius during his career. He excelled as a painter and architect and his portraits and mythological and religious works were admired for their harmony of colour and composition, and the soft clarity of his rendering.

> 'The true work of art is but a shadow of the divine perfection.'
> Michelangelo

Anatomy

The science of investigating the human body and its parts was not original to the Renaissance. Based on the writings of an ancient Greek physician, it was also explored in some parts of medieval Europe. In Christian quarters, however, the idea of dissecting dead men's bodies was considered sacrilegious. Yet with the intense interest in – and growing demand for – creating lifelike art during the High Renaissance, some artists took the risk of studying anatomy through dissection so they could make more accurate representations of the human body. Leonardo worked (illegally) from cadavers, cutting up dead criminals' bodies in order to learn how they are structured and how they function. Michelangelo also left drawings that disclose his close study of human remains. Through this, they set new standards in their portrayals of the human figure.

Dignity and splendour

The earlier ideas of the Renaissance – to be more realistic and to create images from a more human viewpoint – were intensified in these later artists' efforts to perfect their representations of nature. The explicit details and linear clarity of the early Renaissance were replaced by fuller, simpler shapes and forms that showed beauty, dignity, splendour, dynamism, depth and meaning. More flowing and harmonious compositions were created and moods were expressed to

inspire emotional responses in viewers. Purely Christian
considerations were not the only themes that artists of the High
Renaissance focused on as patrons now came from a mix of
backgrounds, including individuals like cardinals, rulers, bankers and
merchants, wealthy families and both the Church and the state. Art
had become an enormously important part of life, and artists were
often invited to join the courts of the nobility, receiving board and
payment in return for producing art.

The High Renaissance, perhaps even more than many of the
movements in this book, included several ideas rather than just one.
But in general, High Renaissance art represents one overall concept –
that the culture in which it was made openly cultivated human
accomplishment. For the first time, skill and talent were encouraged,
nurtured, developed and rewarded; human endeavour was pushed to
its limits and brilliance was recognized, acknowledged and rewarded.

the condensed idea
Zenith of technical and creative achievement

09 Mannerism
(*c*.1520–1600)

Mannerism developed in Florence and Rome after 1520, when society was affected by various events, including the Protestant Reformation that divided central Europe, the plague that was killing people in their thousands and the sack of Rome of 1527. Reacting to the instability, several artists abandoned the harmonious Renaissance ideals and began to produce images that incorporated more emotional content.

The Mannerist phase happened roughly between Raphael's death in 1520 and the beginning of the Baroque period in 1600. As well as the reaction to social and political upheavals occurring across Europe, Mannerism was a direct result of artists' recently elevated status in society. They were no longer simply artisans unobtrusively creating art to support their society's religious convictions, but they ranked alongside scholars, poets and humanists in an environment that appreciated grace, sophistication and style. No longer only produced for religion's sake, art was now recognized for its own merits.

Copying from artists' styles

The term Mannerism was derived in the 17th century from the Italian word *maniera*, which translates as 'style'. It was meant to be disparaging. During the Renaissance period, artists observed and tried to emulate nature as realistically as possible. Mannerists – who witnessed the perfections of the High Renaissance – rejected this, instead copying from other art rather than from life. They emulated the styles of their favourite artists and exaggerated them. The underlying idea was prompted particularly by Michelangelo's later work, which had become especially dramatic and emotive. Several artists took their lead from his grand, sweeping forms and embellished his style, creating even more dramatic images. Another artist who inspired them was Andrea del Sarto (1486/87–1530/31), also of High Renaissance fame, who used expressive colours and varied, complex poses in his paintings. Thirdly, Correggio (*c*.1489–1534) became hugely influential to the Mannerists. He was another Italian High Renaissance artist who created spectacular, eye-catching effects in his religious

Deposition from the Cross

This is a typical Mannerist painting. Although Mannerism started while Michelangelo was still alive, this work shows the difference between his heavy-looking sculptural figures and Mannerist interpretations. These figures are less substantial, appearing almost weightless and balancing on long and slender limbs, while the heads appear small in comparison to the billowing robes. The figures appear trapped inside the frame, moving within a limited, unreal space and their clothes are composed of pastel colours – a direct move from the vibrant hues of the Renaissance. Putting everything together, an atmosphere is created of other-worldliness; these people do not inhabit the usual world, but they appear like creatures from another place. The fantastical aspect of Mannerism captured contemporary imaginations.

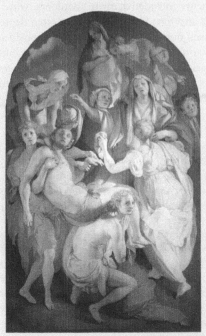

Deposition from the Cross, Pontormo, *c*.1526–8, oil on panel

works, introducing sweeping splendour alongside gentleness and the portrayal of emotion. By pushing perspective as far as possible, Correggio created illusions of vast spaces within his paintings. His skills in depicting figures seen from below inspired Mannerist painters to show their figures from – or in – unusual positions. Painters incorporated extensive use of colour and long, fluid brush marks, while sculptors featured striking poses and dramatic gestures.

Elongation and exaggeration

The unconventionalities of Mannerism appeared in Florence and Rome at about the same time. One of the Mannerists' favourite subjects was the nude. They copied figures they admired in the High Renaissance artists' work, dramatizing and exaggerating various aspects of their figures. Frequently elongating and distorting them, common elements included narrow shoulders, wide hips and long, tapering hands and feet. Figures were also often depicted in intricate or complex poses, not the relaxed, *contrapposto* positions of the earlier Renaissance. Painters did not use realistic colours, but soft pastels or sharp, unnatural hues. Both painting and sculpture was often highly imaginative, focusing on the style as much as the content. While High Renaissance artists had focused on balance and harmony, Mannerists deliberately created instability and tension. Popular themes were often a mix of Classicism, Christianity and mythology.

Mannerism was partly an intentional fashion and partly a way in which the artists did not have to attempt to surpass the skills of the High Renaissance. By trying to be more inventive than their recent predecessors, they created works that had different elements within them to interest viewers. The predominant idea behind this was all

Mannerist portraits

Added to their stylistic interpretations, when Mannerists produced portraits, they did not just paint or sculpt an image of the person in front of them. Instead, for the first time, these artists tried to portray a sense of the person beneath the appearance, making efforts to convey more than simply visual elements by expressing something of their sitters' personalities.

about making art more noticeable, of being flamboyant, interesting and thought-provoking and showing that the artists could manipulate classical proportions and styles with aplomb. They did not necessarily have to copy life as it looked, but could make their own representations as elegant, sophisticated and stylized as they chose.

The main Mannerists

Andrea del Sarto's students, Jacopo da Pontormo (1494–1557) and Rosso da Fiorentino (1494–1540) became prominent Mannerists. By 1540, Pontormo's student Agnolo Bronzino (1503–72) had become Court Painter to Cosimo I de' Medici, the Grand Duke of Tuscany and Lavinia Fontana (1552–1614) was the most highly paid and sought-after painter in Bologna. Bartolomeo Ammanati (1511–92) and the Flemish Giambologna (1529–1608) were major Mannerist sculptors who travelled around Europe, producing fluid-looking works featuring lengthened figures in entwined poses, while Parmigianino (1503–40) was greatly admired and hugely influential for his idealized, youthful figures in contrived poses. Bartholomeus Spranger (1546–1611) and Hans von Aachen (1552–1615), were Flemish painters who gained recognition across Europe for their Mannerist styles.

The spread of Mannerism

Restlessly searching for new ways of expressing themselves, Mannerists moved through Europe, gaining work and picking up ideas. The sack of Rome in 1527 caused a great exodus of artists who escaped to cities throughout Europe and Francis I of France in particular, employed several Italian artists at Fontainebleau, making Mannerism the dominant style in France. By the mid-16th century, the influence of Mannerism had spread far beyond Rome and Florence.

the condensed idea
Exaggeration and stylization, invention and refinement

10 Baroque
(c.1600–1750)

Against a background of religious upheavals during the 16th century, European art changed once again. Baroque art developed as a deliberate way of strengthening the image of Roman Catholicism. Embracing a broad range of styles, it incorporated emotion, dynamism and drama, plus, specifically in painting, new methods of depicting light and tone.

Religious tensions had started with the Protestant Reformation in the early 1500s. Largely due to the development of the printing press in the 1450s, ordinary people began to read for themselves. When the first European Bibles were produced, many began questioning the interpretations of the stories and the validity of aspects of the Roman Catholic Church. Reformers established Protestantism as a new branch of Christianity, which led to a series of religious wars. It shattered the authority of the Catholic Church and destroyed the unity of Western Europe as increasing numbers left Catholicism in favour of Protestantism. Eventually, the Catholic Church responded, eradicating the main elements of Catholicism that Protestants had condemned in an effort to counter the criticisms and try to keep the religions from separating. This became known as the Counter-Reformation and, as part of their plan, Catholic Church leaders commissioned a great deal of art in attempt to reach – and influence – the largest possible audience.

Inspiring contemplation

The Council of Trent specified that any art commissioned for the Roman Catholic Church must be intelligent and intelligible with clear religious content. As promotional material for Roman Catholicism, the original art of the Baroque era included elaborate imagery, brilliant light and emotional content that aimed to provoke empathetic or thoughtful reflection from viewers. Artists began working in the stipulated manner, displaying spectacular and skilful techniques of illusionism. Sculpture and painting portrayed a sense of movement and energy, while painting additionally featured strong contrasts of light and shadow to enhance the dramatic effects.

As the 17th century continued, the popularity of Baroque art extended beyond the Catholic Church to royalty and then the aristocracy. At the time, several European royal families were struggling to maintain their subjects' belief in the 'Divine Right of Kings', and powerful paintings, sculpture and architecture assisted their public image. Through flourishing trade, the Protestant north of Europe prospered, and there, too, the styles of Baroque art gained followers although inevitably, the artistic objectives and subjects differed. With so many different reasons for its production, Baroque art soon comprised a wide range of styles. In some areas it became more extravagant while in others it was restrained to suit more reserved tastes. Emotive Italian artwork, for instance, contrasted with more conservative interpretations in the Netherlands. But the underlying features were always there, such as realism, drama, stimulation of the senses and radiant light effects. In many ways, Baroque art began as a reaction against the stylizations of Mannerism as well as a way of promoting Roman Catholicism.

Appealing to the senses

In Italy, France and Spain, Baroque art continued to be spectacular, intense and dramatic, intentionally evoking emotional responses. In northern European countries, however, as the style became fashionable among the wealthiest citizens, artists had to translate the ideas differently – they were not focusing on winning viewers back into the Church or impressing them with the might of the monarchy. Wherever Baroque art flourished, however, artists' importance in society rose. They were respected as few other artists had been before

Rough pearl

The word 'baroque' is thought to be derived from the Portuguese word *barroco*, which means 'a pearl of irregular shape'. Like most art labels, it was invented by later critics rather than by contemporary commentators and was initially a criticism of the art's extravagances and excessive details, which contrasted directly with the harmony and consistency of the High Renaissance.

The Entombment

Also known as *The Deposition*, this painting shows Nicodemus and a helper as they lower Jesus into his tomb after his crucifixion. In intense grief, the three women throw up their arms. The six figures are densely packed in the composition, set against a black background – symbolizing death and emotional suffering. The body of Jesus, although the lowest of the figures, is actually more or less in the centre of the painting, while the others are arranged in a dynamic diagonal shape, fanning out to the right. All the characteristics of Baroque art are here: *chiaroscuro*; twisting or moving figures; emotion; drama and contrasting elements in the composition, creating tension.

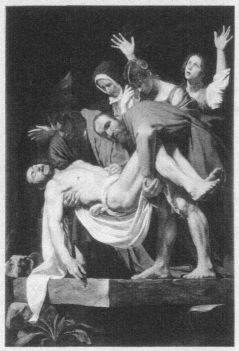

The Entombment, Caravaggio, 1602–3, oil on canvas

them. Art that began as a means to amaze and affect people's opinions soon became the most fashionable art of almost an entire continent. Statues, fountains, churches and palaces appeared in towns and cities and paintings were produced for public and private consumption.

Annibale Carracci's (1560–1609) colourful and lively paintings initially helped to establish the Baroque style in Italy. Caravaggio's (1571–1610) passionately realistic paintings with their exaggerated effects of light and dark focused on human anguish. Elisabetta Sirani (1638–65) was a pioneering female artist in early modern Bologna, who established an academy for other women artists. The leading Baroque sculptor was Gian Lorenzo Bernini (1598–1680), who was also an architect, playwright, painter and set designer. Outstandingly influential, his work portrayed a sense of space and movement – elements that soon became characteristics of most Baroque art. In Catholic Flanders, Peter Paul Rubens (1577–1640), one of the most sought-after artists of his time, embraced the Baroque style with his colourful and exuberant works. His pupil, Anthony van Dyck (1599–1641), became the

> 'My talent is such that no undertaking, however vast in size . . . has ever surpassed my courage.'
> Peter Paul Rubens

leading court painter in England. Nicolas Poussin (1594–1665) became the most influential French painter of the 17th century. Different in appearance to many of the other Baroque artists, his work includes vitality, sensuousness and tension. The Spanish painter Diego Velázquez (1599–1660) employed Baroque techniques through strong colours, contrasting lights and darks and his creation of deep illusionistic spaces. The movement continued until around 1750, although some of its characteristics continued until the 18th century.

the condensed idea
Life, light and dramatic effects, inspiring emotions

11 Dutch Golden Age (*c*.1620–1700)

As a direct consequence of the Baroque style and the divisions caused by the Reformation and rise of Protestantism, a distinct and incredibly realistic painting style developed in the northern Netherlands during the 17th century. Religious and political conflict had divided the Low Countries – Flanders remained Roman Catholic, while the northern provinces of the Netherlands became Protestant.

By the beginning of the 17th century, the Netherlands had become one of the richest places in the world as overseas trade and maritime expansion flourished. With the highest literacy rate in Europe, a sense of pride and religious tolerance prevailed and the country broke with Roman Catholicism and the monarchy. The population surged and skilled artists moved there to appeal to wealthy patrons. Artists were encouraged to represent the new ideas and philosophies that were being introduced and to express the confidence of the nation.

The 'Dutch Golden Age' was the period from about 1620 to about 1700 and was actually also the Baroque period, but the art and approach was different there from the rest of Europe in many ways. Most of it lacks the idealization and exuberance typical of the Baroque. This is because the people it was created for had different attitudes as well as different beliefs. They were diligent and devout and their tastes were more restrained. The artists of this golden age are also often categorized as Baroque artists as they adhered to many of the period's characteristic features, such as close attention to detail and realism, incredible light and tonal effects and dramatic compositions.

Scenes of everyday life

While spirituality, religion and dramatic compositions flourished in Italy, Flanders and Spain, artists in Holland turned to secular subjects, supporting the Protestant belief that humans must not create 'false idols'. Patrons in the Netherlands were not powerful rulers who ordered art for their palaces, or religious leaders who wanted their churches embellished, but ordinary people who enjoyed looking at and displaying art around them as a sign of their financial success. As a result, Dutch artists painted genre scenes that appealed to the

The mirror of nature

Lifelike paintings were particularly popular. The effect of light streaming through the windows was a feature that came directly from the Italian Baroque. Here, a painter (believed to be the artist, even though his face is not visible) is painting a young woman in his studio. She stands by a window in front of a large map of the Netherlands. A tear divides the north and south, which symbolizes the political and religious divisions between the countries. Several other symbolist features occur throughout the painting, some of which allude to Catholicism and its suppression. Vermeer unusually remained Catholic in a predominantly Protestant society.

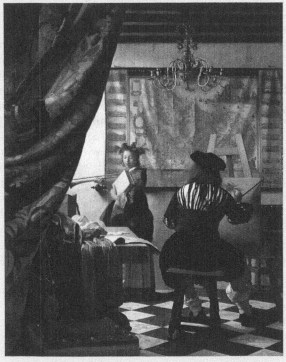

Johannes Vermeer, *The Art of Painting*, c.1666, oil on canvas

Producing art for ordinary people – even if they were rich – was a phenomenon that had never happened before on this scale and it eventually created a trend across Europe. An English visitor to Amsterdam wrote of his amazement to see paintings in shops and ordinary homes and to witness people's patronage of painting and pride in their artists.

wealthy middle classes. Themes included portraits, history painting, interior scenes, still lifes and landscapes. They focused on intricate technical skills and precise realism. Their paintings were relatively small as they were made for state offices, homes or shops.

As the economic growth in the Netherlands continued, the demand for art increased. Paintings needed to appeal to tastes of the buyers, so artists painted subjects that reflected contemporary, local tastes and subjects became even more distinctive. Artists of the northern Renaissance such as Van Eyck paid attention to lifelike details. So contemporary artists painted realistically in an effort to match those skills. The Netherlands had the greatest number of cities in Europe. Amsterdam was the wealthiest and art flourished there in particular, but other centres also witnessed abundant developments. For instance, in Utrecht, several artists who had visited Rome began painting in a style that was profoundly influenced by Caravaggio. Emphasizing the strong light and dark tones like the Italian master, their style became known as Utrecht Caravaggism. Judith Leyster (c.1609–60) was made the first female member of the Haarlem Guild of St Luke, which enabled her to establish her own successful workshop. While Baroque styles influenced Dutch artists, themes differed.

There was little Dutch sculpture at the time; painting and printmaking were the main forms of art produced. Artists usually trained by apprenticeship for several years before becoming technically proficient and working independently. Unlike the rest of Europe, where, by and large, artists were commissioned to produce specific work, Dutch artists often produced speculative paintings, which they then hoped to sell. Large art fairs were held, crammed full

of artists and their work and buyers hoping to find something for a good price. This was all part of the commercial environment and the art was a source of national pride.

Painting themes

Most artists specialized in one particular genre, and certain types of paintings, or genres, were popular. These included history paintings, which featured past events and achievements as well as biblical, mythological, literary and allegorical scenes. Landscapes and seascapes were admired for their focus on recognizable locations. Views depicted in different seasons sold well and the sea was a favourite topic. Interior views of people going about their daily lives were also fashionable, emerging from earlier northern Renaissance interior pictures. Artists also often included symbolic 'clues' that told a moral tale and this idea, of hunting for evidence about messages within a picture appealed to the art-buying public. Still lifes were filled with impressively captured details and many of the paintings were 'Vanitas' works – that showed the worthlessness of life and the transient nature of vanity. Portrait painting was probably the most important type of painting as the successful middle-class citizens wanted to preserve their likenesses for posterity.

> 'The deepest and most lifelike emotion has been expressed, and that's the reason they have taken so long to execute.'
>
> Rembrandt van Rijn

An unprecedented number of outstanding painters emerged during this period. They included: Rembrandt (1606–69), Frans Hals (c.1580–1666), Ruysdael (c.1602–70), Steenwyck (c.1612–59), de Hooch (1629–84) and Vermeer (1632–75).

the condensed idea
Incredible realism and colour

12 Rococo
(c.1700–1800)

Originally an interior design style, Rococo emerged at the beginning of the 18th century. The first paintings in the style were only commissioned to complement Rococo interiors and they were more to do with decoration than with serious content. But soon, these delicate, lightweight and sensuous works of art caught on.

The Age of Enlightenment

The late 17th and 18th centuries are often called the Age of Enlightenment, referring to a time of radical new developments in science, technology and the arts and when traditional structures within society were being questioned. Intellectuals argued that reason could free humans from superstition and religious oppression that had brought suffering to millions in religious wars. This thinking was largely due to the accessibility of encyclopedias. Printing had made knowledge widely available and enabled the new urban middle classes to develop well-informed independence of thought for the first time. The resulting intellectual, social and political reforms gave people fresh hope for the future, and this positive environment had an effect on art..

'Who told you that one paints with colours? One makes use of colours, but one paints with emotions.'

Jean-Baptiste-Simeon Chardin

During this period of rational thinking, circumstances across Europe and in many parts of America were less fraught than they had been during the previous century. Philosophers encouraged the notions of personal freedom and democracy and the wealthy began to openly pursue happiness without being hampered by the guilt that previous religious regimes had enforced. The Rococo style was the visual manifestation of the optimism felt at this time. It appealed to the senses rather than intellect, stressing beauty over contemplation.

French style

Rococo was originally called 'the French style' as it originated in France. Louis XIV's (1638–1715) magnificent palace at Versailles was

Shell work

The term 'Rococo' began to be used at the end of the 18th century. Picking out some elements that were often featured in the designs, the word is thought to have derived from the French word *rocaille*, meaning 'rock work' or 'shell work'. Used by some as a straight description, it was also used contemptuously, implying that the style was frivolous.

opulent and ostentatious and generated the idea that art could merely adorn rather than always having to inform. His successor, Louis XV (1710–74) also surrounded himself with additional opulence but, influenced by his mistress Madame de Pompadour (1721–64), he favoured lighter and more delicate styles. Both styles of art and design focused on light, fun and adornment. There were no hidden, intellectual messages. These artistic changes became fashionable, first in the royal palaces and then with the French upper classes and finally with the burgeoning middle classes. Themes of romance, mythology, fantasy and everyday life were preferred over historical or religious subjects and the style was light, ornamental and elaborate, distinguished by graceful lines, delicate colouring and deft brushwork. The elegant and refined paintings and sculpture perfectly enhanced the corresponding architecture and interior designs that were also being produced across France at the same time. Retaining some of the complex forms and intricate patterns of the Baroque style, Rococo art was smaller in scale and began including other characteristics too, such as Oriental motifs and asymmetrical compositions. After about 1730, through travel and the availability of engraved publications, the style spread from France to Italy and then to other parts of Europe and to America.

'Joie de vivre'

Rococo art was light-hearted and playful, reflecting the *joie de vivre* ('joy of living') that was being adopted. Typical Rococo subjects featured carefree aristocrats in fantasy settings, frolicking and flirting, picnicking, performing or playing music, often at country parties in

The Toilet of Venus

Mythology, voluptuous women and amorous themes predominated during the Rococo period, while smooth curves, asymmetry and soft colours complemented the approach.

This work was commissioned by Louis XV's mistress, Madame de Pompadour, for Bellevue, her château near Paris. Painted like a stage set, the youthful, plump and pretty figures of Venus and her cherubs, surrounded by the carved and gilded sofa and draped, elaborate fabrics are all characteristic of the emphasis on lavishness during the Rococo era.

The Toilet of Venus, François Boucher, 1751, oil on canvas

contrived and graceful pastoral backgrounds or sumptuous boudoirs. Key artists of the period include Jean-Antoine Watteau (1684–1721) who became known for his *fêtes galantes* or 'idyllic scenes' of elegant ladies and gentlemen relaxing or acting in imaginary outdoor settings. François Boucher (1703–70) was Louis XV's favourite artist, famous at the time for his calm and charming paintings and tapestries of classical subjects, allegories and portraits. Jean-Honoré Fragonard (1732–1806) exemplified the style with his delicate, exuberant and playful paintings that perfectly reflected the blithe attitudes of the pre-revolutionary French aristocracy. Jean-Baptiste-Simeon Chardin (1699–1779) recorded the lives of the Parisian bourgeoisie through detailed still lifes and domestic interiors, although his work is less delicate and decorative than much Rococo painting. Élisabeth-Louise Vigée-Le Brun (1755–1842) was also influenced by the Rococo style, particularly in her portraits of Marie-Antoinette, her flowing brushstrokes and her choice of colours. Étienne-Maurice Falconet (1716–91) created delicate, curving and asymmetrical statues depicting themes of love and gaiety. In England, the paintings of Sir Joshua Reynolds (1723–92), Thomas Gainsborough (1727–88) and William Hogarth (1697–1764) included idealized images with Rococo qualities. In Italy, Giambattista Tiepolo (1696–1770) painted celebrated ceilings and murals, while Canaletto (1697–1768) and Francesco Guardi (1712–93) became known as the great Rococo view-painters, with their detailed scenes full of clarity and light.

In general however, the Rococo style was brief. In Germany, late 18th century Rococo was ridiculed as *Zopf* und *Perücke* ('pigtail and periwig') and in most places it soon became unfashionable, eclipsed by a more structured interpretation of the classical elements of Greek and Roman art in the form of Neoclassicism.

the condensed idea
Delicate, decorative art, appealing to the courtly and cultivated

13 Neoclassicism
(c.1750 –1850)

Partly as a reaction against the light-hearted creations of the Rococo and partly in response to astonishing discoveries of Roman cities beneath the ash of ancient volcanic eruptions, the second half of the 18th century saw a deliberate and determined revival of the disciplined and exacting standards of classical Greek and Roman art and the art of the Renaissance.

Starting in 1738 in Herculaneum and 1748 in Pompeii, some of the most dramatic excavations were undertaken. Within a few years entire cities had been discovered buried beneath the ash of the volcanic eruptions of Mount Vesuvius in AD 79. The revelations were unprecedented and astounding – people, animals, homes, streets, shops and belongings were all preserved in the ash. The remains of the art and architecture inspired the creation of new art and architecture, modelled on the clean lines and perfect contours of the ancient civilization. As well as the discoveries at Herculaneum and Pompeii, the German theorist and art historian Johann J. Winckelmann gave impetus to the movement with the publication of his highly influential book in 1755, *Thoughts on the Imitation of Greek Works of Art*. His statement that the most important aspects of classical art were 'noble simplicity and calm grandeur' inspired a generation of artists.

Inspiring patriotism, valour, reverence and morality

Neoclassicism started as a rebellion against the ornate frivolity of the Rococo style that symbolized French aristocracy. In the 1760s, just before the French Revolution, artists began depicting themes from Greek and Roman history and portrayed honourable values such as austerity, valour, honesty, public virtue and personal sacrifice, encouraging comparisons between the republics of Greece and Rome and the contemporary struggles for liberty in France. After the French Revolution, France became a democracy, putting an end to aristocratic rule. The new leaders intended to model their government on the high virtues and moral principles of classical Rome, so artists were commissioned to produce even more art that depicted inspirational scenes from ancient Roman history. Artists painted using firm,

sculptural lines and strong tones and subdued palettes. The movement spread throughout Western Europe, but the style remained predominant in France and England, where it expressed attitudes that the rulers of those countries wished to encourage, including nationalism, courage, honour, dignity and tradition.

Neoclassical art was disciplined and restrained; the artists used precise and accurate techniques, imitating the form and content of classical works of art. Painters applied sombre colours with occasional brilliant highlights, strengthened by the strong light and dark tones of *chiaroscuro*. Quality of line and contour was a more important consideration for them than colour, light and atmosphere. Neoclassical sculptors also emphasized pure lines and angles with smooth, polished finishes. This meticulousness was partly a reaction to the perceived hedonism of Rococo and the dramas of the Baroque. Many of the serious and imposing subjects were derived from classical history and mythology, inspired by the work of Homer and Plutarch and the English artist John Flaxman's (1755–1826) illustrations for the *Iliad* and *Odyssey*.

> 'In the arts the way in which an idea is rendered, and the manner in which it is expressed, is much more important than the idea itself.'
>
> Jacques-Louis David

Napoleon's influence

When Napoleon rose to power in France in the 1790s, he influenced the direction of Neoclassicism, instructing French artists to paint fewer ancient Roman themes and to start depicting modern history. He commissioned several Neoclassical artists to depict him as a national hero, arousing admiration and respect. Once Napoleon gained power, although artists still included columns, pediments, friezes, costumes and other references to the classical world, they began to include more contemporary heroes and stories from recent history and the action in their paintings was often more complicated than earlier Neoclassical work had been.

Neoclassicism became inseparably associated with the French Revolution in the paintings of Jacques-Louis David (1748–1825), who also played an active role in politics. During the years leading up to the French Revolution, to the fall of Napoleon I, he produced several

paintings that served as propaganda for the uprising. After the revolution, his paintings helped to establish Napoleon as emperor.

One of many artists who studied in David's large studio was Jean-Auguste-Dominique Ingres (1780–1867). Ingres spent most of his youth in Italy, returning to France after the restoration of the monarchy, but during his long life he came to be regarded as the high priest of Neoclassicism. Focusing on precision of line and classical subjects, he dominated French painting for the first half of the 19th century. Another significant Neoclassical painter was Anton Raphael Mengs (1728–79) who was widely regarded in his day as Europe's greatest living painter. Also influential was his treatise *Reflections on Beauty and Taste in Painting* of 1762. The leading Neoclassical sculptor was the Venetian Antonio Canova (1757–1822) who became famous for his graceful and elegant marble sculptures portraying delicately rendered flesh. Swiss painter Angelica Kauffman (1741–1807) was extremely sought-after for her portraits and figure paintings. Jean-Antoine Houdon (1741–1828) was also notable, best known for his portrait busts and statues of philosophers, inventors and political figures of the Enlightenment.

> 'To give a body and a perfect form to one's thought: this, and only this, is to be an artist.'
>
> Jacques-Louis David

The Oath of the Horatii

This work launched David's popularity. The simple composition, with figures forming triangular or rectangular groupings, follows Neoclassical ideas. The dramatic light does not obscure the rigid structure of the painting. It portrays the story of a dispute between Rome and Alba in 669 BC, which was to be settled by combat between two groups; the three Horatii brothers and the three Curiatii brothers. However, one of the sisters of the Curiatii was married to one of the Horatii, while one of the sisters of the Horatii was betrothed to one of the Curiatii. Despite the women's lamentations, the Horatii's father insists they fight. David painted the work as a proclamation of revolutionary beliefs, of state before family.

The Oath of the Horatii, Jacques-Louis David, 1784, oil on canvas

the condensed idea
Revolutionary revival of the quest for beauty and perfection

14 Romanticism
(c.1800–80)

Focusing on the emotions, Romanticism emerged after the rigours of Neoclassicism, but although in some ways it was a reaction against it, in other ways, Romanticism and Neoclassicism overlapped. Romanticism was interpreted differently by a variety of artists, poets, authors and composers and it developed as a diverse movement that lasted from the end of the 18th to the late 19th century.

Both Neoclassicism and Romanticism reflected the revolutionary spirit of the times in which they were made. While Neoclassicism embraced the political insurgencies, emphasizing controlled emotion, clean lines and subjects that inspired civic pride and dignity, Romantic art expressed concern over the social changes; depicting extreme emotions that were enhanced by skilful brushwork and a bright palette or imaginatively composed statues. Romantic ideas are not as easily clarified as Neoclassicist notions as there is no simple way of categorizing Romanticism. This was partly because Romantic artists worked with diverse methods and skills in several countries at different times. Their fundamental ideas were similar, but their interpretations varied. Most focused on imaginative, spontaneous approaches and techniques. Some produced work that showed an influence of Baroque art and some responded to the French Revolution, the Napoleonic wars or the American Revolution, while others drew their inspiration from the Romantic literature of the time, such as poetry by Jean-Jacques Rousseau (1712–78), Lord Byron (1788–1824) and William Wordsworth (1770–1850).

Individual expression

Romanticism developed from the struggle many artists felt as they tried to come to terms with a world that was changing so rapidly and decisively. From political revolutions to the Industrial Revolution, traditional values were being erased and what had seemed solid and certain was now confused and unreliable. Even many of the new scientific discoveries that tried to rationalize nature seemed to be against everything the artists had previously understood, so their creations were often nostalgic or reflective. Many Romanticists

Jacob Wrestling with the Angel

Often described as the greatest of the Romantic painters, Delacroix was hugely influential among his contemporaries and later artists alike. With sweeping, dramatic compositions, strong colours and vibrant brushwork, he depicted passionate and dynamic images that aroused viewers' emotions. Recommending spontaneity, he inspired new methods of painting directly onto canvases rather than the usual method of painstakingly planning paintings. He painted this huge mural of a Bible story in a side chapel of the church of Saint-Sulpice in Paris. In the story, Jacob was walking home one night when someone blocked his way. The two wrestled until dawn, when Jacob's opponent revealed himself as an angel and blessed Jacob for showing such determination.

Jacob Wrestling with the Angel, Eugène Delacroix, 1861, oil on canvas

began with an interest in nature and most focused on expressing their innermost feelings through their art. Nearly all rebelled against established artistic rules and conventions, using rich colour and lively brushwork to add expression to their work, as few artists had done before.

Most Romantic artists were against industrialization and the mechanical developments that were increasing in almost every aspect of life, and in contrast – or even in protest – many portrayed themes that explored human nature, folk stories, the medieval era, the exotic, the remote, the mysterious or the supernatural. Some favoured emotive subjects such as love stories or dramatic tragedies. Their art was subjective, passionate, imaginative, expressive and instinctive. They valued emotion more than reason and intuition more than intellect. Logic and rationality were abandoned as artists expressed painful feelings that were usually restrained in polite society. It was bold and daring, expressive and inventive. Heightened emotions were expressed by the artists and felt by viewers of the work. Never before had artists articulated their individual feelings so strongly and significantly and never before had spontaneity been encouraged to be such a positive quality in art.

> 'Romanticism is precisely situated neither in choice of subject nor in exact truth, but in a way of feeling.'
> Charles Baudelaire

Colour, drama and intuition

By the 19th century, the term Romanticism began to be used for the first time to describe the evolving style that was by then embracing the arts, philosophy, politics and even the sciences. Although it began in France, Romanticism developed in various countries across Europe and America at different times and flourished especially in France, Britain and Germany. Although it was never coherent and consistent with all artists who were labelled as Romanticists, Romantic art always focused on emotion and expressiveness rather than structure and stability, as the artists sought to communicate their personal feelings and to make clear their mistrust of many modern events and new developments. Principal Romantic artists took ideas from different disciplines, experimented with technical innovations and created works that were often visually sensational, bold and personal, making a controversial break with past traditions. Leading Romantic artists included Eugène Delacroix (1798–1863) who is considered one of the greatest and most influential of French painters, with his remarkable use of colour. His vivid images were inspired by both historical and contemporary events and by literature and the exotic locations he

visited. English artist, poet and printmaker William Blake (1757–1827) created visionary, atmospheric and symbolic images that expressed his intense imagination and creativity. In Spain, Francisco de Goya (1746–1828) powerfully expressed the horrors of war and increasingly painted fantasies from his imagination mixed with satirical observations of human nature. Théodore Géricault (1791–1824), another of the pioneers of the Romantic Movement, strongly influenced Delacroix with his dramatic, expressive and unconventional paintings, while in Germany, Caspar David Friedrich (1774–1840) created ethereal and atmospheric landscapes often focusing on solitude or loneliness. J.M.W. Turner (1775–1851) was the most famous landscape painter of the Romantic Movement with his prolific, expressive and atmospheric studies of nature. John Constable (1776–1837), another English landscape artist, expressed nostalgic feelings about his native English countryside that he believed was being eroded by industrialization.

the condensed idea
Emphasizing feelings
over conventions

15 Academic art (c.17th–19th centuries)

I n the 19th century, artists' reputations depended to a great extent on the official art academies that had been established across Europe. Academies were increasingly conservative, resisting change and were opposed to innovative or avant-garde ideas. Academic art was therefore art that was approved by the academies, particularly the Académie des Beaux-Arts in Paris – the most important academy of all.

From the 17th to 19th centuries, the European art world was controlled by academies. Art students aspired to join them to study, artists sought to be members and these official institutions effectively defined how art was valued by encouraging, appraising and representing it officially. Academies had been established originally in Italy during the 16th century and flourished across Europe, replacing the medieval guild-apprentice system and becoming the most reliable path for professional artists – through training, competitions, exhibitions and awards. To enter an academy, applicants took challenging entrance exams and if they were accepted, studied formally at the academy for several years. Although originally established in 1648, from 1816, the newly named Parisian École des Beaux-Arts joined with two other art academies and became the foremost art institution in Europe on which all others modelled themselves.

Reputation and status

The academy system was started originally to raise artists' standing above craftsmen, who were seen as manual labourers, so emphasis was placed on the intellectual aspects of art. Academic art training took years of painstaking study, of learning the methods of past artists and practising of skills, and this was only after students had passed the entrance exam and also had a letter of reference from an eminent art professor. For the next few years, students spent each day copying prints of classical paintings and sculpture to understand how to depict contours and tones. Once this was mastered, students then drew from plaster casts of famous classical sculpture and if they attained the

desired standard of this, they were then allowed to draw from life models. No student was allowed to paint until these drawing skills had been perfected and when they did learn to paint, they joined established, academic artists' studios. The artists who taught painting belonged to the academy – they had to be official Academicians. Progression through these exacting stages culminated in students finally being awarded the accolade of 'Associate', meaning that they could work as professional artists. If they continued to produce art that Académie officials approved of, they might be offered the most prestigious title of Academician themselves.

Subject ranking

As well as set skills, styles and techniques that had to be adhered to, Academic art also had a hierarchy of subjects that artists were expected to portray. Of the highest status was history painting, which included myths, biblical and classical subjects. Next in importance were portraits and landscapes and lowest in status were still lifes and genre paintings, or scenes of everyday life. Throughout the 19th century, Neoclassicism, with its emphasis on clean lines, and Romanticism, which focused on an expressive use of colour, were two styles that were both approved of by the Académie des Beaux-Arts and their students were advised to combine distinctive elements from both styles to create an ideal or 'Academic' style.

The Paris Salon

The Paris Salon was the official art exhibition of the Académie des Beaux-Arts. From 1725 and throughout the 19th century, the Salon was held annually or bi-annually and was renowned as the greatest art

event in Europe. Artists submitted their work to be selected or rejected by the official Salon jury and only the conventional styles of Academic art were accepted. Each year, thousands of works were accepted and displayed from the floor to the ceiling, crammed into every possible space. The Salon's judges also decided where paintings and sculpture would be placed and this visibility or obscurity could make or break an artist's career. So every artist, even after training for years at the École des Beaux-Arts, relied on the Académie to maintain or raise his reputation.

The Birth of Venus

Bought by Napoleon III after it was exhibited at the Paris Salon, this painting is a typical example of Academic art. Cabanel, the winner of the Prix de Rome in 1845, has blended an influence of Ingres' Neoclassicism with a flourish of Romanticism. With meticulous brush marks and close attention to realistic details, this reclining figure is an idealistic image of the goddess Venus and just the type of skilful painting of which the Académie approved and the wealthy liked to buy. Portraying a Roman myth presented the artist with an the opportunity to paint a perfect female nude. Cabanel adhered to all that the Académie stood for.

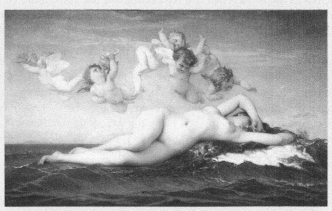

The Birth of Venus, Alexandre Cabanel, 1863, oil on canvas

Leading academic artists

During the 19th century, art became increasingly sought-after as the middle classes prospered. Official exhibitions, art dealers and mass-produced prints further publicized art and Academic art was the most popular style. Leading Academic artists included William-Adolphe Bouguereau (1825–1905), who produced classically styled religious and historical paintings, although his meticulously painted nudes and mythological subjects were the best-known. Jean-Leon Gérôme (1824–1904), was known for his historical, mythological and Oriental

> 'One shouldn't believe in all those so-called innovations. There is only one nature and only one way to see it.'
>
> William-Adolphe Bouguereau

paintings and portraits, Paul Delaroche (1797–1856) painted life-sized histories with a solid, smooth finish, Alexandre Cabanel (1823–99) was Napoleon III's favourite painter who painted portraits as well as historical, classical and religious subjects and Thomas Couture (1815–79) produced history paintings and was an influential teacher. All these artists successfully combined the theories and approaches of Neoclassicism and Romanticism, producing modern interpretations of classical subjects, using imperceptible brushstrokes to create idealized and lifelike realism. The subjects of these paintings were often sentimental, which was fashionable at the time and also complied with the Academy's requirements.

the condensed idea
Conservative art that follows the teaching of official academies

16 Ukiyo-e
(*c.*17th–20th centuries)

Ukiyo-e is the name given to the type of prints that were made in Edo, the former name for Tokyo. *Ukiyo* is a Buddhist word meaning the 'floating world' of changing situations and the Japanese word '*e*' means picture, so *Ukiyo-e* means 'pictures of the floating world'. From 1603 to 1868, while Japan was ruled by the shogun, Edo became one of the largest cities in the world.

During the 17th to 19th centuries, many oppressive decrees were put out by the shogun; pleasure was licensed and the pleasure quarters or entertainment areas in Japanese cities were regulated. This encouraged the idea that frivolity and enjoyment were difficult to experience and the desire to have fun, to relax and be entertained became aspirational to many. Courtesans, geishas, sumo wrestlers and kabuki actors lived in the pleasure quarters and were the celebrities of the Edo period. They became the subject matter of popular *ukiyo zoshi* novels (tales of the floating world) and Ukiyo-e paintings and woodblock prints. The 'floating world' originally meant the transience of life, but came to mean the carefree, agreeable environment of the pleasure quarters that included theatres, restaurants and teahouses and was far away from mundane, everyday life and the expanding city. To most people, the vibrant lives of the celebrities seemed to hover above the dark realities of ordinary existence. Artists began representing these glamorous people in their alluring worlds and the images became sought-after. Later, animals, birds, narrative scenes and landscapes were added to the artists' repertoire and these further expressions of the 'floating world' or world beyond commonplace realities became exceptionally popular. For the first time in Japanese history, artists created images that were desired by the general public.

Hovering above

The name 'Ukiyo-e' came from the sense of hovering over and looking down on the worlds that were represented in the art. The images were depicted in this way to convey to viewers the idea that they were watching and enjoying the agreeable side of life, without actually taking part and disobeying the shogun. For the same purpose, unusual

Ando Hiroshige

From a high viewpoint, foxes huddle beneath a huge nettle tree. This scene shows the Oji Inari Shrine in the north of Edo. The nettle tree in front of the shrine was believed to be where foxes in the Kanto region gathered to transform themselves into humans for New Year's Eve. Local people also studied foxfires to predict the success of the following year's crops. Hiroshige was considered the last great master of Ukiyo-e and changed its traditions from mainly featuring celebrities, to his astute observations of nature – even in this mythological work. With dynamic angles, this composition creates drama and has an even stronger effect when you bear in mind that Japanese is read from right to left.

New Year's Eve, Foxfires by the Nettle Tree at Oji:
One Hundred Famous Views of Edo, Ando Hiroshige, 1857, woodblock print

perspective is often used in Ukiyo-e images, to impart the feeling that viewers are floating above a view or an event. Although most of the images were produced before photography was invented, they are frequently cropped as in photographs, giving the impression of a passing glimpse of a scene, rather than a broad view of the whole picture. These unusual compositions added to the dreamlike fantasies. Diagonals often cut across the pictures, creating the idea of movement and emphasizing the flatness of the paper they were on – there was little attempt to build up tones and textures, images were images and not pretending to be reality. Harmony was important, so blank spaces were balanced between crowded areas of intense colour and pattern.

Ink to printing

Ukiyo-e was popular with a broad range of Japanese people, many of whom could not afford paintings. The first works were created with Indian ink, which was a little costly. Then, in 1670, Hishikawa Moronobu (1618–94), (known as the father of Ukiyo-e) experimented with monochrome woodblock printing. This was instantly popular as the prints could be mass-produced and so were affordable. Some of these prints were also brushed with some coloured ink until 1765, when Suzuki Harunobu (1724–70) developed a technique of printing in full colour. It was a precise and exacting method, but from then on, Ukiyo-e prints were vividly coloured, which complemented their strong designs and they became even more popular.

> 'I envy the Japanese for the enormous clarity that pervades their work.'
>
> Vincent van Gogh

Okomura Masanobu (c.1686–1764) was another influential Ukiyo-e artist of that period. Many Ukiyo-e prints by artists like Kitagawa Utamaro (c.1753–1806) and Tōshūsai Sharaku (active 1794–95) were initially created as posters to advertise theatre performances and brothels or were pin-ups of actors, courtesans and geishas. Eventually, by the 19th century, artists supplemented images of urban culture with images of the landscape. Artists such as Katsushika Hokusai (1760–1849) and Ando Hiroshige (1797–1858) created graceful, sensitive and dexterous effects of weather, perspective and aspects of the natural world.

The Edo and the Meiji periods

The Edo period ended in about 1867 and was followed by the Meiji period, which lasted until 1912. The Edo period was a calm phase, while the Meiji period, when the emperor was restored to power, was more changeable. Ukiyo-e altered as Japan began trading with the West and new influences crept in.

Le Japonisme

Between 1639 and 1854, the Japanese traded only with the Dutch and Chinese. In spite of this isolation, Western ideas and scientific discoveries were spread by the Dutch, who also took news from Japan back to Europe. After the Meiji Restoration in 1868, Japan began trading once more with the rest of the world. Western ideas such as photography and linear perspective influenced Japanese artists and gradually Ukiyo-e seemed outdated and the prints became practically worthless. They began to be used as wrapping paper for exported goods. In Europe, however, their discovery caused a sensation. European artists were overwhelmed by the ideas, including their use of everyday subjects, unusual viewpoints, tilted perspectives, bold, flat colours and strong outlines. Such ideas had never been seen in the West before and they became a source of inspiration for some of the greatest Impressionist, Post-Impressionist and Art Nouveau artists and designers. In France, the craze became known as *Le Japonisme*.

the condensed idea
Japanese woodblock prints and paintings of a changing world

17 Pre-Raphaelite Brotherhood (1848–*c.*1853)

In 1848, a group of seven young English painters, poets and critics formed a 'brotherhood' aimed at stimulating a return of painting in the style of the early Renaissance, before Raphael and Michelangelo. Focusing on the art of 15th century Italy, known as the Quattrocento, they created refined, colourful, detailed works, often full of symbolism.

The group called themselves the Pre-Raphaelite Brotherhood (PRB) as they believed that art had lost its way around the time of Raphael in the late 15th and early 16th centuries. The Pre-Raphaelites' ideas were a reaction against the academic conventions of art that had been handed down since then and which they believed were dull, pretentious and sedentary. The official art academies of the day taught that the art of the High Renaissance and Mannerism was supreme and should be emulated by all artists as closely as possible. Students of art had trained for years by copying the works of the High Renaissance masters. The Pre-Raphaelites believed that the resulting preference for the Academic style, which was a blend of Neoclassicism and Romanticism, was formulaic and contrived. In contrast, they sought to return to what they saw as the beauty and simplicity of the medieval world and to recapture artists' ideals from that time, particularly the Italian art of the Middle Ages. They actually had little knowledge of this early art but they decided that Raphael's art was exaggerated and over-dramatic and that the earlier art was less complicated and more modest. So they rebelled against academic traditions, agreeing to paint only 'truth to nature', which meant rejecting idealism and focusing on creating realistic images with accurate details, complex compositions and bright colours.

The founders

The organizers of the PRB were: Dante Gabriel Rossetti (1828–82), a poet and painter; John Everett Millais (1829–96), a painter; William Holman Hunt (1827–1910), a painter; Thomas Woolner (1825–92), a sculptor and poet; James Collinson (1825–81), a painter;

The Light of the World

This is one of many allegorical works produced by the Pre-Raphaelites. Jesus is about to knock on a door that has been closed for a long time; brambles have grown in front of it. It represents the human soul: Jesus wants to enter, but often receives no response. His words from the Bible's *Book of Revelations* are inscribed on the frame: 'Behold I stand at the door and knock, if any man hear my voice and open the door I will come in to him and will sup with him, and he with me.' With no handle, the door can only be opened from the inside, representing, as Hunt explained: 'the obstinately shut mind.' The seven-sided lantern indicates the seven churches mentioned in *Revelation*. This was painted in a blackened studio, lit only by candles and, as with all PRB works, it is meticulously detailed.

The Light of the World, William Holman-Hunt, 1853–4, oil on canvas over panel

William Michael Rossetti (1829–1919), a writer and art critic; and Frederic George Stephens (1828–1907) an art critic. At the start of the Brotherhood in 1848, their ages ranged from 19 to 23, but despite their youth, they were all critical of both England's industrialization and the narrow views of the people who ran the academies. Although it may be hard to imagine now, their work was shockingly controversial at the time and they began one of the first real avant-garde movements, dramatically defying art world officialdom. Rossetti had the idea to call the group a Brotherhood and to keep it secret from members of the English Royal Academy. They signed 'PRB' in the corners of their paintings and, to begin with, no one outside their group knew what that stood for – all outsiders knew was that it was a secret society, which was suspicious in itself.

Positive and negative influences

The Pre-Raphaelite painters emphasized precise, almost photographic details of all they depicted – everything was sharply in focus. Symbolism and allegory often appeared and they frequently included influences of Tennyson, Browning, Keats and Shakespeare as well as medieval subjects. They made a point of not following Sir Joshua Reynolds, the founder of the Royal Academy of Arts, whom most young artists tried to emulate, as they believed that his style was slapdash and insincere. Their nickname for him was 'Sir Sloshua'. But they admired art critic John Ruskin's (1819–1900) theories and once they met, he admitted his high regard for their work and wrote letters to *The Times* defending their work. In 1851 he published a pamphlet

The wet white technique

To achieve their luminous colour effects, the Pre-Raphaelites used a technique inspired by Renaissance fresco painting. In fresco, paint was applied on to wet white plaster. The Pre-Raphaelites layered two coats of white paint on to their canvases and then began painting while the white undercoat was still wet. The colours appeared jewel-bright and far more vivid than other 19th-century paintings.

called *Pre-Raphaelitism*, which explained and praised their approach and beliefs.

Rejecting tradition

The PRB were extremely serious and wrote a policy on their aims. They declared that they wanted to paint serious and significant subjects, directly from life, as realistically as possible and with the brightest colours available. They also aimed to reject the conventional methods of painting that were taught by rote in the academies and had not changed for decades. They published a periodical, *The Germ* to promote their ideas, which attracted even more criticism, especially from Charles Dickens (1812–70).

> 'Conception, my boy, fundamental brain work, is what makes all the difference in art.'
>
> Dante Gabriel Rossetti

Within five years of the Brotherhood, differences in the work of Rossetti, Hunt and Millais became apparent. Hunt and Millais became more naturalistic. Hunt's work became more moralistic and Millais' work became more acceptable to the authorities and society, while Rossetti's work became increasingly imaginative, mystical and inspired by literature. From 1850, after particularly harsh criticism of a painting by Millais, the group stopped signing themselves PRB and Collinson left. They soon disbanded, although for many more years, their influence continued and several other artists worked with similar styles, techniques and aims. Among others, the artists who continued with the Pre-Raphaelites' aims included Edward Burne-Jones (1833–98), Walter Howard Deverell (1827–54), Ford Madox Brown (1821–93), Arthur Hughes (1832–1915), Simeon Solomon (1840–1905), Henry Wallis (1830–1916) and Charles Allston Collins (1828–73). The work of this new generation has often been called the second phase of the Pre-Raphaelite movement.

the condensed idea
Romantic, colourful and detailed art, reflecting earlier times

18 Realism
(1830s–50s)

The second half of the 19th century saw increasing numbers of artists openly rejecting conventional ideas in art. These artists were concerned more with social realities than with feelings and the imagination. They rejected what they saw as the contrivances of Academic art, Neoclassicism and Romanticism, instead focusing on accurate and objective depictions of the ordinary world.

The artists who abandoned artistic traditions that had been accepted for decades believed in new scientific and technological discoveries and in individual rights – the concept that became particularly strong in France after the 1848 Revolution. One of the main objections to Academic painting was that subject matter did not represent life as it really was to most people. So Realism evolved as artists endeavoured to portray nature and the everyday activities of ordinary people. In painting commonplace subjects and themes, the artists were also championing human rights.

The Barbizon School

Realism originally began to emerge in the work of English artists such as Turner and Constable and the Pre-Raphaelites. Their adherence to painting objectively and directly from nature inspired several French artists, beginning with the artists who became known collectively as the Barbizon School. From about 1830, these painters worked in the Forest of Fontainebleau near the village of Barbizon just outside Paris. Although the Barbizon painters' work was not widely accepted until the 1860s, by painting finished pictures *en plein air* ('in the open air') rather than in the studio, they established landscape as a valid subject, which it had not been before. The main Barbizon artists were Charles-François Daubigny (1817–78), Théodore Rousseau (1812–67), Camille Corot (1796–1875), Constant Troyon (1810–65) and Narcisse Diaz de la Pēna (1807–76).

Taking ideas from the Barbizon School and also picking up on new scientific theories, the ways in which Realists rendered their subjects differed from that of Academic painters. They attempted to portray objects exactly as they saw them. They did not concern themselves

After the Franco-Prussian War of 1870–1, revolutionaries attempted to seize power and create some kind of social equality. They called their organization the Commune, but they were soon overthrown by the official French government. Courbet was one of the many sympathizers who were punished after order was restored and was made an example of the government's reassertion of authority.

with over-refined techniques, such as imperceptible brush marks or subtle nuances of tone, but focused on depicting the truth. They even emphasized the two-dimensionality of their canvases. As democratic thinkers, their themes varied from peasants at work, to landscapes, to groups of figures or genre scenes (scenes of everyday life). Although shocking to traditionalists, their images of peasants, the working classes, the harsh realities of poverty or deprivation, showed modern life as it really was. These themes were so different from the portraits, histories, allegorical and mythological subjects that featured in Academic art that most viewers were indignant. To

'I have never seen angels. Show me an angel and I will paint one.'
Gustave Courbet

be confronted by such realities was not what they expected from art. Ideals of beauty had been replaced with stark realities, removing any escapism that art had previously provided. Until then, portrayals of the poor had been romanticized by artists. This was the first time that such mundane subjects had been depicted with no embellishments. The Academies were affronted – they perceived the work as ugly and deliberately provocative.

Photography

With the invention of photography in 1839, debates arose about the nature and purpose of painting. Instead of the technology making painting redundant, as many suggested it would, it triggered new ideas among many artists. Realism was one of the styles that emerged, as artists realized that ordinary subjects had their own attractions and

purposes – and that photography would be an added accessory to their work. By painting what they saw in front of them directly and without emotion, the Realists were making a stand against Academic rules and artificiality as well as creating a modern approach to art that reflected the bulk of society rather than just an elite few.

The Angelus

A man and a woman are reciting the Angelus, a prayer that commemorates the annunciation made to Mary by the Angel Gabriel. They have heard a church bell ringing and have stopped digging potatoes to pray. All their tools – the potato fork, the basket, the sacks and the wheelbarrow – are close by. The painting was inspired by a childhood memory, and Millet wanted to show how peasants lived and worked. A member of the Barbizon School, Millet is also classified as a Realist. Realists had no set style; their art was more about painting 'real', everyday subjects without artifice, so, for instance, his style differed from Courbet's.

The Angelus, Jean-François Millet, 1857–59, oil on canvas

'Le Réalisme'

In 1855, Gustave Courbet (1819–77) was rejected from exhibiting in the Universal Exhibition, a major event in Paris celebrating the new reign of Emperor Napoleon III. Courbet had a building erected nearby at his own expense, which he called 'The Pavilion of Realism', and displayed his paintings there. Many of his works were on large canvases as in traditional Academic art, but instead of featuring noble themes they were of unglamorous subjects. Academic tradition ruled that large paintings should only be of historic, biblical, mythological or allegorical subjects – but Courbet defied this convention. His work was direct, bold and intense and deliberately challenged officialdom – even his application was considered vulgar as he applied thick, impasto paint with a palette knife. He and the art critic and novelist Champfleury (1820–89) produced a manifesto called *Le Réalisme* which he distributed to all visitors of his exhibition. Other major Realists were: Millet, Rosa Bonheur (1822–99), Honoré Daumier (1808–79), Jules Breton (1827–1906), Édouard Manet (1832–83), and American artists Thomas Eakins (1844–1916) and Winslow Homer (1836–1910). The English landscapists and Pre-Raphaelites can also be classed as Realists. Realism was more about new ideas and changing accepted traditions. It was not a coherent movement to which artists joined, but many artists used Realism as a starting point to move on to even newer ideas.

> 'Painting is an essentially concrete art and can only consist of real and existing things . . . an object which is abstract, not visible, non-existent, is not within the realm of painting.'
>
> Gustave Courbet

the condensed idea
Objective depictions of the ordinary world

19 Impressionism
(1870s–90s)

The name 'Impressionists' was used as an insult by a critic to describe what he saw as ineffectual art exhibited by a group of painters in Paris in 1874. These artists' ideas were groundbreaking and scandalous. Capturing transitory moments of everyday themes, they applied few details, conspicuous brushstrokes and often unblended paints. To contemporary viewers, their art looked unfinished.

The Impressionists had originally started meeting and discussing their ideas during the 1860s when most were students at one of two private Parisian art schools, the Académie Suisse and Gleyre's Studio. A fairly diverse group, they included Claude Monet (1840–1926), Camille Pissarro (1830–1903), Paul Cézanne (1839–1906), Alfred Sisley (1839–99), Frederic Bazille (1841–70), Berthe Morisot (1841–95), Mary Cassatt (1844-1926) and Auguste Renoir (1840–1919). From about 1862, they began meeting regularly at the Café Guerbois in the Batignolles Quarter of Paris, along with Édouard Manet and a few other artists and writers, to discuss their theories about the future of art.

Most admired Manet, who was already causing a stir in artistic circles, and they were also variously influenced by the Barbizon School, Turner, Constable, Realism and new scientific theories and technologies. The invention of photography – both for its technique of working with light and as a practical aid – affected them more than it

Japanese prints

From 1854, after about 250 years, Japan resumed trading with the Western world. A fascination with all things Japanese developed, particularly in France and notably among many artists and designers. The fashion began in Paris and, struck by the astonishingly bright colours and original compositions, most of the Impressionists began collecting Ukiyo-e prints. Many Japanese ideas appeared in their work.

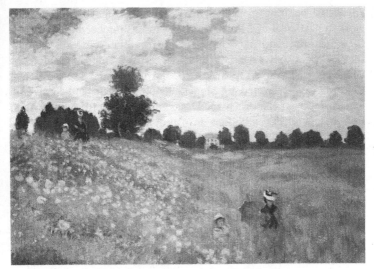
Poppies, Claude Monet, *c.*1876, oil on canvas

had touched any previous artists. Scientific colour theories, the industrial age and Japanese prints gave them further new dimensions.

The Académie des Beaux-Arts continued to dominate the arts in France. Setting rules for subjects and styles and organizing the Salon and art competitions, Académie officials were not used to having their principles questioned. First of all, the Barbizon School and the Realists rebelled and then this group of artists defied them. In 1863, Manet and Courbet entered paintings to the Salon, but their work was rejected. That year, the Salon jury rejected an unusually large number of other works too. Napoleon III declared that the public should be able to judge the work themselves and the Salon des Refusés (Salon of the Refused) was organized. While many came to laugh, the idea arose that art could be different from formally approved styles and that artists could exhibit in places other than the Salon.

Anonymous Society

The artists who met at the Café Guerbois had common philosophies about painting, although their styles differed widely. They all reacted against the constraints of Academic styles and subjects and they all

advocated painting in the open air. They were inspired by Manet's work in particular and the Salon des Refusés stimulated them to start their own independent society, separate from the Académie. In 1873, the Société Anonyme Coopérative des Artistes Peintres, Sculpteurs, Graveurs (the Anonymous Association of Painters, Sculptors, and Engravers) was formed by Monet, Renoir, Pissarro and Sisley and included Cézanne, Morisot and Degas and others who organized their first independent exhibition in April 1874. Amid scathing and mocking comments from visitors, the critic Louis Leroy wrote a sarcastic review, calling it 'The Exhibition of the Impressionists' after Monet's painting, *Impression, Sunrise*, describing the work as inadequate and embarrassing. They did not all exhibit in every show, but they held eight exhibitions between 1874 and 1886. Gradually the hostility towards them subsided and their work became accepted.

Colour theories

Even if their styles and choices of subjects were different, all the Impressionists set out to modernize art. They began by rejecting conventions, following artists such as Courbet and Delacroix, painting bright, often unblended colours with visible brush marks, completing many canvases en plein air, capturing transient effects and focusing on the changing light. Along with landscapes, still lifes and portraits, they painted scenes of modern life, summarizing overall visual effects instead of painting precise details. They studied the dramatic effects of atmosphere and light on people and objects and through varied palettes, they tried to reproduce these effects on canvas. Many of their darker tones were created out of mixtures of pure colours and were barely blended. Most of these ideas evolved from recent scientific colour theories. For instance, coloured rather than grey shadows produced effects of 'colour vibrations', or shimmering overall effects. No object was ever painted with one, flat overall colour. They placed complementary colours (colours that are opposites on the colour wheel) in juxtaposition, to make each other appear brighter and as well as local colour (the colour that an object appears); they also painted reflected colour (colours reflected on an object from surrounding objects).

'For an Impressionist to paint from nature is not to paint the subject, but to realize sensations.'
Paul Cézanne

Sincere art

Rejecting any academic training they had experienced, Monet and the other Impressionists believed that their art, with its objective methods of painting what they saw before them, was more sincere than any academic art. They all agreed that they aimed to capture their 'sensations' or what they could see as they painted. These sensations included the flickering effects of light that our eyes capture as we regard things. In complete contrast to the Académie, the Impressionists painted ordinary, modern people in everyday and up-to-date settings, making no attempt to hide their painting techniques. They avoided symbols or any narrative content, preventing viewers from 'reading' a picture, but making them experience their paintings as an isolated moment in time.

Painting from nature was an approach that most Impressionists adhered to even though several of their styles and subject choices were different. Edgar Degas (1834–1917), for example, was categorized as an Impressionist even though he rarely painted landscapes, but he exhibited with the group and he always painted directly from life, taking inspiration from photography and Japanese prints. All the Impressionists persisted with their innovative ideas, despite the hostility they endured, and by the 1880s they were accepted as the leading group of avant-garde artists in Europe.

the condensed idea
Capturing fleeting moments and light with pure colours

20 Symbolism and Aestheticism
(mid- to late 19th century)

While the Realists and Impressionists were developing their ideas and styles, other artists were also moving away from the conventions of Academic art. Two of these movements were Symbolism and Aestheticism. Symbolism began in France and was an attempt to express hidden truths and mysteries that lie behind outward appearances. In Britain, the Aesthetic movement focused on beauty, emphasizing form rather than content.

Both movements were reactions against Realism and, in certain ways, were similar to each other. Aestheticism was obsessed with beauty, which Realism disregarded, and Symbolists expressed the intangible, while the Realists' objectives were all about visible truths. The Symbolists and Aesthetic artists (Aesthetes) both rejected classic approaches to art and literature and did not believe that art should educate viewers about moral principles.

Art for art's sake

Symbolism was inspired by the writer and critic Théophile Gaultier (1811–72), who was an enthusiast of Romanticism and who promoted the idea of expressing one's 'pure sensations' or perceptions. He encouraged writers and artists to use their imaginations and intuition to produce work, which in turn initiated the idea of 'art for art's sake'. This was the first time that artists had made art simply for its own sake – not for spiritual, political or moral purposes, or even as in Rococo, to decorate or adorn. The notion of art for art's sake meant that art should avoid social, political and moral themes and concentrate purely on creating beauty. The artists and writers associated with Aestheticism and Symbolism experimented with the idea that art should be separate from the everyday world and not an extension of it.

Aestheticism

In line with Gaultier's theories, Aesthetes also admired Romanticism, rejected portrayals of moral or social themes and emphasized artistic

values in their work. Those involved were disgusted by the machine-made products of the Industrial Revolution, overly dramatized Victorian imagery and the rigid and often narrow-minded moral codes of Victorian society. They were receptive to new fashions and interested in appearances, believing that beauty was an imperative

Vision after the Sermon

Usually classed as the first real Symbolist painting, this is about human conscience and inner conflicts. Some Breton women have just heard the priest read a sermon based on the biblical story of Jacob who spent a night wrestling with an angel. The following morning as the sun rose, the angel gave up and blessed Jacob. Against a red background, the real and imagined worlds (secular and spiritual) of the figures and the vision are separated by a diagonally placed tree trunk. The cow represents the simplicity of rural life and the peasants who live closely with the land. Gauguin aimed to remind an acquisitive society of spiritual considerations.

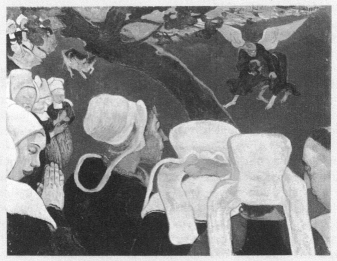

Vision after the Sermon (Jacob Wrestling with the Angel),
Paul Gauguin, 1888, oil on canvas

aspect of life. This idea developed partly as a reaction to industrialization and ended up as a radical revision of the relationships between artists and society.

The writer Oscar Wilde (1854–1900) became a spokesman for Aestheticism after becoming fascinated with the ideas while he was at Oxford University. He retained the interest for the rest of his life. Because of his insistence on having beautiful things around him and his seemingly flippant witticisms, he was perceived by many to be empty-headed, but it was all deliberately cultivated through his beliefs in Aestheticism. The movement is generally considered to have ended soon after his trial in 1895.

Visual artists who practiced Aestheticism included James Abbott McNeill Whistler (1834–1903), Albert Moore (1841–93), Frederic Leighton (1830–96), Burne-Jones and William Morris (1834–96) who aimed to create entire, beautiful environments that ultimately gave their work a social and even political agenda, changing the way people lived. The Pre-Raphaelite Brotherhood was a forerunner to the Aesthetic movement as Aesthetes were influenced by the paintings that idealized medieval life.

Symbolist manifesto

Symbolists did not adhere strictly to one formal or technical approach, but in 1886 the poet Jean Moreas (1856–1910) published his Symbolist Manifesto in *Le Figaro*, listing the groups core values, which were mainly rejecting the principles of Naturalism and Realism. Moreas named three poets as leading figures in the movement: Charles Baudelaire (1821–67), Stéphane Mallarmé (1842–98) and Paul Valéry (1871–1945). Baudelaire believed that ideas and emotions could be conveyed not only through the meanings of words, but also in their sounds and rhythm, which was particularly influential to the Symbolists in general. Paul Gauguin (1848–1903) experimented with his own ideas of Symbolism during the 1880s and conveyed ideas through colour, pattern and rhythm. Believing that European art had become too derivative and lacked symbolic insights, he expressed underlying meanings in his art. Other main Symbolists who created imagery out of myths and dreams were Gustave Moreau (1826–98), Pierre Puvis de Chavannes (1824–98) and Odilon Redon (1840–1916).

Contradiction

Interestingly, although the ideas oppose each other, some artists who have been labelled Realists also produced paintings that can be described as Symbolist. Millet for example, often included symbols in his paintings of peasants at work. Courbet too, seems to suggest other meanings in some of his paintings of ordinary people. Believing that art should be subjective and mysterious, and that subject matter should come from their emotions, dreams and inner perceptions, each Symbolist created personal, often ambiguous symbols that were not traditional religious motifs or other emblems that were familiar to viewers.

From its beginnings with the artistic concerns of a small circle of avant-garde painters, sculptors, writers, architects and designers, the Symbolist movement soon became a broad cultural trend, spreading from France to Russia, Britain, Italy, Spain and Scandinavia. In each of these countries, Symbolism was taken up by a variety of artists using different approaches, but each one embraced the concepts of opposing certain contemporary artistic trends and of portraying messages.

the condensed idea
Secret messages and beauty in art

21 Post-Impressionism
(c.1880–1905)

During the 1880s and 1890s, a number of pioneering artists who had worked in the Impressionist style decided that Impressionism was too simplistic and did not focus enough on elements such as structure and solidity of objects or express emotion through colour. Each of these artists began working with different approaches and styles, and later they became known collectively as Post-Impressionists. In fact, the label 'Post-Impressionism' was not used until 1910, after the main four artists the term described had died. It became an umbrella term and did not encapsulate the individuality and originality of the artists clearly enough, but it has come to be accepted as the name for some ground-breaking painters who produced colourful and inventive work soon after Impressionism had become generally accepted.

Diversity of styles

In 1910, the British artist and art critic Roger Fry (1866–1934) organized an art exhibition in London. Featuring the work of Manet, Cézanne, Gauguin, Vincent van Gogh (1853–90), Georges Seurat (1859–91) and several others, it was an attempt to introduce the British public to the works of the artists who were following Impressionism. Fry called the exhibition 'Manet and the Post-Impressionists', as he explained: 'For purposes of convenience it was necessary to give these artists a name, and I chose, as being the vaguest and most non-committal, the name of Post-Impressionism.' The name stuck.

Like many of these categorizations, the name does not tell us much – only that the artists in the exhibition worked after Impressionism. As a broad term, it became used for several of the developments that emerged from, or because of, Impressionism. It has come to mean the diversity of styles and approaches that some artists used from about 1880 to about 1905. Some of these other artists are Henri de Toulouse-Lautrec (1864–1901), Paul Signac (1863–1935), Émile Bernard (1868–1941) and Maurice Denis (1870–1943). None of the artists concerned are easily classified, so the name continues to be used as a general,

collective expression. Several of the artists have also been classed under other labels, such as Neo-Impressionism, Pointillism, Divisionism, Cloisonnism, Synthetism, Les Nabis and the Pont-Aven School, for instance.

Starry Night

Experimenting with some of the techniques he had learned from the Impressionists, Vincent van Gogh painted this vibrant night scene using even brighter colours and impasto paint, short brush marks and rhythmical patterns. The sky is filled with swirling clouds, blazing stars and a bright crescent moon. A small town nestles behind a huge dark cypress tree in the foreground. This tree suggests isolation and is said to represent van Gogh, while the town signifies the rest of the world and the sky, moon and stars indicate God. The eleven stars possibly also reflect a passage from the Bible when Joseph tells of his dream where the sun, moon and eleven stars bowed down to him.

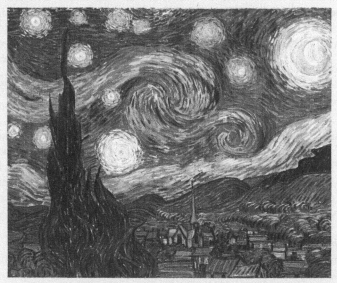

Starry Night, Vincent van Gogh, 1889, oil on canvas

Personal expression

The Impressionists recorded the elusive effects of colour and light that they saw directly in front of them. In general, although the Post-Impressionists' themes were often similar to those of the Impressionists, they moved away from the naturalistic concerns of their predecessors and became more stylized. Although, in the main, the Post-Impressionists accepted this as revolutionary and that it paved the way for them to move in their own directions, they believed that as a style Impressionism was not progressing. Many Post-Impressionists used the pure, vivid colours of Impressionism, most continued to move away from traditional subject matter and most applied short brushstrokes of broken colour to create impressions of movement and vitality. Whatever ideas they took from Impressionism, they all changed it in some way and created images that were extremely personal and more expressive than most art had been until then. Their work influenced several new artistic ideas of the early 20th century.

> 'I dream of painting and then I paint my dream.'
>
> Vincent van Gogh

Working alone

Unlike the Impressionists who socialized and exhibited together, the Post-Impressionists painted mainly alone and did not meet regularly to discuss their theories. Cézanne painted predominantly at Aix-en-Provence in southern France; Gauguin spent most of his time in

Brittany or Tahiti; van Gogh lived in Arles in southern France and then Auvers-sur-Oise, a village to the north of Paris and Toulouse-Lautrec worked mainly in Montmartre in Paris. Gauguin and van Gogh produced art that expressed their personal and spiritual beliefs.

Although their compositions and paint application often appear more simplistic and less sophisticated than Impressionist paintings, they had underlying meanings as well as their surface appearances. Gauguin recreated the pure, flat colours, heavy outlines and decorative qualities of medieval stained glass and manuscript illumination and van Gogh applied curving, colourful, short, thick brush marks to convey his ideas and emotions. Cézanne (who has been called 'the father of modern painting' because he was so influential to later generations) studied at the Académie Suisse in Paris where he met some of the Impressionists. Camille Pissarro (1830–1903) taught him the rudiments of Impressionism, particularly methods of depicting light and colour from direct observation. Cézanne participated in two of the Impressionist exhibitions, but he moved away from capturing fleeting moments, to painting objects from different perspectives at once, using planes of colour and small brushstrokes in an effort to build up the idea of solid structures of everything. Toulouse-Lautrec painted and printed images of the bohemian cafés, brothels and nightclubs of Paris. He depicted disreputable locations and the people who visited and worked there truthfully, but with empathy and insight. His flowing contours and bright colours were completely different from any previous images and his work became synonymous with the period. Overall, Post-Impressionism moved art away from the naturalistic approach that had become acceptable through Impressionism, and towards the major art movements of the early 20th century, such as Cubism and Fauvism.

'A work of art that did not begin in emotion is not art.'

Paul Cézanne

the condensed idea
Individual responses to Impressionism

22 Neo-Impressionism
(1886–c.1900)

mpressionism had a huge influence, but by the late 1880s, some artists began to feel it needed to be modernized and restructured. The term Neo-Impressionism was coined by the writer and art critic Félix Fénéon (1861–1944) in 1886 on seeing a painting in the new style by Seurat at the final Impressionist exhibition.

Seurat began as a fairly conventional art student at the main art school in Paris, the École des Beaux-Arts. He studied classical and Renaissance art at the Louvre and he also admired the work of the Impressionists. As he developed as an artist, he focused on a specific aspect of Impressionism, developing new techniques and approaches in connection with it. Admiring the Impressionists' vibrant palettes, he aimed to exploit scientific colour theories even more than they had done. In the main, the Impressionists used colour intuitively, relying on their perceptions of objects in front of them, using colours in shadows and often avoiding black. Seurat was still interested in depicting colour and light, but he developed a more rational, scientific method of using colour in his paintings. Rejecting the ephemeral effects created by the Impressionists, he developed a highly formalized and stylized method. He was influenced particularly by several books and articles that had been written in recent years about colour theories.

> 'Some say they see poetry in my paintings; I see only science.'
>
> George Seurat

Coloured dots

Unlike many art movements, Neo-Impressionism was a positive name, invented by Fénéon who thought favourably of Seurat's work, to describe what he saw as the new phase of Impressionism. The term refers to a specific painting technique where pigments are not mixed on the palette or canvas, but small dots of pure colour are placed side by side onto canvases to build a whole image. From a distance, viewers' eyes mix the colours. In the early 1880s, Seurat had considered Chevreul, Rood and Blanc's colour theories and determined on using them, convinced that this would create the

illusion of brighter colours to catch viewers' attention. The main colour theory that appealed to him was the 'Law of Simultaneous Contrast' where it was stated that complementary colours (opposites on the colour wheel) made each other appear brighter when placed next to each other. Seurat named his new painting technique 'separation of colour' or 'Divisionism'. It is also often called Pointillism, although Seurat rejected the term. The overall idea was that by placing colours independently rather than blending them, viewers' natural optical mixing would create greater vibrancy and intensity of colour.

Complementary contrasts

Complementary colours are orange and blue, violet and yellow and red and green. By putting any of these pairs side by side, both colours appear more vivid. In a letter of 1890, Seurat explained that his art consists of contrasts between light and dark and contrasts between the complementary colours 'red-green, orange-blue, yellow-violet.' His Divisionist method was based on the colour theory 'rules' and the colour of every mark on his canvases – usually thousands of tiny dots – was determined by these rules.

Seurat's huge painting *A Sunday Afternoon on the Island of La Grande Jatte* of 1884–6 is the second work he exhibited and is considered the first masterpiece of Divisionism. It was this work that inspired Fénéon's name for the movement. First shown at the final Impressionist exhibition of 1886 in Paris, *La Grande Jatte* was overwhelmingly reviled. Even more controversial than Impressionism

Les Poseuses

This is the third large painting that Seurat exhibited and his second completely Divisionist or Neo-Impressionist work. Like most of his other works, it is a large canvas, emphasizing the smallness of the dots and the painstaking process of creating the picture. He laid down dots in each colour, building up the fully hued final image. The painting features one model in three poses, disrobing, posing and dressing in his studio in front of his painting *La Grande Jatte*, which leans on the wall. It was probably Seurat's attempt to show that traditional subject matter was as suitable to his technique as more Impressionist-type subjects. Scattered about the floor are articles from *La Grande Jatte,* including hats, shoes, parasols and a small basket of flowers.

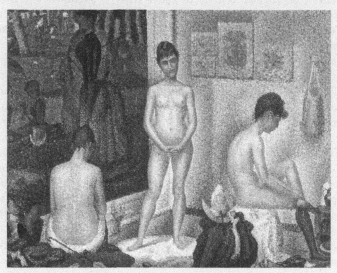

Les Poseuses, Georges Seurat, 1888, oil on canvas

'The anarchist painter is not the one who will create anarchist pictures, but the one who will fight with all his individuality against official conventions.'
Paul Signac

had been when it started, Divisionism was considered overly mechanical and that it contradicted the commonly accepted notions of art. The modern urban scene was similar to many Impressionists' paintings, but instead of conveying their transient effects; Seurat aimed to capture something more significant.

The influence of Neo-Impressionism

At the first Salon des Indépendants of 1884 (an annual exhibition established as an alternative to the official government-sponsored Salon), Seurat met Paul Signac (1863–1935) who was immediately inspired by the colour theories and methods. He began experimenting with Divisionist methods of painting, although his marks were always less subtle, looser and further apart than Seurat's tiny dots and his canvases appeared even brighter. He was quite prolific, painting his favourite motifs of Mediterranean landscapes, usually including the coast, sea and boats. After Seurat's untimely death in 1891, Signac took up the leadership of Neo-Impressionism and remained faithful to the method throughout his career. He exerted a profound influence on succeeding generations of artists, including Henri Matisse (1869–1954) and André Derain (1880–1954). Some other painters who also became Neo-Impressionists exhibited at the Salon des Indépendants, including Albert Dubois-Pillet (1846–90), Charles Angrand (1856–1926) and Henri-Edmond Cross (1856–1910). From the start, Pissarro and his son Lucien (1863–1944) were taken with Neo-Impressionism and for several years they painted using a Divisionist technique, although they applied small strokes rather than dots. Camille Pissarro later returned to a more Impressionist style. In 1886, when van Gogh arrived in Paris, he too was fascinated by the theories and painted several works using the method. In painting history, Neo-Impressionism was only a short-lived, transitional movement, but its influence was vital in the evolution of 20th century art.

the condensed idea
Scientific colour theories in painting

23 Art Nouveau and Secessionism (1890–1905)

Just before the turn of the 20th century, an energetic generation of artists and designers determined to create an international and modern style. In many ways, the art and design movement that emerged was a response to the Industrial Revolution. Although it had fundamental similarities, as Art Nouveau spread across the globe, it was interpreted variously in different countries.

From about 1890, the idea developed that a new style of art and design should herald the new millennium. Across the world, artists and designers either embraced new technologies, discoveries and materials, or rejected machine made goods and retreated into the past. Art Nouveau was the result; a range of contradictory images and ideas, expressed by different practitioners. The movement sought to make art more than just something people see on gallery walls and to break down barriers between fine and applied art.

Sinuous lines

Most of the Art Nouveau artists and designers believed passionately that the decorative arts should be elevated to the staus of fine arts and should move on from retrospective or conservative ideas in art and design. The style simplified many of the ornate and over-embellished Victorian styles that abounded. It was influenced by Symbolism, as well as by Celtic and Japanese art. As an influential and far-reaching movement, it had a profound effect on design and art that continued into the 20th century even though the movement was essentially over by 1905. Whether it was interpreted as art or design, it was characterized by highly stylized, curving, flat, sinuous and asymmetrical shapes, organic forms and rhythmic, decorative patterns. The female figure, animals and plants featured frequently, often particularly focusing on flowers, leaves, tendrils, flowing hair or feathers. Materials too were modern and new: glass, pewter, iron and silver were often used, and colours were soft and muted or bold and strong as in Japanese prints.

Secessionism

In Austria, a localized form of Art Nouveau was practised by artists of the Vienna Secession and it became known as the Sezessionstil ('Secession style'). The movement included painters, sculptors and architects. It was founded on 3 April 1897 by artists Gustav Klimt (1862–1918), Koloman Moser (1868–1918), Josef Hoffmann (1870–1956), Joseph Maria Olbrich (1867–1908) and others. Klimt was the first president of the Secession. Secession artists objected to the rigid and old-fashioned conservatism of the Künstlerhaus, the official art exhibition building in Vienna, and they aimed to exhibit more progressive artists' work than had usually been shown. The artists who were part of the Vienna Secession did not have one cohesive style or approach. They were concerned primarily with exploring the possibilities of art outside the constraints of academic convention. They hoped to create a completely new style. Above the entrance of the Secession building, they had the phrase carved 'to every age its art and to art its freedom'.

International movement

As a reaction to academic art of the 19th century, Art Nouveau's organic, floral and flowing forms appeared in everything from fine art, to furniture, architecture, jewellery and more, in its efforts to make art part of everyday life. Initially, the movement was strongly influenced by the artists Arthur Heygate Mackmurdo (1851–1942) and Alphonse Mucha (1860–1939). In 1883, Mackmurdo's cover

Changing names

The name Art Nouveau derives from the Maison de l'Art Nouveau, an interior design shop that opened in Paris in 1896, specifically to promote modern art. It became known in different countries by different names. In Germany it was known as Jugendstil from a magazine by the same name. In Italy, it became called Stile Liberty after the London store owned by Arthur Lasenby Liberty, or 'Floreale'. In Spain it was called Modernista, in France it was known as Modern Style (or Style Nouille – noodle style) and in Austria, Sezessionstil.

The Three Ages of Woman

Also known as *Mother and Child*, this was Klimt's first large oil painting and represents three main stages of a woman's life: infancy, motherhood and old age.

Following the Secessionist, Klimt elongated the figures, but contained them with flowing, undulating contours and decorative effects. The image is a fine art painting, but with its patterns, curves, colours and textures, it also crosses into design. The influence of Symbolism is evident and Klimt declared: 'Whoever wants to know something about me – as an artist, the only notable thing – ought to look carefully at my pictures and try and see in them what I am and what I want to do.'

The Three Ages of Woman, Gustav Klimt, 1905, oil on canvas

design for the book *Wren's City Churches* caused a sensation. It was asymmetrical, curvilinear and different. In 1894, Mucha produced a poster in Paris advertising the play *Gismonda*, starring Sarah Bernhardt. The elongated, fluid designs of the new artistic style were greatly admired. For a while, the style was called Style Mucha in honour of Mucha's approach. Soon, most Art Nouveau designs were produced throughout Europe and became influential globally. Some of the main exponents included Klimt and Mucha; illustrators Aubrey Beardsley (1872–98) and Walter Crane (1845–1915); architects Henry van de Velde (1863–1957), Victor Horta (1861–1947), Antonio Gaudí (1852–1926), Hector Guimard (1867–1942), Louis Sullivan (1856–1924) and architect, designer and artist Charles Rennie Mackintosh (1868–1928); artists and designers Margaret Macdonald Mackintosh (1864–1933) and Frances Macdonald MacNair (1873–1921); jewellery designer René Lalique (1860–1945) and glassware designers Louis Comfort Tiffany (1848–1933) and Émile Gallé (1846–1904). These artists and designers came from various countries and each adhered to Art Nouveau ideas, but interpreted them in their own individual manner. Every means of expression was acceptable to the Art Nouveau 'treatment', whether it was an advertising poster, an item of jewellery, a building or a piece of sculpture.

Modern society

Art Nouveau was more than a style. It was a way of thinking about modern society and new production methods and an attempt to redefine the implication of a work of art. The idea that one art style could cover everything, from everyday objects, to buildings to fine art was completely new. It continued to influence a variety of art and design movements of the 20th century.

the condensed idea
Merging the fine arts and applied arts with new, simplified styles

24 Fauvism
(1900–20)

The first of the major European avant-garde art movements of the 20th century, Fauvism was characterized by paintings that did not attempt to look lifelike, but featured intensely vivid colours, free brushwork, broken lines and loose compositions. It was a short-lived movement, never formally organized, but it exerted an extensive influence on art and design throughout the 20th century.

Fauvism emerged in Paris at the beginning of the 20th century. It was an expressive style that appeared when huge technological changes, such as the motor car, the radio and wider availability of electricity were transforming society rapidly. In many ways, the movement was a successor to the work of van Gogh, Cézanne and Gauguin. Like the Post-Impressionists, the Fauvists rejected the objectivity and delicate brushwork of Impressionism, making their art more emotive and expressive.

Wild beasts

Although the style and approach of Fauvism continued to be produced by some artists for about ten years, as a movement it lasted just three years and the artists concerned only had three exhibitions together. The artists included Henri Matisse (1869–1954), André Derain (1880–1954), Maurice de Vlaminck (1876–1958), Georges Braque (1882–1963), Georges Rouault (1871–1958), Albert Marquet (1875–1947) and Raoul Dufy (1877–1953). The name was given to them in 1905 when they all exhibited at Salon d'Automne in Paris. As had happened with the Impressionists, they were labelled mockingly by a critic who visited the exhibition. In the gallery where the exhibition was held was a Renaissance-style sculpture. Louis Vauxcelles (1887–1945) pointed at it and exclaimed: '*Donatello au milieu des fauves!*' ('Donatello among the wild beasts!') Vauxcelles dismissed the artists' vigorous brushwork, absence of tone and flamboyant, non-naturalistic use of colour as ridiculous, thoughtless and demonstrating a lack of skill.

> '**I do not literally paint that table, but the emotion it produces upon me.**'
>
> Henri Matisse

Colour

Between 1901 and 1906, several retrospective exhibitions were held in Paris, showing the work of, among others, Gauguin, van Gogh and Cézanne. It was the first time that so many paintings by Gauguin and Cézanne had been seen by the public. Uplifted by the radical ideas they saw, many artists were inspired to experiment with their own ideas. From 1897, Matisse studied art with an Impressionist painter John Peter Russell (1858–1930). Russell explained colour theory to him and Matisse began working with a bright palette. Russell had also been a close friend of van Gogh's and he gave Matisse a drawing by van Gogh. After that, Matisse's use of vibrant colours and thick, expressive brushstrokes became a characteristic of all his works, with little attempt to imitate nature too closely. He also studied the colours in oriental carpets and North African scenery.

Rejecting tradition

Fauvists distorted forms and chose their colours and brush marks for their emotive qualities. They rejected the tradition of painting illusions of perspective, depth, tone and texture, emphasizing instead the flatness of their canvases. Colour was not used descriptively, but to convey feelings or impressions, such as joy or the warmth of strong sunlight. Although their work seemed brash and their methods forceful and careless; their subject matter centred on traditional nudes, landscapes and still lifes. Colour was often more important than anything else. So, with its bold colours and energetic paint application, Fauvism was a direct development of Post-Impressionism,

Matisse and Moreau

In 1892, Matisse enrolled at the École des Beaux-Arts in Paris and was taught by the Symbolist painter Gustave Moreau. Moreau taught Marquet and Rouault as well as Matisse, encouraging them to discover their own artistic preferences rather than follow tradition. His open-mindedness, originality and belief in the expressive powers of colour were innovative and unusual for the time. He told Matisse: 'Think your colour. Know how to imagine it.'

Samuel John Peploe

Inspired by Matisse, this painting is in a naïve style, which gives the work an untrained, childlike appearance, using dazzling colours and simple brushwork. The result is a light-hearted, animated image that does not attempt to appear lifelike. Peploe was classed as a Scottish Colourist, not a Fauvist, but his approach was similar and, like the Fauves, colour was the most important element of his work. Most Fauves placed complementary colours side by side, making each appear brighter by comparison and they applied discordant colours judiciously and used pattern to emphasize different colours.

Still life of dahlias and fruit, Samuel John Peploe, *c.*1910–12, oil on canvas

but also a reaction against Neo-Impressionism, which Fauvists believed restricted spontaneity. Matisse once declared: 'Fauvism shook off the tyranny of Divisionism.'

Ridicule and derision

As Fauvism developed, the movement's artists were subjected to enormous ridicule and derision. With their harsh colours, habit of squeezing paint directly from tubes on to canvases and avoidance of painting realistically, contemporary viewers did not know what the artists were aiming to do and why they distorted reality so violently. It was believed that they could not paint accurately so they were not 'real' artists, merely a group of untalented people who wished to be known as artists. Yet among young avant-garde painters, the style proved popular and others exhibited with the Fauves in the two exhibitions that followed the 1905 Salon d'Automne, including Kees van Dongen (1877–1968) and Othon Friesz (1879–1949). All artists labelled 'Les Fauves' developed similar ways of depicting subjects, exploring colour and applying paint, although they did not follow any cohesive doctrines. Much of the work resembled elements of the naïvety of early art. This was probably inspired by a 1904 exhibition in Paris called French Primitives, which included art from before the Renaissance. Many younger artists were struck by the freshness and perceived honesty of the work. Another interest, which clearly influenced their simplified styling, was African sculpture, which Vlaminck, Derain and Matisse all collected.

The Fauves enjoyed their most successful period between 1905 and 1907. After that, they began to drift apart and follow different ideas. Matisse continued to develop the possibilities of Fauvism for several more years, but most of the others were soon working with new ideas.

the condensed idea
Using bright colour to express emotions

25 Expressionism
(c.1890–1934)

With their vibrant palettes and expressive brushwork, van Gogh, Gauguin and the Fauves paved the way for Expressionism. Originating in Germany in the early 20th century, developing from a feeling of unrest, Expressionism involved the depiction of powerful, candid representations of artists' personal viewpoints. It was a completely subjective movement without one single style.

The term 'Expressionism' is thought to have been coined by the Czech art historian Antonín Matějček (1889–1950) in 1910, when he described a new art style that appeared to be the opposite of Impressionism. According to Matějček, Expressionists sought to express inner feelings rather than the impartial external appearances of the Impressionists. Two years later, in 1912, the term was used again by the writer and editor Herwarth Walden (1879–1941) in his magazine *Der Sturm* ('The Storm').

Moods and feelings

The word 'Expressionism' was used to describe the moods and ideas that some artists conveyed through vivid, harsh, intense and distorted images. The artwork was subjective and personal rather than objective and detached. Artists worked with arbitrary colours and jarring compositions, not attempting to depict lifelike visual appearances or aesthetically pleasing impressions, but aiming to capture emotions through powerful colours and dynamic compositions instead. Like many art movements, Expressionism was not the product of one unified group and many artists who were described as Expressionists did not know each other or accept the label.

Expressionist art emerged more or less concurrently in various cities across Germany as society felt increasingly uncomfortable and anxious about the modern world. The Expressionists were also reacting against traditional art but were in favour of movements such as Symbolism and artists including van Gogh, Edvard Munch (1863–1944) and James Ensor (1860–1949). Most wanted to affect viewers with the strong emotions they portrayed, rather than with their technical skills.

Die Brücke

The Neue Künstlervereinigung München (N.K.V.M., New Artists' Association Munich) was one of several Expressionist groups. Based in Munich, it was started in 1909 by Gabriele Münter (1877–1962) with, among others, Marianne von Werefkin (1860–1938) and Wassily Kandinsky (1866–1944). In 1911, they joined others including Ernst Ludwig Kirchner (1880–1938), Max Pechstein (1881–1955), Kees van Dongen (1887–1968), Emile Nolde (1867–1956), Karl Schmidt-Rottluff (1884–1976) and Erich Heckel (1883–1970) to form Die Brücke (the Bridge). They aimed to challenge accepted styles of fine art, which included Impressionism and Post-Impressionism. The artists believed their work would serve as a bridge between previous and modern art. Most painted in an intentionally simplified and unrefined manner, developing a style that distorted subjects and colours

'The more frightening the world becomes . . . the more art becomes abstract.'
Wassily Kandinsky

meaningfully by exaggerating certain elements. They often painted images of the modern city to convey what they saw as an increasingly aggressive and intimidating world. Nolde was briefly associated with Die Brücke but became better known as an Expressionist who worked alone. Die Brücke artists were also influenced by primitivism (the art of countries such as Africa and Oceania, which was seen as direct, uncontrived and natural). In the shadow of the First World War, they

The Scream

Norwegian artist Edvard Munch helped to inspire Expressionism. In 1893, he produced prints and a painting of *The Scream*, which features an agonized figure against a red sky. In the background is a view of Kristiania (present-day Oslo) in Norway. Munch painted the work after writing about a memory: 'I was walking along a path with two friends – the sun was setting – suddenly the sky turned blood red – I paused, feeling exhausted and leaned on the fence – there was blood and tongues of fire above the blue-black fjord and the city – my friends walked on, and I stood there trembling with anxiety – and I sensed an infinite scream passing through nature.'

believed that modern life had become unbearable, that individuals were greedy, selfish and cruel and that by pointing this out graphically, they could change society for the better. Most Die Brücke artists moved to Berlin between 1910 and 1914.

Der Blaue Reiter

In 1911, in Munich, another group of artists formed Der Blaue Reiter (The Blue Rider), among them Wassily Kandinsky (1866–1944), Franz Marc (1880–1916), Paul Klee (1879–1940), Alexej von Jawlensky (1864–1941) and Auguste Macke (1887–1949). Aiming to reveal spiritual truths, their name came from Kandinsky's painting *Der Blaue Reiter* of 1903. Both Kandinsky and Marc loved the power and beauty of horses and they believed in the mystical significance of the colour blue. They drew inspiration from van Gogh, Gauguin, Munch and primitive art and they believed that through their art they could restore deeper meanings to people's lives. Kandinsky said he was seeking to create 'a new relationship with nature'. Although Der Blaue Reiter was less formal than Die Brücke and never published a

Park Restaurant, Auguste Macke, 1912, oil on canvas

manifesto, in 1912, Marc and Kandinsky published a collection of their essays on art. As leader of the group, Kandinsky believed that simple colours and shapes can portray moods and feelings, rendering subject matter superfluous. In consequence, he was one of the first artists to produce abstract works. Der Blaue Reiter members painted simple, lively and colourful images, conveying their feelings and commenting on the modern world. At the outbreak of the First World War in 1914, Marc and Macke were drafted into German military service and were killed soon after; the Russian members of the group – Kandinsky, von Jawlensky and others – all had to return home. Der Blaue Reiter immediately dissolved.

Other notable German Expressionists who mainly worked independently expressing their own powerful emotions, particularly the horrors of war, include Otto Dix (1891–1969), Lionel Feininger (1871–1956), George Grosz (1893–1959) and Max Beckmann (1814–1950). Some also worked in other countries concurrently, including: Georges Rouault (1871–1958) in France and Oskar Kokoschka (1886–1980) and Egon Schiele (1890–1918) in Austria.

the condensed idea
Art expressing inner angst

26 **Cubism**
(1907–14)

One of the most influential art styles of the 20th century, Cubism was created by Pablo Picasso (1881–1973) and Georges Braque (see Fauvism) at the beginning of the 20th century in France. It began in 1907 with Picasso's unveiling of his painting *Les Demoiselles d'Avignon*, which showed the influence of primitive African and Spanish sculpture and Cézanne's innovative ideas.

Les Demoiselles d'Avignon

This seminal work has been called the first modern art painting. Featuring five distorted female figures with mask-like faces and flat, angular bodies and a still life of fruit that appears to be falling off the canvas, it showed the influence of several different art styles at once. Picasso, like many artists, had been strongly inspired by the Cézanne retrospective exhibition of 1907. He had also recently become aware of primitive art from Africa, Egypt and Iberia. By distorting the forms on his canvas, using mainly pinks and blues (he had just emerged from his blue and pink periods) the painting was shocking and unexpected. Cézanne had looked for underlying structures in all he depicted, sometimes painting objects from different viewpoints at once in order to represent them completely on flat canvases. Primitive art simplified and often distorted forms. Incorporating these ideas and emphasizing the two-dimensions of the canvas, Picasso fragmented and fractured his figures, painting aspects from different angles, showing what we know to be there rather than what we see at a glance and collapsing the impression of space. The subject for *Les Demoiselles* was based on Picasso's memory of a brothel in Barcelona and the work stimulated the development of Cubism.

Analytic Cubism

After seeing *Les Demoiselles d'Avignon* for the first time, Braque stopped trying to depict depth, as Cézanne and Picasso had done, but painted objects from several different viewpoints on one canvas. Soon, Braque and Picasso began working together and when Braque exhibited some of his new landscapes at an exhibition in Paris in 1908,

Cubist Mocha, Eli Adams. This artwork was inspired by Cubism.

Matisse described one of them to the art critic Vauxcelles. Matisse made a quick sketch, showing how Braque's landscape was 'made up of little cubes'. From then on, Vauxcelles referred to the work as Cubism. Although this name diminishes the intensity with which Cubists analysed their subject matter, it stuck.

Braque and Picasso collaborated from 1908 until the outbreak of the First World War in 1914. They rejected the concept that art should emulate the appearance of things or that they should use perspective and tonal contrasts to make their work look 3D. Instead they flattened the appearance of forms while using lines and angles to show every object's structure. By splintering and layering or juxtaposing objects and painting everything from several angles, they felt that they were showing more about their subjects than straight, photographic type

views. Because these paintings were more difficult to decipher than normal pictures, most Cubists reduced their palettes, using only shades of brown, grey, black and neutral tones. Because they analyzed their subjects so carefully and were not trying to reproduce the appearance of reality, this phase became known as Analytic or Analytical Cubism.

Synthetic Cubism

During the winter of 1912 to 1913, Picasso and Braque began creating *papiers collés* – a method of pasting coloured or printed pieces of paper on to canvas. Each piece of paper represented a particular object, either because it was cut to the right shape or because it featured a clue that indicated what it represented. They also began using materials other than paper to signify different objects, such as chair caning. This phase became known as Synthetic Cubism. It was the first time that different textures in the form of collage had appeared in fine art. As the images were so broken and fragmented, the artists added 'clues' to help viewers interpret their images, such as letters and numbers, or painted imitation wood grain – an idea conceived by Braque, who was a former house painter.

Although Picasso and Braque's collaboration initiated Cubism, it was also adopted and developed further by several other painters, including Fernand Léger (1881–1955), Juan Gris (1887–1927), Albert

Cubist content

As Cubist paintings became more abstract, Picasso, Braque, Léger, Gris and other Cubists continued to portray recognizable, everyday objects. Picasso and Braque reduced their palettes, only including neutral tones to give the lines and tones a chance to stand out. Gris and Leger's work was sharper and smoother-looking, while Braque and Picasso added textures and effects to make the surface of the work seem almost sculptural while also still emphasizing the flatness of the canvas. It shows how Cubism was not a finalized achievement, but posed a constant struggle for the artists to break with the past and to make a completely new and modern art.

Gleizes (1881– 1953), Marie Laurencin (1883-1956) and Jean Metzinger (1883–1956). Cubist subjects were mainly objective, regularly featuring still lifes and portraits. Still lifes often included musical instruments, bottles, newspapers and playing cards. For the first couple of years, Cubism was mainly practised by painters, but by about 1910, sculptors produced Cubist works that needed to be viewed from all sides to be clearly understood. The major Cubist sculptors were Alexander Archipenko (1887–1964), Raymond Duchamp-Villon (1887–1968) and Jacques Lipchitz (1891–1973).

Most Cubists interpreted the theories in slightly different ways. Léger for instance worked with bright colours and sharply defined compositions that contrasted with the monochrome works of Braque and Picasso. Gris helped the development of Synthetic Cubism with his angular style. In all adaptations of the movement, Cubism had far-reaching consequences for later avant-garde art and design movements, including Dada, Surrealism, Art Deco, Constructivism and Abstraction.

the condensed idea
Objects shown from different viewpoints to represent the whole

27 Futurism
(1909–16)

While the Cubists were working in France, in Italy, a group of artists were discussing other artistic ideas. From 1909 to 1916, the Futurists as they called themselves, produced art that they believed shrugged off Italian traditions of art and looked to the future, embracing what they perceived as the glorious new world of modern technology.

Futurism was the only 20th century avant-garde art movement that centred in Italy rather than Paris. In 1909, the poet and editor Filippo Tommaso Marinetti (1876–1944), wrote a Futurist manifesto, praising youth, machines, movement, power and speed. At the time, no Futurist work of art existed; the ideas were all theoretical. To Marinetti and his friends, cars, planes and other technological developments represented excitement and the promise of a better future for all. They felt it was time everyone put classical and Renaissance traditions behind them and began to embrace new ideas instead.

Glorifying violence

When Marinetti published the first Futurist manifesto in December 1908 in the Italian newspaper *La Gazzetta dell'Emilia* and a month later in the French newspaper *Le Figaro*, the ideas inspired other writers, artists, architects, designers and composers. The ideas were revolutionary and they all agreed that the machine age was going to improve everyone's lives. In 1910, a group of artists published a second manifesto, which they called the *Manifesto of Futurist Painters*, signed by Umberto Boccioni (1882–1916), Gino Severini (1883–1966), Giacomo Balla (1871–1958), Luigi Russolo (1885–1947) and Carlo Carrà (1881–1966). It was even more specific than Marinetti's 1909 manifesto, demanding that Italian artists stop reminiscing about the past and look ahead instead. While they criticized classical painting, they praised modern technology. A month later, they also issued the *Technical Manifesto of Futurist Painting*, encouraging artists to find ways of representing dynamism and motion in their art. Between 1909 and 1916, more than fifty Futurist manifestos were published, each giving information on the artists' beliefs and often guidelines

about how to think and work towards the new art style. As well as modern technology and industrialization, the Futurists were inspired by Expressionism, Neo-Impressionism, Cubism and the music of Ivor Stravinsky (1882–1971). All machines and new technology and even war seemed to them to be exciting, fast and modern and worth depicting in fine art, not least because they believed that these things

Dynamism of a Cyclist

The Futurists embraced modern technology and celebrated the power of machines. This is an abstract depiction of a cyclist and bicycle, but once the figure and machine are identified, it is possible to see more recognizable elements in the painting, such as a mountainous landscape and the sun glinting on metal. Velocity is implied with broken brushstrokes, short marks and circular, short streaks to represent the rapidly spinning wheels and spokes. The painting demonstrates Boccioni's objective to portray the 'dynamic sensation' of speed using pointed, diagonal lines and angles, creating a rhythm through the build up of pattern and repetition.

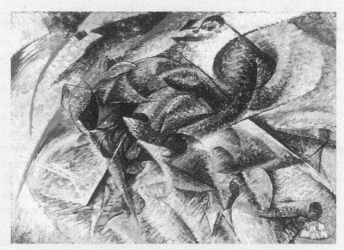

Dynamism of a Cyclist (Dinamismo di un ciclista),
Umberto Boccioni, 1913, oil on canvas

would help people dispense with social prejudices. They described war as 'the world's only hygiene'. They also had ideas about glorifying violence – before they faced the horrors of the First World War.

Rhythm and sequence

In his manifesto, Marinetti had written about the birth of a new beauty; the beauty of speed. And above all, velocity and vitality were what the Futurists aimed to express. To do this, they painted with rhythmical, repetitive lines and broken sequences or blurred forms, demonstrating a familiarity with photography and the recent discovery of x-rays. Objects were shown from different angles at once, although not as vigorously as in Cubism. Bold colours, sinuous or broken brushstrokes and splintered, curving or diagonal lines helped to create impressions of movement and light – in two- and three-dimensions. Complementary colours were juxtaposed to make paintings appear bright and lively. Many works represented the real world, but some were abstract, as most of the artists felt that the process of making art was as important as the completed work itself and that intuition and simultaneity (multiple views) were more important than careful planning.

'I wish to paint the new, the fruit of our industrial age.'
Umberto Boccione

The first major Futurist exhibition was held in Milan in 1911 and in 1912, the group put on an exhibition that began in Paris and travelled to various other European cities. It created a huge stir as it moved to Zurich, Vienna, Berlin, London and Brussels, spreading

Futurist ideas rapidly and inspiring many other artists in several different countries. Along with their radical ideas and abandonment of past traditions, the Futurists soon also began criticizing Cubism, believing that it was not sufficiently forward-thinking. Ultimately however, Cubism proved to be more influential. Meanwhile, Futurism was interpreted in various art forms including sculpture poetry and music and the original group members were so proficient at promoting their work through lectures, public meetings and publicity stunts that they unwittingly contributed to the development of modern techniques in public relations.

> 'A new beauty has been added to the splendor of the world – the beauty of speed.'
> Filippo Tommaso Marinetti

The effects of war

Because the Futurists were so excited about the future, they had underestimated the futility of war, or the devastating power of the machine gun, which they had revered. With Italy's entry into the First World War in 1915, this naïvety was soon upturned. Boccioni and the Futurist architect Antonio Sant'Elia (1888–1916) were both killed in action in 1916 and Russolo was badly wounded. Although a Futurist group reformed after 1918, the artists were disillusioned and their ideals had changed. Despite its earlier vigour, Futurism disappeared, although its influence spread across many countries and into other avant-garde art and design movements, including Russian Futurism, Art Deco, Vorticism, Constructivism, Dada and Surrealism.

the condensed idea
Expressing the dynamism, vitality and power of the machine age

28 Shin Hanga
(1915–39)

Shin Hanga, meaning 'new prints', was an early 20th century Japanese art movement that aimed to revive traditional Ukiyo-e woodblock prints, fused with Western drawing techniques. Created during the Taisho and Shōwa periods, the prints were both modern and romanticized. The artists involved used the original Ukiyo-e collaborative system, where artists, carvers, printers and publishers all worked together in a division of labour.

The term '*shin hanga*' was coined in 1915 by the printer Watanabe Shōzaburō (1885–1962). He had allegedly become dissatisfied with reprinting old Ukiyo-e woodcuts so he decided to create a new style of art that would use all the traditions of Japanese printmaking but would also incorporate contemporary Western-style drawings and paintings. Landscapes, townscapes, beautiful women, actors, birds and flowers were the subjects of choice. Watanabe brought together both Japanese and Western artisans and artists in an efficient, working studio. Soon other similar studios were opened and the Shin Hanga movement became established, flourishing from around 1915 to 1942, then resuming briefly from 1946 until the end of the 1950s.

Western styles

By the early 20th century, Ukiyo-e was outdated and more or less obsolete because of the development of mass printing techniques. So the main idea behind Shin Hanga was to create woodblock prints in the methods that were perfected for Ukiyo-e from the 17th to 19th centuries, but to use Japan's now more integrated experiences with the Western world as the basis for the drawing styles. Retaining traditional Ukiyo-e themes like landscapes (*fukeiga*), beautiful women (*bijinga*) and kabuki actors (*yakusha-e*), the style of the pictures was inspired by Realism and Impressionism. So unlike the flat, stylized images of Ukiyo-e, effects of light and atmosphere, natural colours, tonal contrasts and perspective were all incorporated into Shin Hanga. But Shin Hanga artists did not simply follow the approaches of Western art; they also integrated their own Eastern ideas and methods. Some of the work was nostalgic as artists expressed their longing for the

empty countryside and wooden architecture that was disappearing in much of contemporary Japan. The new ideas and freshness of the compositions were unexpected, while also being technically fluent and accurately rendered. Shin Hanga has also often been called 'neo-ukiyo-e' and in 1921, Watanabe used the term Shinsaku Hanga ('new made prints') to emphasize the creative characteristics of the work.

Prominent Shin Hanga artists

Several Shin Hanga artists became famous. Landscape artist Hasui Kawase (1883–1957) joined Watanabe's Shin Hanga group in 1919. His work was atmospheric and dreamlike and his most celebrated images were of night and snow scenes. In 1956 he was declared a Living National Treasure by the Japanese government. Koson Ohara (1877–1945) began his career as a painter, but later changed to Shin Hanga. He mainly depicted birds and other animals. Itō Shinsui (1898–1972) collaborated with Watanabe for twenty-five years, producing landscapes and images of beautiful young women and became one of the leading figures of the movement. In 1952, like Kawase he was declared a Living National Treasure by the Japanese government. Natori Shunsen (1886–1960) also began as a painter but became known for his prints of kabuki actors. Hiroshi Yoshida (1876–

1950) designed mainly landscape prints that were admired for their atmospheric colour and light. Like Impressionist works, some of his prints show the same subject at different times of the day or during different seasons. Hashiguchi Goyō (1880–1921) produced his first Shin Hanga print in 1915 and for the remaining few years of his life, created images of naturally posed Japanese beauties. Kotondo Torii (1900–1976) also produced images of beautiful women and Toshi Yoshida (1911–1995) experimented with abstract art before returning to his favourite subjects of landscapes and animals.

Popularity and decline

While there was not much of a market for Shin Hanga in Japan, during the late 19th century, Japonisme had become a huge craze in Europe and America with Ukiyo-e being greatly sought-after, so Shin Hanga was also received with alacrity in the West.

In general, the Japanese considered Ukiyo-e to be mass-produced and commercial. Watanabe originally produced Shin Hanga for Japanese buyers, but American and European buyers were charmed by the compositions and the evocative and romanticized Japanese figures and views. In the hierarchy of art in 20th century Japan,

printmaking was placed below oil painting and sculpture, so Shin Hanga was never respected as much there as it was in the West, although in 1921, a *Shinsaku-hanga Tenrankai* ('New Creative Print exhibition') was held in Tokyo and 150 works by ten Shin Hanga artists were exhibited. In the 1930s, two large Shin Hanga exhibitions were held in Ohio in the USA. But as the Second World War approached, the Japanese military government restricted the arts

'Art is the illusion of spontaneity.'
Japanese proverb

and in 1939 the Army Art Association was established to commission and promote official war art and related propaganda. By 1943, artists' materials were rationed. The market for Japanese prints declined and never really recovered, even after the war.

the condensed idea
Traditional Japanese printing techniques fused with Western drawing styles

29 Dada
(1916–22)

As a reaction against the horrors of war, Dada was not really an art movement at all. Those involved declared it was an 'anti-art' movement, protesting against the brutalities of the First World War and the insanity of a world that allowed it to happen in the first place. Significantly, it began in 1916 in neutral Switzerland, two years after the First World War began.

The mass slaughter of the First World War triggered an angry rejection of the values of a society that had led to it. Dada was one of the manifestations of this rejection and it focused on society's artistic and cultural values. The atrocious realities of the war were perceived as being the result of the oppressive inflexibility of society and culture. Dadaists declared that because of 'man's inhumanity to man', art and society were hypocritical and superficial. In their attempts to destroy traditional values of art, particularly idealized references to the past, they aimed to highlight the meaninglessness of war, producing work that was intentionally irrational and that rejected all previously established artistic standards. They deliberately provoked strong reactions in viewers in various ways, because as well as being anti-art and anti-war, Dada was also anti-capitalist.

Scorn and contempt

Many artists and writers went to neutral Zurich in Switzerland during the First World War. While meeting and discussing the abominations of the war and its repercussions, Dada emerged. The founders of Dada included the writer, Hugo Ball (1886–1927), the artist and poet Jean (Hans) Arp (1887–1966), Romanian poet Tristan Tzara (1886–1930) and a few others. In 1916, Ball and his companion Emmy Hennings (1885–1948) set up a nightclub in Zurich: the Cabaret Voltaire, where they were joined by other artists who all aimed to revile the war. Shows were noisy and boisterous, featuring new forms of performance such as 'sound poetry' and 'simultaneous poetry', as well as spoken word, dance and music. Contemptuous behaviour was encouraged from both the artists and the audience. Later, Ball published a journal called *Dada* – the first of many Dada publications.

By 1917 the Cabaret Voltaire had closed. but the artists moved to other locations. Ball said: 'For us, art is not an end in itself ... but it is an opportunity for the true perception and criticism of the times we live in.' Soon, as well as Zurich, Dadaists appeared in Paris, Berlin, Cologne and New York City. Artists involved included Marcel Duchamp (1887–1968), Francis Picabia (1879–1953), Kurt Schwitters (1887–1948), Hannah Höch (1889–1978) and Suzanne Duchamp (1889–1963) among others.

> 'Dada was a bomb ... can you imagine anyone, around half a century after a bomb explodes, wanting to collect the pieces, stick it together and display it?'
> Max Ernst

In their mission to incite shock or anger, Dadaists mixed artistic genres and materials. Dada activities included public gatherings, demonstrations and the publication of art and literary journals. Poetry, automatic writing and collage were all used creatively, prefiguring the 'Happenings' of the 1960s. Everything was created with strong accents of absurdity and disrespect. Those involved maintained that the production of art should be spontaneous and haphazard and should destroy traditions of aesthetics and beauty as millions of lives were being shattered at the Front. Hans Arp wrote: 'Revolted by the butchery of the 1914 World War we in Zurich devoted ourselves to the arts. While the guns rumbled in the distance, we sang, painted, made collages and wrote poems with all our might.'

Random name

Tristan Tzara declared that he chose the name 'Dada' by accident in 1916 when looking through a dictionary. Others added that when a paper knife slipped at random between the dictionary pages, he looked for an illogical word there to demonstrate the senselessness of art. He found Dada. In French, it means 'hobby horse' and in several Slavic languages it means 'Yes, Yes'. Overall, it did not mean much at all.

Rubbish

The basis of Dada was nonsense. It was not just one style, nor was it represented only through art, but along with the cabarets and exhibitions, there was Dadaist music and writing. To publicize their views, the Dadaists bombarded the public with irreverence. In their rejection of bourgeois values, they attempted to annihilate art and they advocated anti-social and unprincipled behaviour in general. Borrowing ideas from previous art movements, such as collage from Cubism, film photography that was just developing, Futurism's dynamism and the Futurists' notions of publicity, Dada constantly criticized the role that art had played in society leading up to the war. Chance was one of the ways in which the artists expressed this. For instance, Arp dropped torn pieces of paper arbitrarily, sticking them down where they fell 'according to the laws of chance', Man Ray (1890–1976) created assemblages (three-dimensional collages) out of everyday objects, Schwitters produced *Merz* – deriving from the German word for

> 'What is generally termed reality is, to be precise, a frothy nothing.'
> Hugo Ball

Readymades

In New York, Duchamp exhibited what he called 'readymades'. These were everyday manufactured objects that he chose and displayed in certain ways, perhaps tilted, inverted or joined together. He was questioning what constituted art, undermining notions of materialism and asking viewers to accept objects as art that had no association with the accepted art of the past. All his selections and placements of his readymades reflected his sense of irony, humour and ambiguity. Readymades were described later as ordinary objects elevated to the dignity of a work of art because they were chosen by an artist. Examples of Duchamp's readymades were: an upturned urinal on a plinth signed 'R. Mutt' and called Fountain or In Advance of the Broken Arm – a snow shovel on which he carefully painted its title.

commerce – which were assemblages of rubbish that he found in the street and Duchamp became notorious for his 'readymades'.

Politically angled

Dadaists were originally on friendly terms with the Futurists, but when the Futurists' extreme nationalism and militarism became apparent, the friendship ended. Dada spread and after the First World War, its manifestations in Germany and Paris were more political than elsewhere. German Dadaists for instance, expressed the turbulence and violence of the time, protesting

> 'I have forced myself to contradict myself in order to avoid conforming to my own taste.'
>
> Marcel Duchamp

against the Weimar government and Nazism. For a few years from 1918, the movement became even more driven, but in 1922, disagreements between Tzara, Picabia and another prominent member of the group, André Breton (1896–1966), led to its disintegration. The extensive repercussions it had created, however, eventually formed the basis of the Surrealist movement.

the condensed idea
Rejecting the traditions of art and society that led to the brutalities of war

Suprematism
(1915–35)

From the second decade of the 20th century, several art movements materialized that were dedicated to abstraction. One of these movements, derived directly from Cubism and Futurism appeared in Russia, developed by the painter and theorist Kasimir Malevich (1879–1935). Radically innovative, Malevich eradicated subject matter from his canvases and, in his words 'sought refuge in the square form'.

The geometric style that Malevich invented pushed him to the forefront of avant-garde art in the early 20th century. Calling his style Suprematism, he announced that he sought 'to liberate art from the ballast of the representational world'.

Victory over the sun

In December 1915 in Petrograd (St Petersburg), Malevich first showed his Suprematist work at the '0,10 the Last Futurist Exhibition'. He exhibited thirty-seven abstract paintings there, among them his canvas of 1913, *Black Square on a White Ground*, which was based on the sets and costumes he had designed for the Futurist opera *Victory over the Sun*. The painting, a large black square painted on a white background, was displayed above a door in the '0,10' exhibition and looked like a traditional Ukrainian or Russian family icon. All Malevich's other paintings in the exhibition also consisted solely of rectangles, circles, triangles and crosses and flat, smooth colour, with no attempt at tonal gradations or lifelike representations of anything. To accompany the exhibition, he wrote a leaflet called *From Cubism and Futurism to Suprematism*, describing the progression of avant-garde movements since the beginning of the century.

A pure language of painting

In 1912, Malevich had already exhibited paintings influenced by Cubism and Futurism, with the German art group Der Blaue Reiter and the Russian art group the Donkey's Tail. In reducing all pictorial elements to simple geometric shapes and blocks of plain colour or monochromatic tones, he believed that he had reached the pinnacle of

artistic expression and was freeing painting from any political or social meaning or connections. Instead of representing what they saw around them, Suprematists eliminated any evocative, symbolic or narrative content, condensing all elements to their simplest and purist forms, ending up with what they believed was a new creative reality instead.

> **'I felt only night within me and it was then that I conceived the new art, which I called Suprematism.'**
>
> Kasimir Malevich

As well as Cubism and Futurism, Malevich was influenced by primitive art, but unlike those art styles, his images had no reference at all to the surrounding world. He was also influenced by mathematics, philosophy and theories about the 'fourth dimension'. His shapes, lines and colours appeared to float on his canvases, detached from any recognizable aspects of life. In shocking viewers, who expected to see representational or recognizable things in paintings, Malevich contradicted conventions, because he believed that his 'pure language' of painting projected the artist's inner mental state.

The Russian Revolution

Malevich described Suprematism as 'the supremacy of pure feeling or perception in the pictorial arts'. It is no coincidence that this art movement emerged as closely as it did to the Russian Revolution of

Kasimir Malevich

Malevich once said that white was 'the real colour of infinity'. His white backgrounds were used on purpose to imply space, distance and perpetuity. By reducing the rest of his palette to just a few colours, he also emphasized the simplicity of the shapes that appear to have been placed randomly across the canvas. These abstract, flat shapes avoid any connections with the surrounding world and encourage viewers to clear their minds of all expectations and to attain a mystical feeling or sensation that did not rely on any memories or consciousness. All his paintings were composed with grids, but he achieved a sense of movement with diagonals, tilted angles and irregularly placed shapes.

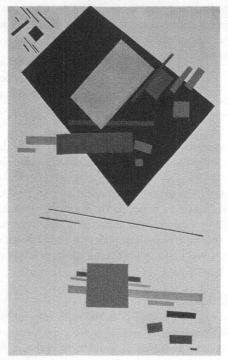

Suprematist Composition, Kasimir Malevich, 1915, oil on canvas

1917. Malevich and his followers based Suprematism on their idealistic principles, believing that they were helping to shape a new society in which acquisitiveness would be replaced with spiritual freedom. In trying to eradicate all physical associations with the world, Suprematism aimed to achieve purity in a society that had little regard for ethical values or principles. Malevich was not religious, but he believed his approach to art was spiritual.

Universal art

In 1916, Malevich published an expanded version of his leaflet of 1915, called *From Cubism and Futurism to Suprematism: The New Realism in Painting.* This was essentially the Suprematist manifesto. In the book, Malevich declared that the Black Square constituted the

'zero of form' that ended previous conventions and heralded the start of a new pictorial language. He also explained that Suprematism developed in three stages: the first stage was black; the second was coloured and the third stage was white. For the concluding stage, he produced a series in 1918 of white-on-white pictures, eliminating colour completely, but still painting geometric shapes that can be seen.

> 'In the year 1913, trying desperately to free art from the dead weight of the real world, I took refuge in the form of the square.'
>
> Kasimir Malevich

The ideas behind Suprematism were in some ways universal, but in other ways completely independent from European traditions. For instance, the resemblance to Ukrainian and Russian icon paintings was intentional. Painted icons were an enduring tradition and these ancient images were much admired. In his first Suprematist works, Malevich painted black shapes on white backgrounds, such as a black circle and a black cross, following the compositions of traditional icons with the main object in the centre of the canvas, sometimes set against a symmetrical cross or circular 'halo'.

In 1922 Malevich worked with other Suprematists on three-dimensional works and in 1927, the Bauhaus published his book *The Non-Objective World,* which expounded his theories of abstract art and described the inspiration behind *Black Square on a White Ground.* Although after the rise of Stalin from 1924 and the establishment of Socialist Realism in 1934, Suprematism was suppressed, it nevertheless helped to change the future of international art, architecture and design.

the condensed idea
Freeing art from the past and creating a 'pure language' of painting

31 Constructivism
(1917–34)

The history of avant-garde art in Ukraine and Russia in the early 20th century is not easy to follow as a great deal of documentation and works of art were destroyed in the aftermath of the Russian Revolution. Yet some of the original ideas altered the course of modern art, architecture and design. Suprematism was one of these ideas and Constructivism was another.

During the first decade of the century, Russia was still an empire under the autocratic rule of the Tsar Nicholas II. By 1918, after the Russian Revolution and the First World War, the entire world had changed irrevocably. In addition, inventions and discoveries such as the Model T-Ford assembly line, escalators, vacuum cleaners, light bulbs and colour photography were changing the way people lived.

Negative space

Like Suprematism, Constructivism was inspired by Cubism, Futurism and Neo-plasticism, but especially by Cubist sculpture. In 1913, Vladimir Tatlin (1885–1953) travelled from Russia to Paris, where he visited Picasso and saw his experiments with three-dimensional collage constructions or assemblages. Believing that art should directly reflect the modern industrial world, on his return to Russia, Tatlin began creating completely abstract relief constructions using industrial and scrap materials. From the start, he said that the space around and between his objects (the negative space) was as important as the structure itself. Between 1913 and 1917, Tatlin produced painted reliefs and then constructions without any reference to identifiable objects or representational themes. From 1915, he worked with Alexander Rodchenko (1891–1956). The two artists both produced purely abstract geometric designs and constructions, clearly influenced by Cubism, Futurism, Neo-plasticism and Suprematism.

Two viewpoints

Immediately following the revolution in 1917, more original Russian artists came to the fore. The brothers Naum Gabo (1890–1977) and Antoine Pevsner (1886–1962) both arrived back in Russia in 1917

after spending several years in Europe, and Kandinsky had returned from Munich in 1914. Despite difficult conditions, all these artists expressed revolutionary ideals with individual interpretations.

Coined by Pevsner, the term Constructivism was in general use by 1920, but even before that, from its beginnings. The idea of Constructivism encompassed two different attitudes. First of all was Tatlin's belief that art had a social purpose, so artists should subordinate any individuality for the good of the community. He aimed to create new forms in new materials that he deemed to be appropriate for the new social order. The second attitude came from Kandinsky's and Malevich's convictions that art is principally a personal rather than a public practice, however general its ultimate purpose may be. This viewpoint, with its moral and spiritual overtones, was later supported by comments by Gabo and Pevsner and it remained an essential aspect of much abstract art that followed.

Experimental and objective themes

In response to developments in technology and contemporary life, Constructivism was created to modernize art, design and architecture correspondingly. Gabo and Pevsner became involved on their return to Russia, introducing even more sculptural elements and further references to architecture, machinery and technology. Kandinsky also became involved but Tatlin considered his outlook too swathed in mysticism to be able to work as objectively as he believed it should be. Other artists who became involved included Liubov Popova,

The Russian political situation

With the Tsar's abdication in March 1917, the overthrow of Kerensky's provisional government by the Soviets the following autumn, the confusion during the first years of the Communist regime and the Civil War with the Whites, at first, avant-garde art flourished in in Ukraine and Russia. Many of the Ukrainian and Russian avant-garde thinkers were given positions in the new state institutions and Constructivism was encouraged as a progressive style that epitomized the new thinking.

Alexander Vesnin (1883–1959), Rodchenko, Varvara Stepanova (1894–1958), Alexei Gan (1889–1942) and Osip Brik (1888–1945). In 1922, Gan's book *Constructivism* was published, which was essentially a manifesto of the movement.

From 1918 and 1928, there were constant social and economic crises in Ukraine and Russia, as governments and regimes changed often. During that time, official opposition to progressive art toughened, so many new schools, artists' organizations and museums were planned, merged and dissolved in swift succession. The ideas of Constructivism soon spread to Holland and Germany and then attained international popularity. The ideas of complete abstraction seemed fresh and forward-thinking by people who were fed up with a society that had given rise to the horrors of recent years. With its relief construction, sculpture, kinetics and painting, Constructivism was perceived as progressive and modern, featuring experimental and objective themes that rejected emotion and broke everything down to its most basic

'I hold that these images are the reality itself.'

Naum Gabo

elements. New or different materials were often used and the methodical approach indicated the artists' strong notions about ignoring all that had led to the First World War, in their attempts to promote universal peace and harmony.

Tatlin's Tower

While he was head of the Commissariat for Enlightenment in Moscow, commissioned to create monuments glorifying Russia's success, among other works Tatlin produced a model for his *Monument to the Third International* (1919–20). Also known as Tatlin's Tower, it was to be built from iron, glass and steel and the main structure would feature four large suspended geometric constructions, which would rotate at different speeds. A few years later, the Soviet Regime decided that Constructivism was unsuitable as propaganda and in 1934 Stalin, who had led the Communist Party from 1924, discredited the movement. But the ideas continued to affect the development of art, design and architecture throughout the Western world.

> 'We know only what we do, what we make, what we construct; and all that we make, all that we construct, are realities.'
>
> Naum Gabo

the condensed idea
Organizing materials to construct space without mass

32 Neo-plasticism
(1917–31)

The term Neo-plasticism was used by the Dutch avant-garde artist Piet Mondrian (1872–1944) to describe his pioneering style of abstract painting, which was dominated by geometric shapes, flat colours and interlocking planes, inspired partly by Cubism. The name was soon also used to describe the work of a group of Dutch artists, architects and designers, called *De Stijl*.

The name Neo-plasticism comes from the Dutch *de nieuwe beelding*, which means 'new art' and began as a description of Mondrian's abstract painting and his idealistic philosophies and developed to include several other artists', designers' and architects' work as well. It was called new art because, in trying to reconcile his painting with his spiritual interests, Mondrian had broken away from representational depictions and was producing completely abstract paintings.

De Stijl

In 1911, Mondrian moved to Paris from the Netherlands and became fascinated by the work of the Cubists. While he admired the new ideas, he believed that Cubism did not go far enough in the development of modern art. He was also involved with the religious and mystical doctrine of theosophy and he aimed to unite his ideas of art with his spiritual beliefs. In 1914 at the start of the First World War, he returned to the Netherlands where he met the painter, architect and writer Theo van Doesburg (1884–1931) and the painter Bart van der Leck (1876–1958). Three years later, Mondrian and van Doesburg published a journal, *De Stijl* ('The Style'), expounding their theories on art, particularly Mondrian's ideas about Neo-plasticism. Ultimately, they were hoping to create a new, international art that represented peace and harmony in response to the horrors of the war. Other artists and designers with similar ideologies were involved and soon the name De Stijl came to relate to their association as well as the publication. The original members of De Stijl were van Doesburg, van der Leck and Mondrian as well as the Belgian painter and sculptor Georges Vantongerloo (1886–1965), Hungarian architect and

designer Vilmos Huszár (1884–1960) and Dutch architects J.J.P. Oud (1890–1963), Robert Van't Hoff (1887–1979) and Jan Wils (1891–1972). Membership increased rapidly. All the artists believed that Cubism had not been sufficiently extreme in developing abstraction and that 'Expressionism was too subjective'. They were also influenced by Russian Constructivism and Suprematism. To explain the ideas

The geometry of Neo-plasticism

The Neo-plasticists reduced all the elements of pictorial design to straight lines of different widths on white backgrounds that crossed and formed various sized rectangles and squares. They also restricted their palettes to the three primary colours and black, white and grey, aiming to evade specific details and descriptions of the world, instead conveying the essence of universal concord and equilibrium. By only using straight lines and flat blocks of pure or neutral colours, all extras were eliminated and the art essentially represented a universal order rather than the physical world.

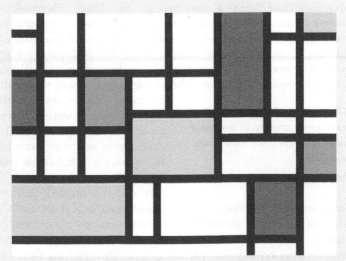

This image was inspired by Mondrian,
with vertical and horizontal lines and flat blocks of colour.

behind the art, Mondrian published a long essay, 'Neo-plasticism in Pictorial Art', in the first eleven issues of the journal *De Stijl*. In 1920, he published a book called *Le Néo-Plasticisme*.

Universal harmony

Mondrian had been a member of the Dutch Theosophical Society from 1909. Central to the aims of Neo-plasticism was a spiritual attitude based on the idealistic and anti-materialistic theories of theosophy. Mondrian believed that by breaking down everything around us to their purist forms, he could create balanced art that expressed notions of universal harmony as clearly as possible by using only pure elements. His grid-like paintings were created through careful deliberation and were intended to reveal the timelessness and spiritual order of the universe. To this end, he insisted that no composition should have a centre or one main focal point and the edges of a painting should be as important as any of the rest, so viewers are compelled to explore the entire image without concentrating on any one particular area. The opposing forces of horizontal and vertical lines in the paintings also have the effect of creating a dynamic balance and sense of calmness and stability, with nothing discordant or jarring.

> 'The pure plastic vision should build a new society, in the same way that in art it has built a new plasticism.'
>
> Piet Mondrian

Neo-plasticism in the applied arts

The Neo-plasticists' completely abstract paintings and designs were based on reducing shapes and colours to their purest and most essential forms. In November 1918, the group's artistic ideology was explained in an eight-point manifesto which was printed in *De Stijl*. Copies were published in Dutch, English, French and German, reaching out across Europe. The following year, the architect-designer Gerrit Rietveld (1888–1964) joined the group. This was an important development as it had a significant impact on the Neo-plasticists' ideas and production. Rietveld's Red-Blue Chair, with its black frame and primary colours highlighting the elements of its construction, was the first use of Neo-plasticism in the applied arts.

> 'This new art will find its expression in the abstraction of form and colour, that is to say, in the straight line and the clearly defined primary colour.'
> Piet Mondrian

The effects of Neo-plasticism

Neo-plasticism ended in 1931 when van Doesburg started a new art group called 'Abstraction-Creation'. He died later that year and the final issue of *De Stijl* was published in 1932 as a memorial to him. Neo-plasticism and De Stijl influenced developments in the Bauhaus and the architectural *International Style* as well as many other modern art and design movements over the rest of the 20th century and into the 21st. Mondrian continued to explore and refine his thoughts about pure colour and form and his uncompromising abstractions were regarded as the pinnacles of avant-garde art. Regarded as one of the most important artists of the 20th century, he influenced generations of artists and designers.

the condensed idea
Pure, geometric abstract art based on theories of theosophy

33 **Bauhaus**
(1919–33)

I n 1919, the Bauhaus school of art, craft and design was founded by the architect Walter Gropius (1883–1969) in Weimar, Germany. It was a descendant of the earlier Arts and Crafts movement in that it aimed to bring together fine art and the applied arts; but, unlike the Arts and Crafts movement, the Bauhaus acknowledged the usefulness of machines.

When Gropius was appointed head of two newly joined art schools in Weimar, he called it Bauhaus, the reverse of *Hausbau*, meaning house construction or house of building. Weimar was the centre of new social and political ideas in Germany since during the same year, the Social Democrats had written the constitution of the new Republic there.

Revolutionary teaching

The Arts and Crafts movement of the late 19th century had been inspired by socialist principles and it encouraged close collaborations between artists and designers to create simply designed objects without excessive decoration. This initiated more widespread design reform. From 1907, Gropius had been involved with a group of avant-garde artists and designers in an organization called the Deutsche Werkbund. Twelve years later, he set about reorganizing and running the Bauhaus based on his radical ideas for its organization and purpose. Aiming to bring art, craft and industry closer together, he structured the school differently from other art and design schools. Soon the Bauhaus became famous for its revolutionary methods of teaching art and design and for many of its avant-garde teachers and pupils. Some of those teachers were artists and designers including Paul Klee, Lionel Feininger, Johannes Itten (1888–1967), Marcel Breuer (1902–81), Josef Albers (1888–1976), Anni Albers (1899–1994), Marianne Brandt (1893–1983) and Kandinsky.

Art into industry

The Bauhaus was formed by combining the existing Weimar Academy of Fine Art and the School of Arts and Crafts, and students were trained in both the theory and the practice of the arts, learning to create

products that were both artistic and commercially viable. Gropius had envisaged a community in which teachers and students would live and work together equally and together, and they would bridge the gap between art and industry. The ideals of William Morris (1834–96), who had led the Arts and Crafts movement influenced Gropius' planning for the school. But in many ways the Bauhaus was the antithesis of the earlier movement as it embraced 20th century machine culture and mass production, whereas the Arts and Crafts artists and designers had shunned all that.

The Bauhaus was the first modern art school, combining both fine art and design education. Built around the concept that craftsmanship is the basis of every art form, all students took a six-month preliminary course, which covered a broad range of practical and theoretical aspects of art, craft and design. Next, students entered into specialized areas for three years, where they were taught by two masters, one artist and one craftsperson. The specialist areas included metalworking, cabinet-making, weaving, pottery, painting, typography, photography, printing and sculpture and after a while, architecture. All students were taught to create functional objects designed and produced with mass-production in mind. In 1923, the school adopted the slogan 'Art into Industry'.

> 'Our guiding principle was that design is neither an intellectual nor a material affair, but simply an integral part of the stuff of life, necessary for everyone in a civilized society.'
>
> Walter Gropius

Directorship and marketing

As well as moving to three different locations, the Bauhaus was led by three different architect-directors. These were: Walter Gropius from 1919 to 1928, Hannes Meyer (1889–1954) from 1928 to 1930 and Ludwig Mies van der Rohe (1886–1969) from 1930 until 1933. The changes resulted in frequent modifications to the curriculum, teachers and internal politics. For instance, the pottery shop was discontinued when the school moved from Weimar to Dessau. Yet the Bauhaus ideals did not really change; they were always based on simplicity in design and functionalism, upholding the belief that beautifully designed items could be mass-produced.

> 'Designing is not a profession but an attitude.'
>
> László Moholy-Nagy

Prominently marketed, the school's reputation spread rapidly. One of the most popular departments was typography, which became increasingly important under figures like the painter László Moholy-Nagy and the graphic designer Herbert Bayer (1900–85). In 1925, Gropius commissioned Bayer to design a typeface for all Bauhaus communication and advertising. Bayer designed a simple geometric sans-serif font with no capital letters, which broke new ground in graphic design.

When Meyer replaced Gropius in 1928, he abolished parts of the curriculum that he felt were too formal. Additionally, he focused on the social function of architecture and design. Under pressure from an increasingly right-wing government, in 1930, Meyer was replaced by the architect Mies van der Rohe. Mies also altered the curriculum, placing a greater emphasis on architecture. The increasingly unstable political situation in Germany combined with the perilous financial state of the Bauhaus, caused him to relocate the school to Berlin in 1930, where it operated on a reduced scale. But in 1933, under Nazi pressure, the Bauhaus was closed. Many of the key figures emigrated to the UK and then the United States, where their work and teaching philosophies influenced generations of young designers. The Bauhaus ethos of good functional design became one of the defining influences of the 20th century.

Bauhaus architecture

When the Bauhaus moved to Dessau, Gropius designed a revolutionary new building that embodied its principles. Built in just thirteen months, it created an ideal working environment for Bauhaus students and teachers. Modern materials and processes were exploited, with a skeleton of reinforced concrete, large windows and flat roofs. Three different wings formed the complex: the school, workshops and the housing and administration areas for staff and students. It became one of the most famous and influential buildings of the Modern movement.

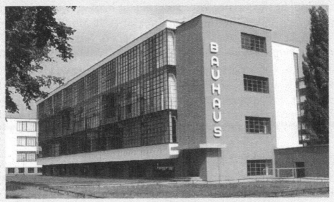

Bauhaus building, Dessau, 1926

the condensed idea
Integrating art, craft and design for modern, functional objects

34 Metaphysical painting
(1917–20s)

As a reaction against both Cubism and Futurism, the Italian art movement, Pittura Metafisica – or Metaphysical painting – was founded in 1917 by Giorgio de Chirico (1888–1978) and also taken up by Carlo Carrà (1881–1966). They painted illogical, dreamlike pictures that look strangely credible. With their unexpected juxtapositions and dramatic perspectives, the images were deliberately intended to play on the subconscious.

Before becoming a painter, de Chirico trained as an engineer. From birth until he was twenty-three years old, he lived in Athens, Florence and Munich and studied art in all three cities. In Munich, he became inspired by the writings of the philosophers Friedrich Nietzsche, Arthur Schopenhauer (1788–1860) and Otto Weininger (1880–1903) and the work of the Symbolist painters, Arnold Böcklin (1827–1901) and Max Klinger (1857–1920). In Florence, in 1910, he produced a series of paintings that he called *Metaphysical Town Squares*, taking his influences from philosophy, Symbolism and Italian architecture. From then on, he continued painting bizarre, otherworldly cityscapes.

Eerie and unearthly

From 1911 to 1915, de Chirico lived in Paris. He was indifferent towards many of the avant-garde movements he saw there, such as Cubism and Fauvism, but he admired the artists who were still including realistic elements in their paintings. From the start of his artistic career, he always painted figuratively and in Paris, he exhibited at the Salon d'Automne and the Salon des Indépendants. Not everyone received his work well, but among others, Picasso, Apollinaire and the art dealer Paul Guillaume (1891–1934) were enthusiastic about it.

On his return to Italy in May 1915, de Chirico was deemed unfit for the Italian army, so he spent the rest of the First World War painting at Ferrara, transferring to Rome in 1918. His paintings portrayed irrational, but fairly convincing scenes that seemed eerie and nightmarish. With strong perspective, dramatic shadows, mysterious figures and strange lighting, all the locations he depicted appeared to be frozen in time. Metaphysical paintings all seem still,

calm and often sinister. They all feature dramatic architecture with classical features, exaggerated perspectives and incongruous elements. Many metaphysical paintings incorporate unexpected and illogical objects, which all add to the disconcerting feelings they portray.

Visionary art

In painting their haunting and disturbing images, Metaphysical painters believed that they were uncovering deeper dimensions and going beneath the visual surfaces of everyday life. In doing this, they were aiming to encourage viewers to look beneath superficial appearances and question the enigmas and mysteries that surround us all. Many of the images show desolate, deserted city squares or oppressive enclosed spaces. Buildings and statues stand rigid and silent, throwing long, uncanny shadows; trains pass in the distance, clocks point to the time in empty streets. There is never any real suggestion in the paintings about exact times or locations, but they touch viewers' unconscious minds with feelings of apprehension and suspense. The Metaphysical artists aimed to draw attention to the mysteries of everything around us. Carrà said that their awareness of everyday things pointed to 'a higher, more hidden state of being' and he and de Chirico believed that they were following the distinguished traditions of early Italian art, particularly the paintings of Giotto and Uccello.

Two forms of existence

De Chirico's metaphysical philosophy was mainly based on his belief (founded on Nietzsche's theories) that everything in the visible world has two types of reality: the usual, everyday existence that we are all aware of and another form of being that he described as a 'spectral or metaphysical manifestation…seen only by rare and isolated individuals in moments of clairvoyance.' In his painting, he aimed to pass through the first form of existence in order to reach the second and through his works, to help others experience that elusive second form of reality. In 1918, he published his manifesto *Noi Metafisica*, explaining his aims.

The Scuola Metafisica

The term Pittura Metafisica was first used around 1913 by Apollinaire to describe de Chirico's painting style. Meanwhile in Italy, Carrà had become disillusioned with Futurism and in 1917 he met de Chirico when they were convalescing in a hospital in Ferrara during the First World War. The two men began collaborating, producing their bizarre, yet strangely realistic works. They were joined by de Chirico's younger brother, Alberto Savinio (1891–1952) a writer and composer, the painter Giorgio Morandi (1890–1964) and Filippo de Pisis (1896–1956) a poet and later a painter. Between them, they formed the Scuola Metafisica (Metaphysical School). They discussed and explored the ideas of the German philosophers de Chirico had studied when he lived in Munich; theories such as Schopenhauer's notions of intuitive knowledge, Nietzsche's concept of the enigma and Weininger's geometric metaphysics. They also considered the work of the Symbolists and Orphism that Apollinaire had introduced to de Chirico in Paris. All these became essential factors behind their ideas. Unlike the Futurists, the Metaphysical painters did not experiment with new painting techniques, but simply portrayed their unusual visions in a smooth style, following a fairly classical manner.

> 'There is much more mystery in the shadow of a man walking on a sunny day, than in all religions of the world.'
>
> Giorgio de Chirico

Valori Plastici

From 1918 to 1921, the art periodical *Valori Plastici* ('Plastic Values') was published in Rome in Italian and French. The publisher was a critic and painter, Mario Broglio (1891–1948). The first issues included articles by de Chirico, Carrà and Savinio, who explained the principles of Metaphysical Painting. Although the magazine also featured articles on avant-garde art such as Cubism and Neo-plasticism, the journal mainly criticized modern art and advocated a return to Italian classical traditions of painting using skilled techniques and naturalistic representations.

Surrealism

In the autumn of 1919 de Chirico published an article in *Valori Plastici* called 'The Return of Craftsmanship'. In it, he recommended a return to traditional methods of painting and representation. By the following year, he argued bitterly with Carrà, which split the group, although in 1921, he, Carrà and Morandi exhibited together in a show called 'Young Italy'. Although their movement was brief, their ideas and ideals became highly influential: in Italy, a revival of Classicism emerged; in Germany, various artists were considerably stimulated by them; but perhaps most significantly of all, in France, they helped to inspire Surrealism.

'To become truly immortal, a work of art must escape all human limits: logic and common sense will only interfere.'

Giorgio de Chirico

the condensed idea
Uncovering enigmatic truths hidden behind appearances

35 Harlem Renaissance (1920s–30s)

During the 1920s and 1930s, there was an outburst of creative activity among a number of black Americans living in Harlem in New York City. The arts they explored included music, dance, film, painting, theatre and cabaret, all inspired by their African heritage. It became known as the New Negro Movement, after art historian Alain Locke's book *The New Negro* of 1925.

From 1910 to 1930, two million Americans of African descent moved from the Southern United States to northern cities like Chicago, Philadelphia, Cleveland and New York City. Harlem was a newly built suburb of New York City and many wealthy and educated African Americans settled there. At around the same time, Locke's book *The New Negro* encouraged black artists to reinvigorate their creativity by focusing on their heritage.

The Great Migration

The American Civil War had ended in 1865. Until that time, 95 per cent of African Americans had lived as slaves in the South. After the Civil War, the southern states deprived these liberated black slaves of their rights to vote and most amenities and services were segregated by race. When job opportunities began to arise in the North in the early 20th century due to industrialization, thousands of black people moved there from the South. In 1917, when America joined the First World War, despite still being denied full citizenship and experiencing widespread prejudice, hundreds of thousands of African Americans supported their country and fought in the US military. Although some, such as the entirely African American 369th Infantry Regiment, returned from the war to a heroes' welcome, many were still not appreciated. By 1919, race riots and other civil uprisings reflected rivalries that were increasing over jobs and housing while even more black people were migrating to the North. From the 1920s, many black Americans who had settled in the northern states began celebrating their roots through art, literature, music and dance. This acknowledgment of their origins became nicknamed 'New Negro Movement'. Most of those involved had been part of the Great

Migration, although some were Afro-Caribbean artists and intellectuals from the British West Indies or Paris who had moved to the United States in search of a better life after the First World War. Many settled in Harlem, and soon the movement was renamed the Harlem Renaissance.

Racial and social integration

As black Americans became established in the northern states of America, many wanted to express their identities, their emergence from slavery and their cultural links with Africa. Many who were growing up in the neighbourhood of Harlem were middle class and well educated and they expressed themselves articulately and meaningfully, demonstrating their pride in their heritage and often destroying some racist stereotypes along the way. Their interpretations of the arts helped to strengthen attitudes towards them and to encourage better racial and social integration. For

'We younger Negro artists now intend to express our individual dark-skinned selves without fear or shame.'

Langston Hughes

the first time, African American paintings, writings, music and dance became absorbed into mainstream American culture. From being so severely oppressed, African Americans began to believe they could expect more from life and exploiting this optimism, they expressed themselves in ways that were appreciated and enjoyed by many.

Diverse cultures and characteristics

The Harlem Renaissance, which lasted approximately from the end of the First World War until just before the Second World War, did not have one single characteristic or style. Instead, in response to the diversity of the cultures the artists had come from and had grown up in, the work encompassed a wide variety of cultural elements and approaches. Although they relied on black patronage, Harlem Renaissance artists also depended on the support of white patrons, who had more significant connections and so could offer greater opportunities. Many white patrons became particularly interested in what they perceived to be the 'primitive' culture of black Americans.

Various artists were part of the Harlem Renaissance. They included Aaron Douglas (1898–1979), who became known as 'the father of Afro-American art' with his murals for public buildings and illustrations and cover designs for many publications, including the two primary Harlem Renaissance magazines, the *Crisis* and *Opportunity*. William H. Johnson (1901–70) moved to Harlem from South Carolina in 1918 and was the first artist of African descent to

Jazz

Jazz music was a powerful element of the Harlem Renaissance. In due course it became popular with both black and white Americans, blurring their differences. Eventually, after huge prejudices were overcome, jazz helped artists of the Harlem Renaissance to communicate with everyone. Both black and white Americans gathered to dance to or listen, often helping to obscure segregation lines, moving towards eliminating discrimination. Harlem Renaissance paintings often featured images of nightlife with jazz bands, dancing and cabarets.

achieve sustained recognition by the American art world. His work was a blend of a primitive style, elements of Modernism and themes of Afro-American daily life. Lois Mailou Jones (1905–98) was born in Boston and began painting as a child, continuing until she was in her nineties. Her vibrant paintings and textile designs featured bright colours, flat patterns and shapes, favouring the primitive styles that were so admired. Sargent Claude Johnson (1888–1967) moved to California in 1915 and worked as a painter, potter, ceramicist, printmaker and graphic designer, but mainly as a sculptor. He won many awards for his sculptures that exploited his racial identity. Charles Alston (1907–77) moved to New York City from North Carolina in 1913. As well as painting murals throughout Harlem, he directed the Alston-Bannarn Harlem Art Workshop along with the painter and sculptor Henry Bannarn (1910–65).

> 'If you have to ask what jazz is, you'll never understand.'
> Louis Armstrong

the condensed idea
Afro-American creative expressions of culture and race

36 Mexican Muralism (1920s–30s)

The Mexican Revolution occurred in 1910, soon turning into a civil war that lasted until 1920, with further intermittent spates of unrest throughout the 1920s. During that time, a small group of Mexican artists produced large-scale paintings in public places, intended to educate, inspire and instil a sense of national and socialist identity. They became known as the Mexican Muralists.

Although Mexican Muralism emerged directly out of the country's political situation, the painters involved were also inspired by a number of European art movements, such as the Renaissance, Post-Impressionism, Cubism, Expressionism, Symbolism and Surrealism. In addition, they drew on the art and culture of their heritage, such as Mexican folk art. The most prominent artists of the Mexican Muralist movement were José Clemente Orozco (1883–1949), Diego Rivera (1886–1957) and David Alfaro Siqueiros (1896–1974). They became known collectively as *Los Tres Grandes* or The Big Three.

Public art

Of the many revolutions in Mexico's history, the most significant was from 1910 to 1920. In 1922, the new national revolutionary government, particularly the Minister for Education, José Vasconcelos (1882–1959), decided to use art as propaganda and assigned artists to help create a new national awareness, to focus on the lives of the oppressed, to boost confidence and to emphasize the optimism of the new Mexico in comparison with the oppression and unfairness that existed before the revolution. The new government commissioned certain painters to produce a large number of public murals that would be accessible to all and would emphasize Mexico's strengths and help to shape a more democratic country, without class barriers or prejudices. Mexican Muralism was the most powerful and extensive programme of state-sponsored mural painting since the Italian Renaissance and the murals demonstrated the artists' commitment to post-revolution left-wing politics. Siqueiros was the most politically active of the three artists – he spent time in prison and fought in the Spanish Civil War – but they were all strongly patriotic and held

The largest mural

Although created many years after the Mexican Muralist movement had ended, this work by Siqueiros shows how it continued its influence, particularly in Mexico. The Polyforum is part of the building complex that makes up Mexico City's World Trade Centre where many cultural, political and social activities take place. It was financed by Manuel Suárez (1896–1987) a businessman and patron of the arts, and is made up of twelve enormous exterior panels, covered in murals depicting the March of Humanity. Siqueiros painted on most of the surfaces of the building, creating the world's largest mural. The images depict civilization's evolution from the past to the present and include a vision of the future.

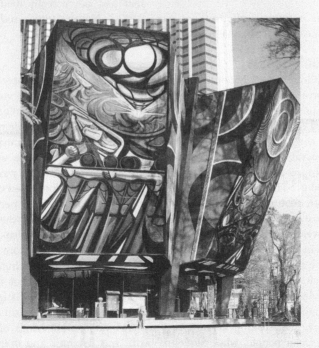

Polyforum Cultural Siqueiros, David Alfaro Siqueiros, 1971, asbestos panels, cement, metal, acrylic and pyroxyline

socialist views. The murals they painted were intended to convey social and political messages to everyone, even the illiterate. Most of the murals were painted in public places in the capital, Mexico City and in Guadalajara, Mexico's second largest city. They expressed pride in Mexico and in different ways, portrayed their indigenous heritage. Muralism was sponsored consciously as it had long been established as a traditional art form in Mexico that had never really died out.

> 'We condemn so-called easel painting and all the art produced by ultra-intellectual circles on the grounds that it is aristocratic and we glorify the expression of monumental art because it is public property.'
>
> David Siqueiros

For example, wall paintings were part of Mayan culture and also appeared later in Spanish Baroque churches in Mexico.

Realist style

Although most Mexican Murals are realist in style, with simple clear narratives so that they could be easily understood by as many viewers as possible, all the artists mixed traditional and modernist influences and each managed to find individual ways to respond to the demands of the political agenda and to make their work Mexican, universal, decorative, educational and inspirational. Rivera, for instance, who is recognized as the leading figure in the movement, drew on modern and pre-Hispanic art (that is, before the European colonization of the 16th century). He had lived in Europe from 1907 to 1921, spending most of the time in Paris and working with Picasso and Gris, where he developed his own bold and colourful form of Synthetic Cubism.

In his murals (and frescoes), he included elements from pre-Columbian cultures but also incorporated several Cubist techniques, such as basing his compositions on diagonal grids or not using traditional perspective and featuring elements of Gauguin's Symbolism. Orozco's work was influenced by Expressionism with dark and striking colours that focused on the sufferings of the Mexican people, while Siqueiros' work was dynamic and dramatic with strongly contrasting colours, showing strong influences of Surrealism, folklore and Michelangelo, whose work he had studied during a visit to Europe from 1919 to 1922.

Mexican Muralism in America

The Big Three became highly esteemed in the United States, where they each contributed to public art projects and consequently influenced several subsequent art movements. In the early 1930s, Rivera lived in San Francisco, Detroit and New York, painting murals for municipal buildings. In 1931, he had a retrospective in the Museum of Modern Art, for which he painted several small-scale portable frescoes. Between 1927 and 1934, Orozco lived in New York and painted a series of murals for the New School for Social Research there. Siqueiros lived in New York City in the early 1930s, where he participated in a 'Mexican Graphic Art' exhibition as well as producing a mural in Los Angeles with a team of students.

Mexican Muralism was intermittent when The Big Three were in the USA. They all adapted their styles to produce smaller canvases which were vital for getting their work better known outside Mexico and the United States and also to supplement their incomes, which they needed to do. They all received private commissions for these smaller paintings, often from American patrons.

the condensed idea
Large-scale public art to publicize Mexican heritage and hope

New Objectivity
(1923–33)

Many of the artists involved in Neue Sachlichkeit, or New Objectivity, had previously worked as Expressionists, Cubists, Futurists or Dadaists. Emerging in Germany during the 1920s, New Objectivity was a reaction against avant-garde art in general and Expressionism and Abstraction in particular, but even more specifically against the horrors of the First World War and the society that emerged afterwards.

The German artists classed as part of the New Objectivity movement were determined to depict the corruption and contradictions they witnessed around them. Shock and disillusionment over the First World War and the events and developments following it had given them a bitter attitude and, unlike many of the other contemporary art movements, rather than look towards a better world, these artists believed that in order to both protest and to come to terms with what was happening, they should depict reality as they saw it and point out how wrong it was.

Impartial expressions

New Objectivity was therefore just as emotional as all the other avant-garde movements, but the artists aimed to remain objective and to mirror society in their representations to emphasize the failures of the war, the ensuing Weimar government and society in general. Rather than a fully developed and coherent movement however, New Objectivity was more of a tendency or trend; the artists worked individually and did not associate in any particular groups. Because of this, some historians still dispute whether it can be classed as a movement at all. But all the artists shared an underlying disenchantment with abstraction that had been becoming more widespread. Neue Sachlichkeit artists worked in the German cities of Berlin, Dresden, Karlsruhe, Cologne, Düsseldorf, Hanover and Munich. Although there were some similarities, all the artists expressed their feelings in their own individual ways. Gustav Friedrich Hartlaub (1884–1963), the director of the Städtische Kunsthalle museum in Mannheim, first used the term New Objectivity in 1923,

Martha, Georg Schrimpf, 1925, oil on canvas

to describe these artists who had turned away from modernist ideas
and towards traditional painting values.

Everyday scenes in unreal situations

Leaning more towards the detailed and realistic painting styles of the
Northern Renaissance, New Objectivity artists focused on careful
compositions with close attention to perspective, precise contours,
natural or subdued colouring, thinned paint and unobtrusive
brushwork. Figures were always at the centre of every theme, usually
in domestic interiors or other everyday scenes in situations that
seemed unreal.

The chief exponents of New Objectivity were Beckmann, Dix,
Grosz, Herbert Böttger (1898–1954), Georg Scholz (1890–1945),
Conrad Felixmüller (1897–1977), Georg Schrimpf (1889–1938),

Christian Schad (1894–1982) and Rudolf Schlichter (1890–1955). Otto Dix and George Grosz had served in the First World War and experienced the appalling conditions of the trenches. They vehemently opposed the political and economic situation in Germany since the end of the war and they aimed to convey their distaste of developments since 1918. Dix painted the atrocities of the war and the corruption of post-war Berlin and Grosz depicted his disgust with German post-war society in general.

> 'My aim is to be understood by everyone. I reject the "depth" that people demand nowadays.'
> George Grosz

In 1925, Hartlaub's museum held a major exhibition called *Die Neue Sachlichkeit: Deutsche Malerei seit dem Expressionismus* ('The New Objectivity: German Painting since Expressionism') in which he showed over 120 paintings by thirty-two artists. In the introduction to the exhibition catalogue, he wrote that there were two types of Neue Sachlichkeit artists: the Verists, or truth-tellers, who were mainly left-wing and aggressive and aimed to depict underlying insecurities and anxieties about the present and their haunting memories of the war, and the classicists, who were not quite so hostile and who painted less disturbing, more objective images, trying to capture timelessness and

Magic Realism

The journalist and art critic Franz Roh (1890–1965) wrote an article about some of the work he saw at Hartlaub's 1925 exhibition called *Nach Expressionismus: Magischer Realismus* ('After Expressionism: Magic Realism'). Magic Realism was basically what Hartlaub had already called the classicist part of Neue Sachlichkeit. Roh emphasized that he used the word magic rather than mystic, to indicate the magical elements in many of the paintings. The term became used fairly regularly, although not consistently, and was later used to describe another style of writing and painting in America and Europe during the second half of the 20th century.

orderliness. The Verists distorted appearances to emphasize ugliness and provoke strong reactions in viewers. Dix and Grosz were examples of Verists, while Schrimpf and Carl Grossberg (1894–1940) were examples of classicists, who were soon also dubbed Magic Realists.

Social commentary

So, while Surrealism, Expressionism and various styles of geometric abstraction developed, the New Objectivitists were making more overt social commentary. Their cynicism had grown, as had the Dada movement, out of the First World War, but in New Objectivity, realistic detail was used more specifically to point out the horrors and corruption of people and society. New Objectivity can be compared to the Social Realism that predominated in America, but artistic interpretation was more aggressive in Germany where so many were affected by the war and its aftermath.

In their criticisms of the corruption and extravagance in their country after its defeat in the First World War and the ineffectual Weimar Republic that governed until 1933, New Objectivity painters tried different approaches. Beckmann portrayed threatening scenes in a style that resembled medieval stained-glass windows; Schad painted precise, often erotic-looking pictures and Dix and Grosz made aggressive and satirical observations of the social divisions in German society; the

> 'A day will come when the artist will no longer be this bohemian, puffed-up anarchist but a healthy man working in clarity within a collectivist society.'
> George Grosz

harshness of the terms of the Treaty of Versailles and the duplicity, depravity and corruption they experienced all around them, with strange and uncomfortable contradictions and juxtapositions in their paintings.

the condensed idea
Depicting the realities of post-First World War German society

38 Surrealism
(1924–50s)

After the First World War, Surrealism emerged in Paris as a development of Dada. It began as a literary movement when André Breton, Louis Aragon (1897–1982) and Philippe Soupault (1897–1990) defined it in their 1924 publication *The Surrealist Manifesto*. They explained that the aim of Surrealism was to free our conscious thought processes from reason and logic, no matter what the consequences.

The word 'surreal' is now in common usage, but it did not exist until 1917 when Guillaume Apollinaire – the poet, playwright and art critic who had named Orphism and Metaphysical painting – first invented the expression. *Sur-réalisme* can be interpreted as super-reality and it was adopted by the writers Breton, Aragon and Soupault for their manifesto in 1924.

Interpreting dreams

Strongly influenced by the theories of Sigmund Freud (1856–1939), the founder of psychoanalysis, the ex-Dadaist, poet and writer Breton declared that Surrealist painting and writing should express our deepest thoughts – as studied by Freud. In October 1899, Freud had published his book *The Interpretation of Dreams* in which he identified a part of the human mind where memories, intuition and our most fundamental instincts are stored. He called this the unconscious and he explained that these hidden depths of our minds can be understood if we analyse our dreams. He also believed that the unconscious could be accessed through certain methods, which could help explain the complex inner workings of our minds.

One of the methods he used to unlock the unconscious was 'free association', where a person does not think rationally, but intuitively. Soon several more writers and artists joined the Surrealist group and many used Freud's theory of free association, which Breton called 'pure psychic automatism'. In this, the writers and artists stopped thinking consciously and allowed their pens, pencils or paintbrushes to make marks – lines, words, shapes. They believed that by doing this, they were tapping into the unconscious and the resulting words,

colours and shapes would express their underlying feelings and emotions. The idea was that the unconscious was the source of the imagination and it should be accessed to achieve maximum creativity. The Surrealists aimed to merge the conscious with the unconscious in their creations, linking the worlds of dream and fantasy with the everyday world of reason and logic.

The Surrealist Revolution Although it developed from Dada, Surrealism was quite different in that it took a positive stance rather than a negative one, and while Dada was deliberately pointless, Surrealism was intended to be functional. In 1924, Breton became editor of the magazine *La Révolution Surréaliste*, producing twelve issues in five years and the first Surrealist exhibition was held in 1925 in Paris. Exhibiting artists included Max Ernst (1891–1976), Jean (Hans) Arp, Man Ray, Joan Miró (1893–1983), Pierre Roy (1880–1950), Picasso and de Chirico. In 1928, Breton published the book *Surrealism and Painting*, illustrated by Picasso, and in 1929 he published a second *Surrealist Manifesto*. In the same year, Salvador Dalí (1904–89) dramatically entered the group with a bizarre film, *Un Chien Andalou* ('An Andalusian Dog'), that he co-directed with Luis Buñuel (1900–83). With no plot, the sixteen-minute film used free association and caused a sensation when it was shown in Paris.

> 'I try to apply colours like words that shape poems, like notes that shape music.'
>
> René Magritte

The Bureau of Surrealist Research

At the same time as the publication of the *Surrealist Manifesto*, The Bureau of Surrealist Research, also known as the Centrale Surréaliste, was opened in Paris by Antonin Artaud (1896–1948). It was an office where Surrealist writers and artists gathered to meet and discuss their beliefs and to investigate various theories they purported about the subconscious. The group took this all extremely seriously, believing that their enquiries were equal to scientific research.

Three main approaches

Surrealism did not stipulate any one painting style, but there were three key approaches. The first was the creation of imagery through mechanical techniques in order to stimulate the imagination. The main techniques were collage and 'frottage' which were rubbings taken from a wide range of textured surfaces to create chance patterns

Un Chien Andalou

Released in 1929, this bizarre short film became renowned for its irrationality and shock value. With no plot or chronology, the black-and-white film follows Freud's theories of free association. This scene of a man slitting a woman's eye with a razor is often particularly recalled and the entire film explores the absurdity of dreams and our unconscious minds. Surrealism caught the imaginations of the world and has continued to inspire or be plagiarized widely, seen in literature, advertising, fashion, the press, film and in other art movements, such as Fluxus, Abstract Expressionism, New Media art and the YBAs (Young British Artists).

Still from the film *Un Chien Andalou*, dir. Luis Buñuel and Salvador Dalí, 1929

and mysterious-looking images. Ernst soon adapted the technique to oil painting, calling it grattage (scraping). The second two approaches were more enduring. They were realistic and 'oneiric' or dreamlike, as in the work of artists such as Dalí and René Magritte (1898–1967), or they were created through automatism, so were often completely abstract, as in the work of artists such as Miró

> 'To be a Surrealist means barring from your mind all remembrance of what you have seen, and being always on the lookout for what has never been.'
> René Magritte

and André Masson (1896–1987). Miró claimed that he frequently starved himself in order to induce hallucinations as he worked. With their eccentric, baffling, incongruous or disturbing coincidences, placements and compositions, Surrealist paintings challenged viewers to question what they saw and to look deep into their unconscious minds in order to understand themselves better. The major Surrealist painters were Arp, Ernst, Masson, Magritte, Yves Tanguy (1900–55), Dalí, Roy, Paul Delvaux (1897–1994), Dorothea Tanning (1910–2012), Leonora Carrington (1917–2011) and Miró. The ideas were radical and Breton also expected them to live, work and behave in a certain way, adhering to their beliefs. Because of this, Surrealism was sometimes compared to religion. Breton was quite tyrannical and he expelled those who did not conform or were unmanageable. Among others, these soon included Masson, Artaud and Dalí.

By the end of the 1920s, Surrealism, with its influences from Symbolism, Metaphysical painting and the nightmarish paintings by Hieronymus Bosch (1453–1516), Goya and Henry Fuseli (1741–1825), was attracting many international followers. It was one of the most influential avant-garde movements of the 20th century and its influence continues to the present day.

the condensed idea
Liberating the creative powers of the unconscious mind

Social Realism
(1930s–60s)

Not to be confused with Socialist Realism, which was the official Soviet Union art form established by Joseph Stalin in 1934 and later adopted by other Communist parties, Social Realism was an art movement that emerged in the 1930s, particularly in America. It usually conveyed a message of protest depicting social, political or racial injustice or economic hardship.

Since the Industrial Revolution, the living and working conditions of the lower classes had concerned many artists, and the 19th-century Realists, such as Courbet and Millet and the British painters Luke Fildes (1843–1918), Frank Holl (1845–88) and Hubert von Herkomer (1849–1914), made a point of portraying the poor in their works.

Social commentary

In the years following the First World War, building on the social commentary of Realism, Social Realism developed as independent painters, printmakers, photographers and film makers reacted against the ways in which many artists idealized life's hardships and inequalities. Calling attention to the everyday conditions of the working classes and the poor, Social Realists criticized the social structures that allowed and maintained these conditions. With their socialist attitudes, they usually conveyed the poor as noble and dignified, deserving better but enduring all with fortitude. The ideas these artists conveyed have some shared characteristics with the official communist art of Socialist Realism. Whereas Socialist Realism was an official government-sponsored art movement, Social Realism was unofficial and so far more subjective and personal.

The Great Depression

At the beginning of the 20th century, in Europe and America, slums burgeoned while the middle classes prospered. After the First World War, however, many felt a new sense of social consciousness. As these artists, photographers and writers focused on the harshness of life for the poorer classes, they became known as Social Realists and by the 1930s, with the austerities of the Great Depression, American Social

Realists were recording the deprivations of the poor in a dispassionate and detached manner. Many were inspired by the work of the Mexican Muralists and artists of the Ashcan School (a group of early 20th-century American artists who painted the less attractive aspects of New York city life and landscape).

American Social Realists include Ben Shahn (1898–1969), who incorporated lithography and graphic design techniques in his social documentary-style work. Reginald Marsh (1898–1954) painted crowds and particularly women in New York's subways, nightclubs, streets, bars and restaurants; Dorothea Lange (1895–1965) was a documentary photographer and photo-journalist who captured the human desolation of the Great Depression, influencing the development of documentary photography. The three Soyer brothers were also prominent, particularly Raphael Soyer (1899–1987) who painted ordinary people in New York City. Jack Levine (1915–2010) became known for his satirical paintings and prints and Arnold Blanch (1896–1968), was a painter, etcher, illustrator, printmaker, muralist and art teacher who gained recognition for his softly rendered paintings and prints of aspects of American life.

'When you talk about war on poverty it doesn't mean very much; but if you can show to some degree this sort of thing, then you can show a great deal more of how people are living.'
Ben Shahn

The Bread Line

Although associated with Pop art, Segal discovered a technique to create life-sized sculptures, using plaster and medical bandages for setting broken bones and fractures. Segal wrapped his subjects in cut-up medical bandages dipped in plaster and once the plaster had dried, he would cut off the hardened cast. This dejected queue of life-sized men was created for the Franklin D. Roosevelt Memorial in Washington DC at the end of the 20th century. The monument defines twelve years of Roosevelt's term of office (1933–45) and so included the period of the Great Depression, when people were hungry and dejected. The work reflects the Social Realist works of the time.

The Bread Line, George Segal (1924–2000), 1997, bronze

Regionalist art

Like many art movements, Social Realism was not consciously planned and organized, but it occurred when several artists and writers developed similar views simultaneously and sought to express them creatively. Circumstances had provoked the movement and the interpretations varied between artists. In America for instance, American Scene Painting, also known as Regionalism, overlapped

with Social Realism. American Realists painted scenes of American life, but unlike the Social Realists, they focused on nostalgic representations of rural life. Whereas Social Realism pointed out the tragic situations of the urban poor during the Great Depression, the Regionalists' images of unchanged countryside and industrious inhabitants were more positive, reassuring and hopeful. The painting styles of Social Realism were usually realistic and objective, while Regionalism often displayed a fusion of techniques, blending lifelike images with abstraction. The three artists most associated with Regionalism were Thomas Hart Benton (1889–1975), with his strongly tonal, figurative images that were striking and vivid; Grant Wood (1891–1942), who is recognized for his portrayals of the rural American Midwest, particularly his 1930 painting *American Gothic*; and John Steuart Curry (1897–1946) who was against painters involving themselves in social commentary or political propaganda as the Social Realists did.

European developments

Although Social Realism is mainly considered to be an American art movement, in Europe similar sentiments were expressed by artists such as Käthe Kollwitz (1867–1945) and George Grosz in Germany, and, in Britain, the Kitchen Sink School of the 1950s included artists such as John Bratby (1928–92), who painted working-class interiors and still lifes to express their dissatisfaction with society and morals after the Second World War.

the condensed idea
Realist art, literature and film making social or political comment

40 Abstract Expressionism (1943–70)

After the Second World War, while Europe struggled to recover, America began to move into a position of political and economic power. Many European intellectuals and artists such as André Breton, Piet Mondrian and Max Ernst had emigrated there to escape persecution. Once settled, they created, taught and spread their artistic influences. The situation was ripe for a completely new art movement.

In the late 1940s, optimism and patriotism increased across the USA. Interest in culture and American history rose and a number of artists began working in a new, confident way. Of course, the mood across America was not all bright. Newspapers and newsreels had publicized the suffering and destruction of the war; the first nuclear bomb had been dropped on Hiroshima, the aftermath of the Great Depression lingered in some areas and the Cold War emerged. In the light of all this, numerous artists expressed their own and society's mixed feelings of hope, wariness, anger, horror and fear about the times in which they lived.

Spontaneity and individuality

The Abstract Expressionists were a small group of loosely associated artists who had worked in various styles before the war, but by the 1940s began working in radical new directions, reflecting the mood of the moment. From 1941 when America entered the Second World War, shocking images and descriptions of the atrocities that were occurring in Europe were seen by the American public. By the mid-1940s, several artists working in and around New York discussed how they could express their feelings and the feelings of the nation about the state of the world. They decided to use paint expressively, but rather than stories or themes, colour and paint application would spread their messages.

Abstract Expressionism was more of a general attitude than a particular style. The artists all knew each other, but they did not work as a group or plan to form an art movement. Contrary to the earlier themes of Social Realism and Regionalism, these American artists aimed to express their feelings individually and spontaneously.

Pollock first showed his radical Action paintings in January 1948, created by laying huge canvases on the floor and dripping household paint on to them straight from a tin or with a stick or trowel. He described his paintings as 'energy and motion made visible'. Yet his works are not as haphazard as they might at first appear. The act of painting was, for him, subjective and instinctive, expressing his innermost feelings, resulting in a complex, densely textured mesh of colours and lines.

Homage to Pollock, Lauren Jade Goudie, acrylic painting. It imitates Jackson Pollock's dripping technique and chaotic blend of colours.

The New York School

European avant-garde art had been a determining source of inspiration for the Abstract Expressionists. The influx to America of many artists as refugees introduced them to some of the ideas, but there were also several venues in New York where the art could be seen. In 1929, the Museum of Modern Art had opened, soon holding

exhibitions of Cubism, Abstract art, Dada and Surrealism as well as retrospectives of Matisse, Léger and Picasso, for instance. Other venues displayed works by Mondrian, Gabo and El Lissitzky among others and in the Museum of Non-Objective Painting, which opened in 1939, a collection of Kandinsky's paintings was exhibited.

The term Abstract Expressionism was used initially in March 1946 in the magazine *The New Yorker*, by the writer and critic Robert Coates (1897–1973) in describing the work of Arshile Gorky (*c.*1904–48), Willem de Kooning (1904–97) and Jackson Pollock (1912–56). Soon other artists working in similar styles were being called Abstract Expressionists too or, as they were mainly based in New York City, they were sometimes called 'The New York School'. They included Lee Krasner (1908–84), Robert Motherwell (1915–91), William Baziotes (1912–63), Helen Frankenthaler (1928–2011), Grace Hartigan (1922–2008), Mark Rothko (1903–70), Barnett Newman (1905–70), Adolph Gottlieb (1903–74), Richard Pousette-Dart (1916–92) and Clyfford Still (1904–80).

'Abstract Expressionism was the first American art that was filled with anger as well as beauty.'
Robert Motherwell

Abstract Expressionism describes the artists' aims of painting in an abstract and emotionally expressive way. Other influences included primitive and ancient art and Surrealism, especially Miró's automatism. The artists expressed their ideas individually, but there were some common elements, such as huge canvases and areas of paint, few references to real objects and no picture frames. Their first public exhibitions were held in the mid-1940s, but they were not well received.

One movement, two strands

Within Abstract Expressionism were two main types of painting styles. These were only roughly categorized, but became known as Action painting and Colour Field painting. In Action painting several of the artists painted without consciously planning in order to express their inner emotions, working intuitively, making sweeping, expressive and energetic marks on large canvases with brushes or other means. They dripped, swept or smeared paint across the entire surface. This technique was alternatively called Gestural Abstraction

Also known as non-figurative or non-representational art, abstract art developed at the beginning of the 20th century but became particularly popular after the Second World War up until the 1980s. Since photography had been invented in the 19th century, many artists had sought new ways of expressing the drastic changes and events taking place in the world. Diverse forms of non-representational art became particularly fashionable, as it frequently appeared fresh, intelligent and progressive.

as the action, or gesture of applying paint, was more important than the final outcome. Artists who were called Action Painters included Pollock, de Kooning and Franz Kline (1910–62). While they were generally angry and vigorous, the other type of Abstract Expressionists, Colour Field painters were more passive, painting large areas of colour on their huge canvases. But however they worked, all the Abstract Expressionists shared an interest in Carl Jung's (1875–1961) ideas on analysis, religion, dreams and memory and they all aimed to express the turmoil of the post-war world.

the condensed idea
Expressing emotions stimulated by worldwide tragedies

41 Colour Field painting
(1947–60s)

Colour Field painting is one of the ideas of Abstract Expressionism. The term was originally used in about 1950 to describe the work of a few painters, particularly Mark Rothko, Barnett Newman and Clyfford Still. Colour Field painting was essentially the covering of large canvases with single or limited colours, to elicit emotional or contemplative reactions in viewers.

After two world wars, Europe was devastated. For the first time, America became the centre of art and design as several European artists moved there, joining US artists and art schools. Soon, an atmosphere of renewal and regeneration developed. Colour Field painting emerged – a creative idea that ran alongside the Abstract Expressionist movement during the 1950s.

Expressing the infinite

In the late 1940s, some artists began to express individual interpretations of Abstract Expressionism, experimenting with new ways of handling paint and colour. Originating from Fauvism, Expressionism and Surrealism, Colour Field painting was characterized by large areas of flat single colour or the merging of two or three colours, soaked into or spread across extremely large canvases. Interested in religion and myths, the artists involved exploited the expressive potential of colour, painting large areas or fields of colour to stimulate contemplation. The huge paintings were usually painted as a series and meant to be seen together, inducing spiritual, semi-religious experiences in viewers. The artists were independently searching for a style of abstraction that would go beyond simply conveying images. Each wanted to express the idea that art could give viewers more than appearances, but that it could have infinite other implications and effects. To achieve this, they used strong colours in large areas intending to release or inspire viewers' emotions. With no attempt to create figurative images or even abstract designs, they did not worry about brush marks or tonal contrast for instance, but they focused on painting each canvas with vast areas of richly painted surfaces.

No boundaries

Beginning just after the Second World War in New York, Colour Field painters began working individually on similar ideas. The works emphasize the flatness of the canvas and tension is created between colours and indistinct shapes. Overlapping, blurred lines confuse viewers' understanding of depth and distance to stop anyone 'reading' anything into the works. The artists were aiming to evoke universal feelings and contemplation in all. Colour Field painting was the first style to decisively avoid the suggestion of a form or mass placed against a background. Instead, the entire canvas became equally important, with no focal point or main element. The paintings have no frames, implying that there are no boundaries between the works and the rest of the world.

Hard-edge

Another idea developed during the 1960s that was part of Colour Field painting became known as Hard-edge painting. The artists involved also applied intense colours smoothly, emphasizing the flatness of their surfaces, but instead of blurring edges, they painted clean lines and sharply outlined shapes. Hard-edge painters were particularly influenced by Synthetic Cubism, Neo-plasticism, Suprematism and the Bauhaus and rejected the gestural, unstructured approach of Abstract Expressionism.

Painting rituals

Rothko once said: 'I'm not an abstract artist; I'm interested only in expressing human emotions.' Not too far removed from Malevich's ideas of Suprematism, the original Colour Field painting was all about flat areas of colour to provoke emotions or spiritual awakenings in viewers. These paintings were created to evoke these feelings, but the way that Rothko worked was often almost religious and he remained secretive about his ritualistic methods. It is known that he painted under bright stage lights, but insisted that the finished works were viewed in muted light, so the colour appeared to float. He was also extremely specific about where, when and how the paintings should be seen.

Eliminating surplus details

One of the catalysts behind Colour Field painting was the artist and teacher Hans Hofmann (1880–1966) who had worked in Paris with Robert Delaunay and other avant-garde artists before emigrating to the United States in 1932. By the 1940s, he was painting coloured rectangles across his canvases in order to generate a sense of tranquillity. In 1947, Rothko produced vast paintings of amorphous, hazy-edged colours, avoiding all references to the natural world, but building up different tones and intensities to provoke particular moods. Initially, he used pale colours that reflected light, but later his palette became more sombre and intense and he produced series of paintings that were to be displayed around a room, surrounding and totally involving viewers. In the year that Rothko first exhibited his Colour Field works, Clyfford Still also exhibited several canvases saturated in various colours in different formations. Unlike Hofmann or Rothko however, Still's arrangements were irregular and ragged, appearing like torn strips of paper or fabric. Barnett Newman's mature paintings were even more simplified than Rothko's or Still's. He

Abstract, by Steve Wood, is a contemporary acrylic work, painted in homage to Rothko.

covered his canvases with colour and then divided them with a simple vertical stripe or two. Despite their disparities, all Colour Field paintings have elements in common, including the elimination of superfluous details; the emphasis of two-dimensional surfaces; the attempt to reveal the artist's emotional state of mind and the intention of stimulating contemplation.

In the 1950s, Helen Frankenthaler (b.1928) developed Colour Field painting ideas further. After working in a Cubist style she began staining or soaking diluted oil or acrylic paint on to unprimed canvases, so that the pigment became integral to the work and the large flat colours in her paintings seemed airy and uplifting. Frankenthaler was one of the artists featured in an exhibition in Los Angeles in 1964 that Greenberg called Post-painterly Abstraction.

the condensed idea
Swathes of colour on huge canvases to provoke contemplation

Pop art
(1956–60s)

After the rationing and austerity of the Second World War, mass production and mass media proliferated in many parts of Europe and America. Consumerism had arrived and some artists in London and New York decided to utilize this as their subject matter. Based on popular and commercial culture, their creations became known as Pop art, the antithesis to Abstract Expressionism.

The 1950s and 1960s saw the end of wartime rationing in Britain and the start of a consumer boom. Meanwhile, across the Atlantic, America was also experiencing confidence and a surge in consumerism. Mass production and mass media flourished. Not intended to last or even to be taken particularly seriously, the Pop art movement has since become part of the established history of Western art and irreversibly changed attitudes towards fine art.

Symbols of mass consumerism

Pop art began in the mid-1950s and reached its peak in the mid-1960s. It became one of the first creative expressions of Postmodernism. Pop artists wanted to brighten up the tarnished post-war world and to celebrate the future; they also wanted to embrace popular commercial culture, challenge abstract art and mock the society that had brought about two world wars. In some ways therefore, it was a descendant of Dadaism in its condemnation of the traditional, 'stuffy' art world and a society that encouraged it. By exploiting commercial images and objects, such as comic strips, money, magazines, newspapers, celebrities, advertising, fast food, packaging, pop music, television and Hollywood films, the artists were also sharing their fascination with contemporary mass culture.

This was tomorrow

In 1956, the Independent Group participated in an exhibition at the Whitechapel Gallery in London called 'This is Tomorrow'. Artists, architects, musicians and graphic designers worked in groups and a jukebox played the entire time. The theme of the exhibition was everyday living and the artists and designers exploited some of the

imagery of popular culture. Richard Hamilton created a collage for the exhibition catalogue made up mainly of images from American magazines, which he called *Just What is it that Makes Today's Homes so Different, so Appealing?* The image, which included the word 'POP' on a large red lollipop, achieved iconic status almost immediately as it said so much about contemporary society and culture. 'This is Tomorrow' is now perceived as a defining moment in post-war art and where British Pop art was launched. The expression Pop art was not used until two years later, however, by Lawrence Alloway in a 1958 edition of *Architectural Digest* to describe how some artists were exploiting images of popular culture and consumerism.

Soon, other artists were producing art based on the images and attitudes of modern society. In 1961, the 'Young Contemporaries' exhibition in London brought artists such as Peter Blake (b.1932), Patrick Caulfield (1936–2005), David Hockney (b.1937), Derek Boshier (b.1937) and Allen Jones (b.1937) to public notice. Their work was light-hearted and concurrent with the pop music phenomenon that was occurring in 'swinging' London. Meanwhile, in America, several artists rebelled against the domination of Abstract Expressionism and began using images of materialism, often with commercial printmaking processes, aiming to reach wider audiences.

In 1962, a Pop art exhibition was held at the Sidney Janis Gallery in New York: the 'International Exhibition of the New Realists'. Artists such as Claes Oldenburg (b.1929), produced massive, realistic models

The Independent Group

The Independent Group (IG) was a group of artists, architects and intellectuals who met regularly at the Institute of Contemporary Arts (ICA) in London from 1952. In discussing their ideas about modernism and popular culture, they formed many of the fundamental ideas of Pop art. Members of the group included artists Richard Hamilton (b.1922), John McHale (1922–78), Eduardo Paolozzi (1924–2005) and William Turnbull (b.1922), the critic Lawrence Alloway (1926–90) and architects Alison Smithson (1928–93) and Peter Smithson (1923–2003)

Cartoon style

Lichtenstein was heavily influenced by both consumer advertising and comic book style and he exploited some of the techniques used by comic book artists, such as dramatic compositions, cropping and foreshortening. In 1961, he began painting his own over-sized cartoon images, also using techniques derived from commercial printing, particularly huge coloured circles resembling printing's Benday dots. Benday dots are part of the comic printing process, similar to Pointillism or pixels. In comics and newspaper images, tiny dots are placed close together or far apart, to create the appearance of colours and tones.

A contemporary interpretation of Roy Lichtenstein's comic-style Pop art, which inspired many imitators.

of everyday objects, Roy Lichtenstein (1923–97) painted huge cartoon strip images, Andy Warhol (1928–87) produced silk screen images of celebrities, consumer products and news stories and Robert Rauschenberg (1925–2008) and Jasper Johns (b.1930) produced paintings and sculptures of symbols of mass consumerism.

Disapproval or endorsement?

Sometimes Pop art was a criticism of consumer society, at other times it was an endorsement. But all Pop artists denounced their personalities and created objective styles, aiming to inspire viewers to reconsider aspects of popular taste and attitudes that had previously been considered outside the confines of fine art. For instance, James Rosenquist (b.1933) and Warhol exploited their commercial backgrounds, eliminating the divide between the commercial and fine arts and inspiring new ways of working that had not been considered in fine art before. There was no one process or method and no uniform style, but some Pop art included duplications, prints, paintings, photographs, collages and three-dimensional creations, often made with materials that were new to fine art. Many critics were horrified by the ways in which they presented their 'low' subject matter as art.

Despite originating from similar ambitions and attitudes, Pop art was never a coherent movement and all the artists had their own agendas and approaches. Most of them respected the images they borrowed. By the late 1960s however, Pop art had lost its shock value and other art ideas were emerging. But the ideas had helped to take art out of its traditionally narrow, elitist official circles and to hurl it into the modern, materialistic, consumerist world instead.

the condensed idea
Colourful creations based on mass consumerism

43 Op art
(1960s)

In the autumn of 1964, the term Op art was used in *Time* magazine to describe a new style of art that created optical effects. Because of the illusions it provoked, it was also sometimes called Retinal art. The artists involved created geometric designs and patterns in order to generate sensations of movement or vibration in viewers' eyes.

The *Time* magazine article stated: 'Preying and playing on the fallibility in vision is the new movement of "optical art" that has sprung up across the Western world . . . Op art is made tantalizing, eye-teasing, even eye-smarting by visual researchers using all the ingredients of an optometrist's nightmare.'

Processes of perception

Op art was inspired by the Suprematists and Constructivists as well as Neo-Impressionism, Neo-plasticism and Colour Field painting. Op artists used geometric shapes and lines to create their illusory effects, sometimes only using black and white or blocks of colour, often repeating elements across large canvases or making use of ideas about perspective and generally playing on viewers' perceptual processes. Always abstract, some of the art appears to move, distort or vibrate as it is observed. Most of the Op artists drew on colour theories and the physical and emotional aspects of perception. Leading figures of the movement were Bridget Riley (b.1931), who for years used only black and white lines and geometric patterns across large canvases to induce appearances of movement or instability; Victor Vasarely (1906–97) who built up mosaic-like tessellated patterns to create impressions of three-dimensional forms and Jesús Raphael Soto (1923–2005) who created 3D optical works that either appear to vibrate or that actually move, so altering viewers' perceptions of each work. Soto's work links Kinetic and Op art.

Kinetic art

Kinetic means relating to motion and Kinetic art actually moves, unlike Op art, which only appears to move. Kinetic art is usually three-dimensional with works that are generally made up of parts

Bridget Riley

Whether it represents an illusion of waves or abstract rhythmical curves, a painting by Bridget Riley can be unsettling. For years, Riley worked only in black and white, subtly varying her lines and shapes in order to explore the dynamic effects of optical phenomena and to create perplexing visual effects in viewers. She has always aimed to engage viewers not only with her actual paintings, but also with how they are physically perceived. After a visit to Egypt in the early 1980s, she began using colour. Many of her paintings are inspired by her experiences and observations, such as light and colour in the landscape.

A contemporary artwork emulating and
illustrating the principles of Op art with black and white lines,
curves and shapes, creating optical effects.

designed to be set in motion by an internal mechanism or an external stimulus. In the 1950s and 1960s, at about the time Op art was developing, several artists began producing kinetic sculpture. These included Alexander Calder (1898–1976), George Rickey (1907–2002) and Jean Tinguely (1925–91), each working independently, making diverse examples of Kinetic art, such as sculptures that moved in the wind or turned themselves on and off at random or even some pieces that self-destructed. Kinetic art forms were pioneered by Duchamp, Gabo and some of the Constructivists, but became more popular in the 1960s. The label 'Kinetic art' was used from the mid-1950s and some of the kinetic artists, such as Soto, also produced Op art. Many kinetic works were based on geometric shapes.

The Responsive Eye

In 1965, the Op art movement was brought to the attention of the American public with an exhibition in New York City's Museum of Modern Art called 'The Responsive Eye'. The exhibition was the first to show optical art to the public and included works by Riley, Vasarely, Albers, Richard Anuszkiewicz (b.1930), Julian Stanczak (b.1928) and Tadasky (b.1935) among others. Visitors attended the exhibition dressed in Op art-inspired clothing and admired the work, although critics condemned it for being full of gimmicky visual tricks. But with 1960s fashions, Op art images quickly became popular and were used in a number of commercial contexts, appearing in print, television,

Happenings

In the late 1950s and early 1960s, Happenings began happening. Initially in America, these performances or events were created by artists and later became called Performance art. Happenings are often seen as an offshoot of Kinetic art and a descendent of Dada and Surrealism. The name was first used by the artist Allan Kaprow (1927–2006) in the title of his 1959 event in New York: *18 Happenings in 6 Parts*. Happenings required some spectator involvement and although planned beforehand, could also be improvised and could take place anywhere.

advertising, graphics, fashion and interior design. But despite its appeal to the public and designers alike, it never became as widely accepted or as internationally renowned as Pop art.

The primary goal of Op art was to fool the eye and the artists worked to create illusions of movement out of static works of art. The colours, lines and shapes were selected and designed, not to evoke any particular mood or atmosphere, nor to narrate any stories, but purely to induce visual sensations in viewers. Colours, lines, shapes and perspective were utilized to achieve desired optical effects to confuse viewers' eyes. The works required viewers to look at them. Yet Op artists did not necessarily welcome the public's approval. Bridget Riley for instance, who threatened to sue a manufacturer who plagiarized her works for fabric designs, declared that 'commercialism, band-wagoning and hysterical sensationalism' were damaging the art world.

> 'I think that the more that I exercise my conscious mind, the more open the other things may find that they can come through.'
> Bridget Riley

Astonishing evocations

Op art ideas emerged from different sources. Vasarely, for instance, was originally a graphic artist and much of his work can be seen as a direct development from that. His paintings are not meant to confuse or disturb viewers, but to fascinate and induce shapes and colours, while Riley's paintings might look scientific or mathematical, but she says she has always worked intuitively, although carefully. Many Op art paintings are disorienting, dazzling or disturbing. Despite being almost always totally abstract, sometimes along with other effects, Op art paintings evoke recognizable elements, such as water, wind or fire.

the condensed idea
Stimulating optical effects

44 Minimalism
(1960s)

In 1965, the British philosopher Richard Wollheim (1923–2003) wrote an essay called *Minimal Art* and even though he was writing about Colour Field paintings and Dada works, the expression Minimalism became used to describe a form of abstract art that was developing in New York at that time. It was an extreme art form that developed from several 20th century movements.

Minimalism was a reaction against Abstract Expressionism. Minimalists aimed to replace the emotional subjectivity with reason and impartiality. In place of splatterings of paint, they worked with cool, mathematical accuracy. Minimalism extended the idea that art should not be an imitation of anything, but should have its own identity. Minimalists followed the Constructivist idea that art should be made of modern, industrial materials and so it was often composed of materials such as bricks, fluorescent lighting or metal sheeting.

Stripping art to its essentials

In an attempt to completely liberate art from the ties of tradition, the Minimalists concentrated on the ideas behind art and stripped down the industrial materials they used to their most fundamental states. Basing their works on simple geometric shapes, they reduced their colours, shapes, lines and textures in order to abandon any sign of personal expression. They wanted viewers to experience their works without any distractions from subjects, compositions or narratives for example. Most Minimalists created three-dimensional works, but a few also painted and all avoided any attempt at representation or illusion. Key Minimalists were Frank Stella (b.1936), Carl Andre (b.1935), Ellsworth Kelly (b.1923), Ad Reinhardt (1913–67), Dan Flavin (1933–96), Donald Judd (1928–94), Sol LeWitt (1928–2007), Robert Morris (b.1931) and Richard Serra (b.1939).

Theoretical ideas

The movement developed from Frank Stella's Black Paintings, which were a series of paintings that consisted of black stripes separated by thin strips of unpainted canvas, revealing no hidden meanings, symbols

or references. As he declared, a picture was 'a flat surface with paint on it – nothing more'. The paintings were first exhibited at the Museum of Modern Art in New York City in 1959 as part of the 'Sixteen Americans' exhibition and they inspired several other artists to produce work focusing on similar ideas, but often interpreted in three-dimensions.

All Minimalism comes primarily from theoretical rather than practical ideas, and, although it was never an organized movement, it became popular among artists in the 1960s and 1970s. Each artist translated the theories in individual ways. For instance, Donald Judd (who strongly rejected being called a Minimalist) used industrial materials to create abstract works that emphasized the purity of colour, form and space and totally avoided illusionism. In the early 1960s he began to create three-dimensional structures that he called 'specific objects', focusing on relationships between his work, viewers and the surrounding environment. Carl Andre was influenced by Brancusi and Stella and like many other Minimalists, also rejected the tradition of artistic expression and craftsmanship by using standard industrial units such as bricks, sheet metal, Perspex and wood, arranging them into floor sculptures in simple arithmetic combinations. For more than thirty years, Dan Flavin worked with fluorescent lighting, exploring shapes, light and colour, placing

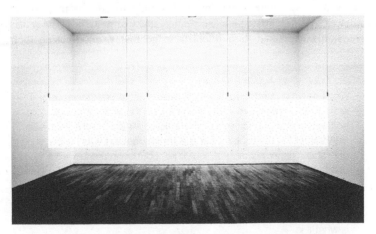

This black and white exhibition room illustrates the empty space, clean lines and reduced elements characteristic of Minimalist art.

coloured or white tube lights against white walls, so the light spreads and illuminates the space. Sol LeWitt began to experiment with abstract black-and-white reliefs in 1962, followed by simple geometric constructions out of just a few basic shapes, such as cubes, spheres and triangles and simple colours of red, yellow, blue and black. Sometimes his sculptures appeared logical and sometimes illogical, but this was intentional, so that viewers could interpret them as they preferred. As with the Constructivists, negative space was as important as the objects themselves. Ad Reinhardt's monochrome paintings, writing and lecturing made him a major influence on Minimalism.

> 'One might not think of light as a matter of fact, but I do and it is, as I said, as plain and open and direct an art as you will ever find.'
> Dan Flavin

What you see ...

Proceeding from Pop art ideas and Dada's readymades, Minimalists used materials that were often used in building work, such as aluminium, galvanized steel, house bricks, plywood and lighting. These mass-produced materials were used to depersonalize the work and if colour was used, it was not chosen to express moods or feelings or even to symbolize anything, but simply to add balance to the work or to differentiate between shapes, space or materials. The artists frequently expressed their interests in geometry, often basing their

Reductivism

Also known as Reductivism, Minimalism was all about reducing art to its bare minimum in order to expose the underlying idea, so there were no ambiguities or emotional allusions – the antithesis to Abstract Expressionism. For the Minimalists, art was no longer only about either painting or sculpture, but new materials were used to convey innovative concepts, usually about logic and order. Artists such as Dan Flavin and much later, Iván Navarro (born 1972) used electric lights to alter perceptions of the surrounding space. Minimalism was intentionally no-nonsense: what you see is what it is.

work on grids or other mathematically based ideas, but they determined to distance themselves from any suggestion of personal input. It was always: what you see is what you get. Every piece of Minimalist art was intended to be considered without any hidden agendas, deeper meanings or emotional connections. In questioning the nature of art and its place in society, the artists were more interested in viewers' reactions than in the objects themselves. It was a completely revolutionary concept and although many mocked and derided it, the movement had a strong impact on art, design and architecture that followed.

'What you see is what you see.'
Frank Stella

the condensed idea
Rejecting social comment, pretentiousness and excess

45 Conceptualism
(1970s–80s)

In the late 1960s, the term Conceptual art began to be used to describe types of art that were appearing that did not take the form of conventional art objects. Also often called Idea art or Information art, the principles of Conceptualism are ideas that take precedence over traditional materials, methods and skills usually used in the production of art.

Through his questioning (and flouting) of the rules of art, Duchamp was one of the major influences on Conceptualism, but the movement can also be seen as a steady progression from art that had been produced over the 20th century, such as some of Kandinsky's Expressionist ideas, Neo-plasticism, Abstract Expressionism, Colour Field painting and Minimalism.

Communicating ideas

Conceptual art came to be used as an umbrella term, describing several different types of art, including Performance art, installations, Video art, Earth art and Land art. As in Minimalism, the art is more about questions than answers and there are strong overlaps in the two movements, with several artists being categorized as belonging to both. Sol LeWitt for example, produces work that is often classed as Minimalist, but he considers himself a Conceptual artist. Robert Morris produces Minimalist sculpture, but a lot of his work can also be called Conceptualist. By its name, it is probably clear that Conceptual art can be almost anything; it is simply ways in which artists communicate their ideas. These Conceptualists think beyond the limits of traditional media and then present it in whatever form is suitable for their idea. The idea is always more important than the final result.

Conceptualism, as it became known, began in the late 1960s, when a number of artists began producing work that was based on various previous art movements, such as Dada and Minimalism. It emerged in several different countries simultaneously and despite angry criticism from many quarters, has remained hugely influential since. Most artists who have been categorized as such, did not choose to be

'Conceptualists', nor did many join groups or produce a manifesto, but they began working in diverse ways to express their feelings and attitudes that were often contrary to conventional art practice.

Conceptual artists include Joseph Beuys (1921–86), who produced many spectacular performances; Marcel Broodthaers (1924–76), who exhibited everyday objects, words, simple drawings, short films and three-dimensional structures; Victor Burgin (b.1941), who writes and produces video installations; Michael Craig-Martin (b.1941), who uses readymade materials and objects and taught several younger artists who went on to be Conceptualists; Gilbert and George, who include Gilbert Proesch (b.1943) and George Passmore (b.1942) who work together and who have become known for their distinctive, formal manner and colourful concepts that they call 'living art'; Yves Klein, who experimented with various methods of applying paint and Joseph Kosuth (b.1945) who explores the nature of art, rather than art itself.

> 'Ideas alone can be works of art; they are in a chain of development that may eventually find some form. All ideas need not be made physical.'
>
> Sol LeWitt

IKB

In 1957, Klein invented his own blue paint, created with ultramarine pigment and other chemicals to result in a pure, brilliant blue that he called 'International Klein Blue' or 'IKB'. This particular blue has had spiritual connotations for centuries in art, beginning with the pre-Renaissance pigment made with lapis lazuli, used for the Virgin Mary's clothes or the blue paint used in Kandinsky and Marc's Der Blaue Reiter works. From this time, Klein used this intense blue paint to saturate everything from huge canvases to classical-type sculptures, obscuring differences between painting and sculpture.

Challenging established concepts

One of the first things Conceptual artists questioned was the assumption that artists always create certain kinds of material objects. They asserted that the actual final product is not as important as the process – so artistic skill is irrelevant for their purposes. Because there are so many ways in which Conceptual art has manifested itself, many diverse areas have been called Conceptualism and there have been so many influences, that it is difficult to establish when the movement actually began, who started it and what it really is. Debates about this continue, but all agree that Conceptualism is a form of art that confronts and questions the idea of producing traditional artwork. Like Minimalism, it has always challenged the established ideas for producing, exhibiting and viewing art. Artists in both movements maintain that the importance given to the actual artwork previously led to an inflexible and elitist art world that kept art from the masses and could not be enjoyed by all – one of the concepts of Pop art. Conceptualists focus on their ideas, producing art that is not necessarily traditional painting or sculpture and does not need to be viewed in a gallery. They deliberately produce work that is difficult to classify according to artistic traditions. Some of the ideas are extremely simple, some are profound or complex – or stupid – and intentionally so. Although most Conceptual artists have not protested about wars or poverty, for example, as many other 20th century artists

Art and language

The Art & Language group was founded at the end of 1968 in the UK by the artists Terry Atkinson (b.1939), David Bainbridge (b.1941), Michael Baldwin (b.1945) and Harold Hurrell (b.1940) who had met while teaching in Coventry together. Later, other artists also joined the group and it became a changing association of conceptual artists. Through the journal they published, *Art-Language*, they influenced the development of Conceptual art in Britain and America.

had, they nevertheless often reflect their frustrations and irritations about society or politically related issues.

In 1967, LeWitt's article, 'Paragraphs on Conceptual Art' published in the American journal *Artforum*, defined Conceptual art as art that 'is made to engage the mind of the viewer rather than his eye or his emotions'. LeWitt continued to explain that even art that is not made is art as long as it begins with an idea. In line with this, Conceptual artists have often presented their ideas in visually dull formats so that viewers focus on the central idea or message. Despite peaking in the 1970s, Conceptualism has remained a widespread international movement.

> 'All of the significant art of today stems from Conceptual art. This includes the art of installation, political, feminist and socially directed art.'
> Sol LeWitt

the condensed idea
Expressing and challenging notions of 'what is art'?

46 **Performance art**
(1970s–80s)

Originating from theatrical events staged by the Futurists, the Surrealists and the Dadaists, particularly the activities at the Cabaret Voltaire and by the Action paintings and Happenings of the 1960s, Performance art is often categorized as being part of Conceptualism. It implemented the late 20th century idea that had developed in several movements that artists and viewers were dependent on each other.

In the 1960s, the term Performance art became used to describe ways in which artists were using their bodies to portray ideas. They expressed themselves in dancing, singing, miming, acting or other types of performance and these could be performed once only or several times, in expected or unexpected locations, planned or impromptu. In Germany and Austria, Performance art was given the title Actionism. It became a major phenomenon in the 1960s and 1970s and like other forms of Performance art, has generally been considered to be an aspect of Conceptual art.

Action photographs

An important influence at the start of Performance art was a series of photographs taken in 1950 by the photographer Hans Namuth (1915–90) of Jackson Pollock creating Action paintings. The images became renowned and spread the idea of Action painting among viewers, critics and other artists, but they also inspired further methods of artists involving their entire bodies in the creation and portrayal of art. In addition, at about the same time, 'Happenings' were occurring, first of all in New York and then spreading to other parts of the world. These performances or events required viewers' involvement as much as the artists' input and soon became known as Performance art. The German Conceptual artist Joseph Beuys, who served as a fighter pilot in the Second World War but sustained terrible injuries when his plane crashed, was a hugely influential pioneer of Performance art. From 1963, he made an impact with his actions that reflected many of his experiences. These were all created to express social and political issues and human suffering through

various metaphors and innuendos. In Britain, Gilbert and George have presented original Performance works since 1969, but they call their work 'Living art' rather than Performance.

Performance art takes many forms and one of the problems for the earliest Performance artists was the transient nature of the work – once the performance was over, there was no record of it. So Performances are usually recorded as photographs or in film or video and these are usually how the ideas are spread to a wider audience. Most Performances do not require a script as they are not traditional performances as we understand them. They are content-based rather than drama-based, although they can include stories. The actions are not performed purely for entertainment, but Performance artists seek to encourage audiences to question their assumptions about life, society, politics, psychology or other issues that concern the artists. Some of the Performances satirize life; others are protestations, while some ask spectators to question accepted attitudes, opinions and behaviour. The main idea is that Performance art is a form of direct communication with an audience, provoking thought or awareness and always seeking to change viewpoints or perceptions in some way.

> 'Everyone will be famous for fifteen minutes.'
>
> Andy Warhol

Fluxus

Originating in Germany in 1960, Fluxus became an international movement. The name means 'flow' in Latin and the artists, composers and designers involved had a similar outlook to the Dadaists in their promotion of 'living art, anti-art'. Many artists became involved with Fluxus and in Paris, Copenhagen, Amsterdam, London and New York, members put on various activities including concerts of avant-garde music and performances. Ignoring art theories, they shifted the importance of what an artist creates, to the artist's activities and emotions.

Silent performance

Performance art is different from performing arts. Although an audience might expect to be entertained, entertainment is not Performance artists' intention. Unless the performance is in an exhibition, audiences do not usually purchase tickets and performance art is generally a one-off. The composer John Cage (1912–92) produced the first 'Happening' in 1952, which influenced all ensuing Performance art. This was his *4'33"* where musicians sat with their instruments before an audience, but remained silent for exactly four minutes and thirty-three seconds. The noises made by the audience, such as coughing or shuffling, became part of the performance and raised questions about expectations.

John Cage 'preparing' a piano in 1957 by placing objects between or on the strings or hammers to change the sound

Artists' interpretations

Yves Klein produced Performances connected with painting. For instance, in 1961, he had three nude models covered in his own blue paint, IKB and instructed them to roll around on white paper as 'human brushes', producing work he called Anthropometry. Andy Warhol became famed for staging new types of events and performances with his friends at parties and public venues in New York, such as music, film and slide projections. In 1970 Gilbert and George staged the first of their 'living sculpture' performances when they painted their heads and hands in gold and sang and moved to a recording of the song 'Underneath the Arches' for lengthy periods. Since then, they have rarely appeared in public without wearing similar suits that they wore for this performance and they insist that everything they do is art. Ana Mendieta (1948–85) focused on gender and cultural identity in her performances of the 1970s, with reference to her native Cuba and the way her life was being played out as an exile in America. Beuys' strange appearance and behaviour was a façade for his rational ideas about anti-nuclear weapons and the future of the environment that he expressed through his performances.

The principle of giving preference to the concept of the art, rather than the object, came from several 20th century avant-garde movements. Performance artists wanted to take their art out of galleries and away from the traditions of being only understood by a privileged few. In this way, they also aimed to eradicate the elements of capitalism that surrounded art – there would be no agents, no costly hangings or expensive purchases; Performance art was truly for everyone. Of course, this utopian idea did not always materialize, but many of the artists had political agendas and their ultimate aim was to make viewers consider different ways of thinking.

the condensed idea
Performing to introduce and encourage fresh viewpoints

47 Land art
(1960s–early 21st century)

In the late 1960s, Land art emerged as one of many developing artistic trends, with artists seeking to move away from what they perceived as the blatant commercialism of the art world. In their quest to find and use new materials, disciplines and locations for the creation and exhibition of art, many produced huge sculptures from natural materials, often in landscape settings.

Also known as Earth art or Environmental art, Land art is characterized by artwork produced directly with the environment. Developing as part of the Conceptual art movement in the 1960s and 1970s, Land artists create diverse and expressive works that utilize natural materials. Every Land artist has worked differently – there is no one method or approach. Some sculpt into the earth, some record where they have been in the landscape with temporary signs, some have brought natural objects, such as stones, earth, twigs or rocks, into galleries to create installations or have created works using natural materials in the open air. If not made as an installation in a gallery, Land art is sometimes documented as photographs, maps or films and exhibited in galleries, often as part of a sequence or story.

Transitory and unique

Some of the most prominent Land artists have included Robert Smithson (1938–73), Richard Long (b.1945), Andy Goldsworthy (b.1956), Michael Heizer (b.1944), Walter De Maria (b.1935), Nancy Holt (b.1938) and Dennis Oppenheim (b.1938). The movement started in the USA and became popular in other, mainly European, countries. Much of the work is huge, created using local, natural materials. These monumental works within the environment are usually created far away from urban environments and are left to change and erode naturally. Many of the earliest works, created in the deserts of Nevada, New Mexico, Utah or Arizona now only exist as video recordings or photographs. Being site-specific, this type of art is not always accessible to the public

> 'My remit is to work with nature as a whole.'
>
> Andy Goldsworthy

Spiral Jetty

In 1970, Robert Smithson transformed a huge area of natural wasteland into a vast piece of Land art. *Spiral Jetty* was a spiral road made of mud, salt crystals, black basalt stones and earth on the Great Salt Lake in Utah, USA. The 1,500 foot long (460 metres), 15 foot wide (4.6 metres) spiral is only visible when the level of the Lake falls below 4,197.8 foot (1,279.5 metres). Originally, the black spiral stood out against the algae and bacteria-reddened Great Salt Lake during a low tide. For thirty years, it disappeared underwater, but re-emerges whenever the water recedes and is now more white than black because of salt crystal encrustation.

Robert Smithson, *Spiral Jetty,* photo taken in 2005

and, being open to the elements, it often deteriorates rapidly. As they are usually one-offs, they are also transitory but this is frequently one of the objectives. Land artists have often been against the overpowering, commercial forces within the art market and as their art cannot be owned by anyone or replicated exactly, they can express themselves freely. Most Land art originated out of a concern for the environment, and explorations of the relationships between humans and their natural surroundings is often one of the main objectives.

Like *Spiral Jetty*, much of Land art is inspired by natural processes. Smithson, like most other Land artists, was fascinated by physical processes within the environment and ways in which nature performs, erodes, reacts and changes. Among other things, Nancy Holt builds enormous structures resembling ancient megalithic structures such as Stonehenge and arranges them according to astronomical sequences.

'A work of art when placed in a gallery loses its charge, and becomes a portable object or surface disengaged from the outside world.'

Robert Smithson

Conceptualist, Minimalist and Land artist Walter De Maria has created huge works, often using industrial materials in American deserts, ensuring that the weather and natural light effects change his structures' appearances, to evoke thoughts about Earth and its relationship to the universe. As can be imagined, a lot of this work can only be seen properly from the air – Smithson died in a plane crash while surveying one of his works. In only being accessible to a wealthy few who can afford to view it, critics have complained that this kind of Land art opposes the original objective of being for everyone.

Anti-commercialism, anti-industrialization

Most Land artists were reacting against the perceived artificiality, insincerity and commercialization of art during the late 1960s and the destruction of the countryside through industrialization. The movement began in October 1968 with an exhibition called

Fresh perceptions

Christo and Jeanne-Claude (both b.1935) can be categorized as Environmental artists, Performance artists and Conceptualists. They maintain that ideas behind their art and the processes of making it are as important as the final result. With massive lengths of fabric, suspended or arranged around or in vast urban or rural locations, the works they create encourage viewers to reconsider what they see.

'Earthworks' at the Dwan Gallery in New York. The following year, another exhibition, 'Earth Art' was also held in New York. The two exhibitions received wide-ranging attention from the press and public and for a few years, Earthworks was the name given to all environmentally inspired sculpture. It was welcomed by many critics as a branch of Minimalism and Conceptualism but also by environmentalists and others who wanted to protest against urbanization and materialism. Andy Goldsworthy (b.1956) produces both temporary and permanent structures made from natural, found indigenous materials, such as twigs, stones, snow or leaves in natural and urbanized settings, emphasizing the qualities of the surroundings. His work can be huge or tiny, colourful or monochrome, obvious or obscure and complex or simple. He aims to point out the dangers of society's disengagement from nature.

The work of Land artists sometimes involves photography, poetry, text and other materials as well as natural materials from the environment. Richard Long, for example, walks through remote and often wild parts of the world, recording his journeys with maps, poetry and photographs. He sometimes leaves a mark, such as a collection of stones or imprints on grass and photographs these and he usually collects found objects along the way, such as driftwood or small rocks, to incorporate into installations in galleries on his return.

'I am for an art that takes into account the direct effect of the elements as they exist from day to day apart from representation.'
Robert Smithson

the condensed idea
Working with natural environments to alter perceptions

48 Neo-Expressionism (1970s–90s)

Emerging in the 1970s as a reaction against Minimalism and Conceptual art, Neo-Expressionism grew until it became the dominant style of avant-garde art in the 1980s, chiefly in America, Germany and Italy. It was essentially a revival of painting in an Expressionist manner with many influences, such as the late work of Picasso. Neo-Expressionists conveyed violent emotions using crude and unrefined approaches.

Feeling dissatisfied with the introspective intellectualism that had developed in several recent art and design movements, a number of artists began to work in a fairly angry and expressive manner, simultaneously in Germany, America, Italy and a few other countries during the late 1970s. Rejecting what they saw as the pretentiousness of Minimalism and Conceptualism, they worked in ways that they considered to be the opposite, expressing emotions rather than applying cool consideration. Mainly returning to figurative easel painting, they included elements of autobiography plus their own symbolism and story-telling elements. The movement was not one unified concept and so various names have been used for it. In the USA, labels have included New Fauvism, Punk art and Bad painting (because of the lack of conventional art skills); in Germany, it was called Neue Wilden (New Fauves) and in Italy, it was called Transavanguardia (beyond the avant-garde).

> 'I begin with an idea, but as I work, the picture takes over. Then there is the struggle between the idea I preconceived and the picture that fights for its own life.'
> Georg Baselitz

Public scandal

Since the decline of Expressionism in the early 20th century, many artists have persisted in working with an Expressionist-style approach and in 1963, Georg Baselitz (b.1938), opened a one-man exhibition in West Berlin, displaying his extremely expressive and often shocking style and content. The show caused a public scandal; several of the works were confiscated on the grounds of indecency and the police

closed down the entire exhibition. Although his later work was not quite so contentious, Baselitz continued producing controversial work, for example painting all his figures upside down for a while, continuing to work in a raw and unrefined style in paintings and sometimes sculpture. By the 1970s, he was branded the leader of a group of German artists who were all also producing emotional, roughly rendered work. This was the group that became known as Neue Wilden. Included in the group were Anselm Kiefer (b.1945), who often uses non-art materials in his paintings, such as china or straw, the sculptor and painter Markus Lüpertz (b.1941), the painter Eugen Schönebeck (b.1936) and the painter, printmaker and sculptor A.R. Penck (b.1939).

American Neo-Expressionists include Philip Guston (1913–80), who in the late 1960s changed from Abstract Expressionism to Neo-Expressionism and began creating cartoon-style images of personal symbols and objects, Julian Schnabel (b.1951) a painter and filmmaker and David Salle (b.1952), a painter, draughtsman, printmaker and Performance artist, who has produced installations as well as paintings in which he overlaid images in different styles based on found

Francesco Clemente

The Italian self-taught painter Clemente, like most other Neo-Expressionists, drew upon a wide-range of influences, including theosophy, Hinduism, other non-European crafts and cultures and elements of Expressionism and Surrealism. His themes were frequently the human form, his own image, sexuality, myth and spirituality, non-Western symbols and dreamlike visions. After moving to New York in 1981, he began producing large oil paintings and collaborating with Andy Warhol and Jean-Michel Basquiat (1960–88) on several paintings. Fascinated by the margins of a person's inner and outer world, he explored the contradictions and conflicts that occur within all of us, within our rational and irrational selves; and our conscious minds and our imaginations.

materials. Italian Neo-Expressionists include Sandro Chia (b.1946), Francesco Clemente, Enzo Cucchi (b.1950), Nicola de Maria (b.1954) and Mimmo Paladino (b.1948), and in Britain, Christopher Le Brun (b.1951) and Paula Rego (b.1935)

> **'The reality is the picture, it is most certainly not in the picture.'**
>
> Georg Baselitz

are often classed as Neo-Expressionists. In France in 1981, a Neo-Expressionist group, called Figuration Libre (Free Figuration), basing their art on popular urban culture, was formed by Robert Combas (b.1957), Rémi Blanchard (1958–93), François Boisrond (b.1959) and Hervé Di Rosa (b.1963). Between 1982 and 1985, these artists exhibited alongside their American counterparts Keith Haring (b.1958), Jean-Michel Basquiat and Kenny Scharf (b.1958) in New York City, London, Pittsburgh and Paris.

Common traits

Although it was a diverse movement, there were several common characteristics to Neo-Expressionism, such as a general belief that Conceptual art, Minimalism and Pop art did not stimulate the imagination. The artists were also inspired by a wide range of elements, including Picasso's late works, the art of George Grosz, Ernst Ludwig Kirchner, Edvard Munch and Willem de Kooning, Fluxus, primitive art, graffiti art, art produced by the mentally

Commercial controversy

Neo-Expressionism continued through the 1980s, a decade of social, economic and cultural change, when affluence, consumerism and materialism reached new heights in many countries. Neo-Expressionism was welcomed by many artists who perceived the contemporary art world as pretentious and corrupt, with prices for new art attaining ridiculous heights. One of the many controversial aspects of Neo-Expressionism was the way that instead of rejecting all this, they encouraged commercialism and over-marketed themselves to the art-buying world.

unstable, Carl Jung's theories and their own violent feelings. They took subjects from advertising, book cover illustrations, rock music, comics, history and myths. Although the sources and ideas were varied, most Neo-Expressionist paintings had similar characteristics. Traditional drawing or painting skills were not required and neither were conventional ideas of composition and design, as an expression of spontaneous emotion was the focus. Most of the painting was rough and messy, sometimes bright or jarring and clashing. Marks were made with brushes, fingers or other unorthodox methods and materials and applied almost haphazardly. The artists communicated a wide range of themes, feelings and interests, such as inner tensions, anger, hostility or nostalgia.

> 'I don't really care about anatomy. Something perfectly drawn to me is just somebody showing you they can draw.'
>
> Julian Schnabel

Most of the artists involved were not as desperately angry as their Expressionist predecessors had been and they simply depicted the harshness of the world as they perceived it, ignoring aestheticism, which led to debates about the intentions and worth of painting, with Neo-Expressionism frequently cited as an example of all that was wrong with the medium. By the middle 1990s, Neo-Expressionism had lost its momentum.

the condensed idea
Reinstating painting with intense and expressive subject-matter

49 Hyperrealism
(1990s–early 21st century)

In the late 1960s Photorealism emerged in America, along with various other art movements, in defiance of the conceptual and abstract art that was being produced. Photorealism was painting in which the final works appeared as sharply realistic as photographs. It was almost a non-idea – the artists' purpose was simply to use accurate painting skills to produce realistic-looking art.

Although it can be seen to have originated from Photorealism, Hyperrealism was not so straightforward. At the end of the 20th century, certain artists began producing art that was as exact and detailed as Photorealism, but created with particular, usually subtle changes in order to express philanthropically driven messages. Hyperrealists all work in different ways and represent a variety of subjects, including portraits, landscapes, cityscapes, figures and narrative or genre scenes. Although the work is created to appear detached and anonymous, it is usually deliberately emotive and often conveys an individuality that is as strong as Expressionism.

Social consciousness

Photorealism was originally established in the 1960s, evolving from Pop art, so it emphasized mundane, everyday themes and meticulous painting skills. They often consciously evaded human emotion, political value and narrative elements. In contrast, Hyperrealists are concerned with contemporary culture, politics and social issues, so they express a variety of ideas in their work, such as the vulgarity of consumerism, extremes of suffering, the plight of the working classes or the fragility of the human form. As with Photorealism, the first artists to create Hyperrealist works were American and included Denis Peterson (b.1945), Richard Estes (b.1936), Audrey Flack (b.1931) and Chuck Close (b.1940). Because the work is so exacting and precise, each piece takes months to create. Paintings are made with small brushes and built up with imperceptible marks and sculpture is created out of various materials that can be moulded into lifelike shapes and forms. Many Hyperrealists work directly from photographs to create works that appear to be photographs – part of

Hyperrealism requires a high level of technical ability and precision, but most artists also use mechanical methods to create their work, including photographic or multi-media projections onto canvases to be traced around. Some also use the traditional and painstaking grid method of transferring images. Many use airbrushes to blend colours indiscernibly. Sculptors often use polyesters applied directly onto moulds or on models' bodies to obtain the required shape.

the fun is in inviting viewers to decide whether or not an image is a photograph or has been produced with brushes and paint or whether a sculpture is a real thing or a manmade object.

How real is real?

Hyperrealism is nearly always subjective, with meticulous details creating illusions of reality that are even more distinct and exact than photographs or even reality itself. The idea is not to capture a literal copy of a photo or of reality, but to exaggerate it and call attention to an aspect that concerns the artist. Textures, surfaces, lighting effects, shadows and colours appear sharper and more distinct than reference photos or even the actual subject itself. The style evolved from Photorealism and the high-resolution images produced by digital cameras or on computers. It also derives from the philosophies of various theorists, in particular the sociologist, philosopher, photographer and political commentator Jean Baudrillard (1929–2007) who theorized about contemporary society's inability to distinguish reality from fantasy. Baudrillard and others questioned what is actually 'real' in a world where various media can completely shape an event or experience. Work varies, depending on artists' interests, as in Estes' representations of cities as eerie places characterized by reflective surfaces and impersonal structures, Close's portraits that confront viewers with unnatural and unexpected proportions and prominences, Gottfried Helnwein's (b.1948) themes of the Holocaust and Nazism, or Peterson's series that portray human suffering in detached detail, arousing empathetic feelings in viewers.

The unexpected

Many Hyperrealists have created images and objects that have expressed their feelings about political or social matters, such as totalitarian regimes, racial or religious intolerance, persecution and discrimination, society's disregard for the vulnerable and disadvantaged, or the human condition. Hyperrealistic images often

Ron Mueck

Australian sculptor Mueck's (b.1958) work epitomizes Hyperrealism. Startlingly lifelike and often made in unexpected scales, it confronts viewers with its shocking realism. Using silicone, polyester resin, polyurethane and other materials that allow him to replicate intricate details, Mueck creates precise details, including wrinkles, stubble, mottling of skin and hair, triggering feelings of unreality in viewers, jolting them into reconsidering certainties of life; aspects that they did not think about. From 1997 to 2000, Mueck took part in the travelling 'Sensation' exhibition in the UK, Berlin, America and Australia, which launched his reputation and helped to propel Hyperrealism into the forefront of the contemporary art world.

Mask II, Ron Mueck, 2002

challenge viewers in conveying the unexpected. This could be an incongruous juxtaposition, a surprising dimension or an uncomfortable truth that we might otherwise have ignored. Ron Mueck's sculptures for example, such as his *Mask* of 1997, his tiny silicone *Dead Dad* of 1996–7, or *In Bed* of 2005, a huge, mixed media sculpture of a woman lying in bed, are strikingly lifelike, but in astonishing sizes, forcing viewers to re-evaluate what they are looking at. In contrast, Duane Hanson (1925–96) also made Hyperrealistic sculptures, usually representing ordinary citizens of the USA, but these were always life-sized and shockingly realistic, even in close proximity and they, too, make viewers reconsider their own attitudes. Many Hyperrealist paintings are airbrushed, using acrylics, oils or a combination of both. Denis Peterson's visually compelling and frequently disturbing paintings are usually created as a series and focus on uncomfortable issues such as genocide, survival, pain and suffering perhaps caused by conflict. The provocative subjects are portrayed with meticulous detail and often cropped, to encourage viewers to become voyeurs on situations that may make them feel uncomfortable. Although his paintings are comments on issues being shown, he deliberately leaves his own emotions aside, in order to allow viewers to make up their own minds.

'Subject matter is a separate medium through which viewers can connect to reality through the falsity and simulation of the image, which ironically is convincing.'
Denis Peterson

the condensed idea
Super-realism that challenges viewers' opinions

50 New media
(1970s–early 21st century)

Artists have always exploited new media, so it was inevitable that videos, computers and the internet, for example, would appeal to some as a means to create original art. From the first computer-generated works produced in New York and Germany in the mid-1960s, to the interactive internet art events of the 21st century, New Media art has been developed in frequently unanticipated ways.

It can be argued that New Media art started when artists originally began using oil paints in the 15th century or when they started using photography in the 19th century. But the term New Media was not coined then. Instead, it was first used to describe art that exploited the new, mainly technological media of the late 20th and early 21st centuries. Then, artistic developments included the use of video in the experiments of artists such as Nam June Paik (1932–2006).

The World Wide Web

The term Digital art was coined in the 1980s, when the World Wide Web was launched. The World Wide Web was originally created by Timothy Berners-Lee (b.1955) in 1989 to give physicists working at the European Laboratory for Particle Physics a method of sharing and discovering vital global information using computers connected to the internet. Some of the first people after the physicists to make use of the World Wide Web were artists who immediately recognized the potential of being able to express themselves as no preceding artists had been able to do.

Because of the nature of new technological evolution, developments in New Media art since the turn of the 21st century have been rapid, international and often transient. New Media art is an umbrella term for a wide range of art that can include digital technology such as the internet, video and computer animations, photography, smartphones and other, generally computer-related materials. From early on in its development, the impact of digital technology began transforming traditional artistic activities such as painting, drawing and sculpture and became recognized artistic practices. When digital technology became less expensive, more widely accessible and easier to use, some

Heath Bunting

Best known for his involvement in the development of the net.art movement in the 1990s, Heath Bunting is involved in a huge variety of different media and works through actions, documentation and images. He can be classed as a Conceptual artist or a New Media artist as in most of his work the idea is of paramount importance. Breaking down divisions between art and everyday life, his work is often intended to be amusing and occasionally controversial and to reach viewers in unconventional ways. Most of his work, such as Irational.org is about commercialism, visibility, networking on the internet and questioning the nature of boundaries between life and art, life and the internet and perceptions and communication.

Irational.org, Heath Bunting, 2010

As new technologies and media are used by artists, old 'new' media, such as videos, film, tapes and certain software become superseded by other materials, so it becomes increasingly difficult to conserve, protect and show artwork that was innovative in fairly recent times but that is often fragile and quickly outmoded. Conservation has always been a priority in the art world and this is continuing but with fresh challenges for newer methods of producing art.

established artists began using it such as Richard Hamilton who used the computer graphics program Quantel Paintbox system in 1986 to recreate his Pop art collage *Just What is it that Makes Today's Homes so Different, so Appealing?* In 2009, David Hockney first began using his new iPhone to create mini works of art, spreading the idea that iPhones and other new media are acceptable materials from which to make art.

The potential of participation

When home computers first began appearing in the 1980s, more artists began trying new ways of creating art using them. Jeff Wall (b.1946) manipulated photographs digitally to create fantasy images that appear realistic (inspired by Surrealist art), while Heath Bunting started Irational.org in 1994 and continues to explore the potential of ways in which everyone can interconnect through the World Wide Web and the possibilities of viewer involvement and participation. Bill Viola (b.1951) works with video art, using images, light and sound to emphasize ideas about life and existence. In the mid-1990s, Dirk Paesmans (b.1965) and Joan Heemskerk (b.1968) formed the Jodi art collective or Jodi.org. Their irreverent, jokey works are often created out of computer games, which they modify and alter, incorporating animations, graphics,

'Technology has become the body's new membrane of existence.'

Nam June Paik

unexpected pop-ups and changing URLs. Peter Stanick (b.1953) produces Pop art-style digital paintings of New York street scenes, Christophe Bruno (b.1964) explores questions over language and Jake Tilson (b.1958) first created his website *The Cooker*, in 1994. *The Cooker* features many images, texts and experiences from around the world, which can be viewed on any computer screen, meaning that the art is available to all and can be used by any viewer as preferred. Every element of *The Cooker* relates to the theme of food and every page takes the viewer or participant to a new area. Some of the featured elements are sounds of meals being prepared, images of restaurants around the world or travelling on a train to reach a certain place where food will be cooked.

> 'You have to allow uncertainty into art. It's that little seep of chaos that creeps in – you have to be ready for it.'
>
> Jake Tilson

New Media art is continuing to emerge and develop and as it does it is not clear how it will eventually be produced or perceived. There are bound to be many changes and developments as technology progresses and new artists try original ideas. So far, there is no one consistent concept or standardized practice, there are wide varieties in the ways in which New Media artists work. The main ideas include the exploitation of and experimentation with new media and can be as broad as the artists' imaginations and abilities. New Media artists come from a variety of backgrounds, from traditional fine art training, to graphic designers or photographers, computer experts, sound artists, or those with technology-based experiences.

the condensed idea
Using developing technology to create new forms of art

Glossary

Abstract art that includes nothing intentionally representational from the real world

Abstraction art that does not imitate the appearance of objects in the world, but distorts things, emphasizing what the artist perceives as essential

Academic art a classical style of art, promoted by government-sponsored academies, particularly in France during the 18th and 19th centuries

Acrylic paint quick-drying paint in which pigments are combined with a synthetic medium

Allegory representation of a story in which people and events have symbolic meanings

Anthropometry the name given by Yves Klein for a certain type of painting using human bodies rather than brushes

Amorphous with no definite shape or form

Assemblage a work of art made with objects or fragments of objects that were originally used in other ways

Avant-garde forward-thinking, unconventional art and artists

Benday dots a printing process where small coloured or monochrome dots are combined to create deeper colours and tones

Chiaroscuro an Italian word referring to the use of strong tones to create a sense of depth

Classicism a high regard for and emulation of the art of classical antiquity

Collage an artistic technique where artists stick different materials, such as cloth, newspaper or tissue paper, to a flat surface

Complementary colours colours that are opposites on the colour wheel and when placed together they have the effect of making each other appear brighter

Composition the arrangements of elements in an artwork

Contrapposto Italian for 'opposite', describing a figure in an artwork, where the weight rests on one leg while the other leg is bent at the knee, causing the hips, shoulders and head to tilt, suggesting relaxation; the stance originated in Greek art and was revived by Renaissance artists

Divisionism separate, individual dots or strokes of coloured paint, applied in juxtapositions to follow colour theories intending to appear brighter when viewed from a distance

En plein air painting finished works of art in the open air, rather than taking sketches back to the studio

Figurative art that aims to realistically represent recognizable aspects from the world

Foreshortening aligned with linear perspective, this is a method of representing three-dimensional forms on two-dimensional surfaces, distorting shapes so that objects appear as if they are coming towards viewers

Found objects also known as *objets trouvés*, objects that have been found by artists, incorporated in artworks and exhibited so others can appreciate them

Fresco a type of painting in which paint is applied to wet plaster

Frottage rubbings taken from different textured surfaces to create patterns or unexpected images

Genre French for 'type', different art themes are classified as genres, but also 'genre paintings' describe scenes of everyday life

Glaze in painting, the creation of semi-transparent layers to build up a shiny finish

Grattage a technique of oil painting, where the artist scrapes into thick paint, creating patterns, textures and pictures

Humanism an approach to life based on reason, focusing on human experience, thoughts and hopes and a positive attitude to the world

Impasto extra thick application of paint

Kinetics sculpture that moves

Modernism beginning with Realism at the end of the 19th century, a period when artists and designers determinedly rejected past art styles and created new forms of art that seemed more appropriate for contemporary viewers. It was generally associated with ideas of idealism in society and a belief in progress

Mosaic a picture or design created with bits of coloured glass, stone or tile, inlaid in mortar

Mural a large painting on a wall

Naïve in art, naïve painting is simplified and childlike in its technique and subject

Narrative art that tells a story

Naturalism a late 19th- and early 20th-century movement that was inspired by new thinking about natural science, especially Darwin's theories, aimed at faithful, objective representations of reality

Photograms photographic images made without a camera by placing objects onto the surface of photographic paper or other similar materials and exposing them to light

Photorealism the name of an art movement that developed in the 1960s as a reaction against Minimalism and Abstract art, mainly in America, featuring paintings that replicate photographs

Pointillism a technique of applying tiny dots of bright coloured paint onto white surfaces, so that from a distance the colours appear to blend

Oneiric pertaining to dreams

Postmodernism a general term referring to literature, art, design, philosophy, architecture and culture that focuses on individual interpretations and emerged in the 1960s as a reaction against Modernism. Two of its main characteristics are the merging of barriers between high and popular culture and a rejection of any single style or definition of what art should be

Quattrocento a blanket term for the culture and art of 15th-century Italy, the main period of the Early Renaissance

Readymade found objects that are exhibited in a new context as art

Sans-serif a typeface, font or form of lettering without any 'ticks' at the tips or ends of letters; sans comes from the French word meaning 'without'

Sfumato from the Italian verb *sfumare* meaning to vanish, sfumato describes the smokiness that some Renaissance artists, Leonardo da Vinci in particular, achieved when blurring paint to create soft tonal contrasts

Vanitas meaning vanity in Latin, a vanitas is a work of art, usually a still life, in which objects symbolically refer to the insignificance and brevity of life and vanity, reminding viewers of their own mortality

Verist taken from the Latin word *verus*, this term was first used to describe ancient Roman artists who depicted the whole truth about their subjects, such as wrinkles or warts and was later used for certain artists of the New Objectivity movement, who aimed to depict truth and reality however ugly or difficult to accept

Index

About the author

Susie Hodge has an MA in the History of Art by Research
from Birkbeck, University of London. She is author of over 100
books, including *The Short Story of Art* and *Art in Minutes*.

Picture credits
5 Scala/BPK, Bildagentur fuer Kunst, Kultur und
Geschichte; 9 Scala, Florence; 13 iStock / Carmen
Ruiz; 17 Scala; 22 Andrea Jemolo/Scala; 26 Dean
Conger/CORBIS; 30 Scala; 33 Shutterstock / Reed;
37 Scala; 42 Scala; 45 Austrian Archives/Scala; 50
The Metropolitan Museum of Art/Art Resource/
Scala; 55 Scala; 57 Scala; 62 Scala; 65 Yale University
Art Gallery/Art Resource, NY/Scala; 69 The Print
Collector/Heritage-Images/Scala; 74 Scala; 77 Scala;
81 The Art Archive / National Gallery of Scotland
/ Superstock; 85 Digital image, The Museum of
Modern Art, New York/Scala; 90 The Art Archive
/ Musée du Jeu de Paume, Paris / Laurie Platt
Winfrey; 94 Scala – courtesy of the Ministero Beni
e Att. Culturali; 98 Getty Images/The Bridgeman
Art Library; 102 Bettmann/CORBIS; 105 iStock /
Richard Weiss; 109 Getty Images/The Bridgeman
Art Library; 122 The Gallery Collection/Corbis; 129
Shutterstock / Reinhold Leitner; 135 Wikimedia.
com; 145 The Art Archive / Dagli Orti; 149 Private
Collection/ The Bridgeman Art Library; 154 The
Kobal Collection / Bunuel-Dali; 158 Shutterstock /
Nicholas R. Ellermann; 161 Shutterstock / Lauren
Jade Goudie; 166 Shutterstock / Steve Wood; 170
Shutterstock / brushingup; 173 Shutterstock / Lisa
Fischer;177 Shutterstock / telesniuk; 186 Getty
Images / Fred W. McDarrah; 189 Shutterstock
/ Eric Broder Van Dyke; 198 Getty Images /
EyesWideOpen; 201 Heath Bunting.

Greenfinch
An imprint of Quercus Editions Ltd
Carmelite House
50 Victoria Embankment
London EC4Y 0DZ

An Hachette UK company

First published in 2009
Copyright © 2009, 2023 Susie Hodge

A CIP catalogue record for this book is available from the British Library

ISBN 978 1 52942 928 2
eBook ISBN 978 1 52942 927 5

10 9 8 7 6 5 4

Printed and bound in Great Britain by Clays Ltd, Elcograf S.p.A.

MIX
Paper | Supporting
responsible forestry
FSC® C104740
www.fsc.org

Papers used by Greenfinch are from well-managed forests and other responsible sources.